Australian Art

Oxford History of Art

Andrew Sayers is Director of the National Portrait Gallery of Australia. Previously he was Assistant Director (Collections) at the National Gallery of Australia. Between 1985 and 1996 he was Curator of Australian Drawings at the National Gallery of Australia. He was responsible for several retrospective exhibitions of the drawings of Australian artists. His definitive study *Drawing in Australia* was published in 1989, following the extensive survey exhibition mounted for the Bicentennial in 1988. He is the author of *Sidney Nolan: The Ned Kelly Story* (1994) and *Aboriginal Artists of the Nineteenth Century* (1994).

Oxford History of Art

Titles in the Oxford History of Art series are up-to-date, fully-illustrated introductions to a wide variety of subjects written by leading experts in their field. They will appear regularly, building into an interlocking and comprehensive series. Published titles are in bold.

Oxford History of Art

Australian Art

Andrew Sayers

OXFORD
UNIVERSITY PRESS

OXFORD

UNIVERSITY PRESS

Great Clarendon Street, Oxford OX2 6DP

Oxford New York

Athens Auckland Bangkok Bombay Calcutta
Cape Town Dar es Salaam Delhi Florence Hong Kong Istanbul
Karachi Kuala Lumpur Madras Madrid Melbourne Mexico City Mumbai
Nairobi Paris São Paulo Singapore Taipei Tokyo Toronto Warsaw
and associated companies in Berlin Ibadan

Oxford is a registered trade mark of Oxford University Press
in the UK and in certain other countries

0-19-284214 5

10 9 8 7 6 5 4 3 2 1

British Library Cataloguing in Publication Data
Data available

Library of Congress Cataloguing in Publication Data
Data available

Picture research by Charlotte Morris
Typeset by Paul Manning
Design by Oxford Designers and Illustrators
Printed in Hong Kong on acid-free paper by C&C Offset Printing Co. Ltd

*The web sites referred to in the list on page 241 of this book are in the public domain and the
addresses are provided by Oxford University Press in good faith and for information only.
Oxford University Press disclaims any responsibility for their content.*

Contents

Introduction

The history of Australian art presented in this book includes both the art of Australia's indigenous peoples and the art of the people who have lived in Australia since its colonization by Britain in 1788. To treat 'Australian art' as a subject which encompasses both these traditions of visual culture is not easy; in fact there are significant conceptual difficulties in this approach. The largest difficulty lies in the definition of the word 'art' when applied to Aboriginal culture and definitions of the word in the fundamentally (though not exclusively) Western culture of the settler peoples.

The word 'art' has, of course, always been notoriously difficult to define. Perhaps a different way of looking at the subject would be to suspend semantic difficulties for the moment, and to proceed with an inclusive approach. Indeed, in our own time no other approach seems appropriate to a book with the encompassing title 'Australian Art'. The word 'Australian' in that phrase may have no particular validity as an art-historical concept (indeed much of the discussion of the art of Europeans in Australia over the past 200 years has been a somewhat unfulfilled search for some unique or characteristically 'Australian' iconography), but the adjective does have political, historical, and cultural meaning. In each of these realms of meaning, people of indigenous and non-indigenous descent are inextricably linked. This book begins, therefore, with the simple recognition that the shared destiny of peoples in Australia must be reflected in the history of its art.

Aboriginal art is fundamentally different in conception from the art of Europeans in Australia. It may be thought that to bring the two together amounts to cultural appropriation. Yet I have not attempted to theorize a common operating system in the visual cultures of indigenous and non-indigenous Australians. Rather, I have accepted that there is a duality in the art of Australia. The form of a book such as this—with its different levels of text (headings, body text, display boxes, captions, illustrations) assists in presenting a multifaceted rather than a singular reading of separate but shared and (partly) co-terminous histories. Aboriginal and Torres Strait Islander art is incorporated at various points throughout this book to draw attention to its ongoing, yet fragmented, history within the culture that has

Detail of 81

given rise to a reference text of this kind—the culture we might, for convenience, call modern Australia. Whilst different approaches could be imagined, they would come from writers with backgrounds different from mine. There is a basic narrative structure of this book which, I hope, will not interfere with the capacity of the reader to imagine other histories, to make comparisons across time and between the works illustrated. In a book of this limited length the illustrations carry a great deal of their own argument which the creative reader can reconstruct.

Despite the 'basic ontological gap' between Aboriginal and non-Aboriginal world-views, Aboriginal art does have an art history, in the accepted meanings of that term. There were Aboriginal art histories before the colonization of Australia, but the European colonization of 1788 began to change the nature of Aboriginal art in fundamental ways. Whilst there are certain continuities in Aboriginal art, it has never been either monolithic or static. The history of Australia's rock art (outlined in Chapter 1) is an extremely long history and one in which different styles and motifs have changed and adapted. Similarly, the history of art made by indigenous Australians since 1788 has been one of change. Since the 1890s, the development of markets for Aboriginal art has affected both its production and its form. In the twentieth century, particularly since the Second World War, non-Aboriginal artists in Australia have not been able to see themselves as having a monopoly on Australia's visual culture: an earlier generation could ignore Aboriginal art as merely 'primitive', but not the post-war generation. In more recent decades an Australian art-world has developed in which demarcations between the forms of indigenous art and non-indigenous art are breaking down. For these reasons alone (and putting aside the worldwide perception of our own generation that indigenous arts are *the* distinctive arts of Australia) it can only be a distortion to see Aboriginal art as wholly separate from some other field which might be designated as 'Australian Art'.

There are at least two stories of Australian art. A moment's reflection will remind us, though, that there are a hundred, a thousand stories. Yet the fundamental duality of Australian art history heightens our awareness that conventions and structures shaped the art of Europeans in Australia just as conventions and structures form frameworks for the art of indigenous Australians. If the adjective can be used without its pejorative overtones, I think we can say that art in Australia is largely conventional; the twentieth century has developed a myth of continual radical innovation in art, but that is rarely encountered in the art of Australia.

We can take nothing for granted in looking at the art of Australia—least of all that we wholly understand anything about the art of the past. In Aboriginal art there are encoded meanings which it may or

may not be possible to know. Some interpretative information is privileged, which allows for an 'inside' reading of certain motifs and symbols, in addition to the 'outside' reading which is possible for the uninitiated. But can we—indigenous or non-indigenous citizens of the contemporary world—understand, with any greater sense of surety, the motivations of the art, say, of the first European voyagers to Australia?

Some of the conceptual complexities we face in the study of Australian art can be dramatized by looking briefly at a specific comparison—two views of Groote Eylandt, an island off the coast of Arnhem Land which was named by the Dutch explorer Abel Tasman in 1644. The first of these views is by William Westall, the English artist who accompanied Matthew Flinders on his charting and surveying voyage around the coast of the Australian continent in 1801–3. His drawing is a simple record of the view from the northern coast of the island [1].

In making his drawing of Groote Eylandt, Westall was carrying out his assigned role: when he joined Flinders's expedition the artist's role was understood to be primarily a documentary one—to record the physical attributes of landscapes and people encountered on the voyage. The most precise form of landscape depiction Westall undertook was the reproduction of coastlines—to add visual information to the logging and cartographic measurement which was the principal aim of the coastal survey. Fundamentally, therefore, Westall's drawings were to serve as part of a mass of precisely calibrated information in various forms—taxonomical, mathematical, and visual, much of which was included in Flinders's *A Voyage to Terra Australis*, published in London in 1814.

Accurate visual records such as these were but a small part of the field which constituted 'art' for early nineteenth-century Europeans; in fact many would probably have denied that such drawings could properly be described as art at all. Certainly painters such as Westall had a strong sense that there were more important forms of visual art than documentary drawings—forms of art and subjects which could be used to express great ideas and enduring truths. Indeed, Westall saw his own Australian drawings as of limited value and interest; he complained that he needed to visit other parts of the world to collect the type of material on which he could base satisfactory paintings which, in his own words, 'the barren coast of New Holland afforded him no opportunity of doing'.[1] From the standpoint of the present it is hard to empathize with Westall's description of the natural landscape of the unspoiled coast of Australia as 'barren'; on the contrary, Westall's art seems to describe a natural paradise.

When we compare Westall's drawing with a bark-painting [2] made on Groote Eylandt in 1948 by the artist Gulpidja and depicting

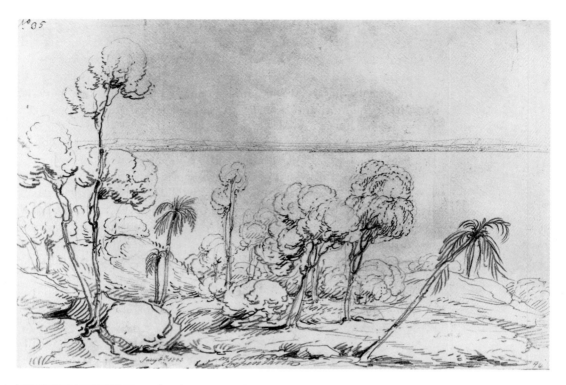

1 William Westall

Groote Eylandt, 1803

In the course of Flinders's circumnavigation of the Australian continent, the expedition's landscape artist, William Westall, made many such pencil drawings. The view is taken from the northern coast of Groote Eylandt looking towards the Central Hill, used as a navigational point by Flinders in his charting of the northern coasts.

the journeys of ancestral beings, the contexts and conventions of Westall's sketch are made clear. Gulpidja presents us with a different kind of mapping of the land, which describes the journey of the ancestor figure Jundurrana from the Arnhem Land mainland to Groote Eylandt and the totemic stingray site at Central Hill.[2] Gulpidja's painting is a reiteration (rather than a record) of the activities of the ancestral beings. Whereas Westall's drawing is marked with a precise date in the Western calendar, Gulpidja's work describes no such precise time but is intended as a medium between the ancestral past and the present.

Both Westall's Groote Eylandt topography and Gulpidja's Groote Eylandt creation narrative are part of the story of Australian art. It is important that we acknowledge both understandings of that part of the Australian landscape, yet at the same time we must admit that there are limitations which prevent us from entering fully into either. Having admitted the limits of our own world-view, we can expect only to understand the contexts, admire the skill and descriptive power of the artists, appreciate the motivations for image-making on the artists' parts, and, finally, bring our own experience to bear in making sense of these depictions of the external world.

2 Gulpidja, Groote Eylandt

Jundurrana creation story,
1948

This bark-painting represents the journey of the Groote Eylandt ancestor figure Jundurrana. The oval in the left-hand portion of the composition represents the totemic site at Central Hill and the smaller rectangle an important rock-art site. The creation of the Anguruku River by Jundurrana in his manifestation as a sawfish is represented in the middle and right-hand sides of the composition where he is surrounded by other ancestral beings in the form of stingrays.

This book differs from previous histories of Australian art in several respects. It is conceived as an examination of the contexts of illustrated examples, so it pays less attention to the history of institutions and art-world controversies than previous works. But that is not to deny that institutions of art—markets, organizations, publications, critics—are all fundamental to the shape of art in Australia.

Because this book is focused on the discussion of illustrated examples of Australian art, there are many artists who have contributed to the story of Australian art who do not appear. In a book of this length and breadth the reader cannot expect comprehensiveness and is not well served by the expedient of sentences laden with artists' names—sentences which usually end in the art historians' cop-out phrase 'and others'. To some degree the plates are made to stand for works not illustrated; but of course they cannot actually do so. Although works of art share stylistic conventions and contexts, no work of art can stand for another. The bibliographic essay at the end of the volume directs interested readers to the mass of literature on specific aspects of Australian art and acts to recognize the ideas and scholarship of generations of artist-commentators, writers, curators, and researchers on whose work this book rests.

In order to create a new shape for the history of Australian art I have

confined this book to works created in Australia—with a couple of exceptions, every work included in this book was produced there. This is not to deny that expatriatism is an important part of our artistic heritage, but I believe that there has generally been an over-emphasis on works made outside Australia (often by artists who had tenuous links to the country), which has created a distorted view of the nature of Australian art in Australia. This policy may be thought to discriminate against the post-Australian work of some fine artists—William Strutt, for example, or Stella Bowen—yet when these artists are at their most French, or English, it is hard to see how their works can profitably be examined as sharing the specific concerns of their contemporaries in Melbourne or Adelaide.

This book includes examples of painting, sculpture, drawing, printmaking, and photography. The decorative arts are included, especially when they are a central part of the visual thinking of a generation (as they are, say, around the turn of the century). The book does not set out to propose a connecting idea behind Australian art —all such mythical grand themes can only be argued at the expense of all they exclude. I see this book more as a journey through a landscape with stops along the way to look at some features in detail. The idea of *journeying through* is an important one in Australian art and many of the works included in this book—beginning with Westall's recording of his journey and Gulpidja's reiteration of the creation journeys of his ancestors—are about journeying through. If there is a principle which has guided the selection of the examples illustrated, it could best be described as a bias towards works which engage with the natural world with the humility of the traveller and a marvelling appreciation of detail and nuance (in other words, those works in which the artist has combined visual imagination with mastery of his or her medium).

The story of Australian art is, of course, not wholly a story of artists' engagement with the natural world, and this book includes examples of many other motifs and ideas. The relationship of people to land has been an enduring theme in Australian culture, but it has not been the entire concern of our artists and we must guard against the idea becoming a cliché. On the other hand, the theme cannot be dismissed as simply worthless or romantic; it is undeniably one of the important ideas in Australian art history and inevitably becomes an important idea in this book.

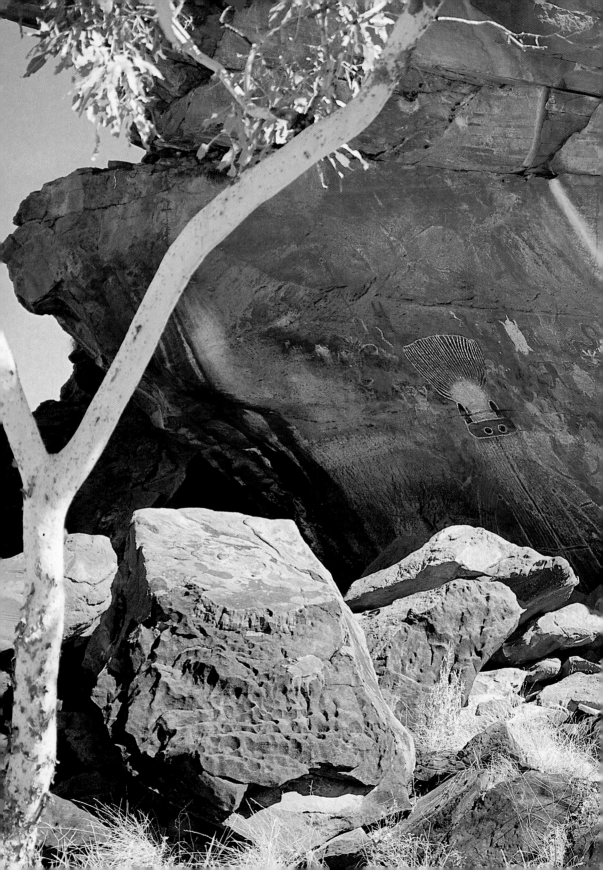

Art and the Dreaming

When the British colonizers made a landfall on Australia in January 1788 they stepped on to a land covered with art. Arthur Phillip, who led the first colonizing voyage of modern Australia, became aware of Aboriginal art even before he had declared the reach of British law over the continent. In his second official report on the progress of the settlement in Sydney, Phillip wrote:

In Botany Bay, Port Jackson and Broken Bay we frequently saw the figures of men, shields, and fish roughly cut on the rocks, and on top of a mountain I saw the figure of a man in the attitude they put themselves in when they are going to dance, which was much better done than I had seen before; and the figure of a large lizard was sufficiently well executed to satisfy everyone what animal was meant.[1]

Phillip's reference to figures engraved on rocks is the first recognition of Aboriginal rock art among Europeans in Australia. His report of the frequency with which such rock engravings were encountered around the settlement of Sydney is not surprising, for it has been estimated that there are between 400 and 500 engraving sites within a radius of 100 kilometres of Sydney. Each of these sites consists of at least six and up to 145 such representations as Phillip described.[2] In addition to animals and figures, the engravings include animal tracks, weapons, other artefacts, and some linear geometric forms [3].

Governor Phillip would have known of James Cook's 1770 conclusion that Australian Aborigines lived in an idyllic tranquillity in which social inequality and want were unknown ('The Earth and Sea of their own accord furnishes them with all things necessary for life'), but he had few other preconceptions about Australia's indigenous peoples before arriving in Australia. His appraisal of the rock engravings around Sydney was simple. First, he did not doubt that these representations were the work of Aboriginal people. Second, he imagined that the figures were depictions of Aboriginal people 'themselves'. What Phillip could not have known, however, is that some of these figures were probably depictions of the great ancestor figures, whose journeys through the landscape were believed by the Aborigines

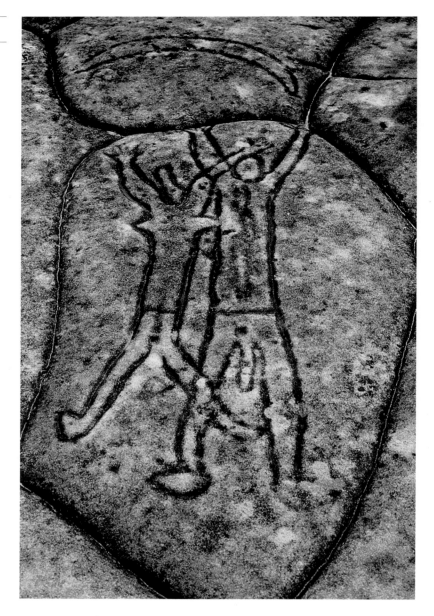

3 Rock engraving, Ku-ring-gai Chase

This well-preserved figure group is to be found at West Head, an exposed headland some 40 km to the north of Sydney. It is characteristic of the hundreds of such rock engravings on sandstone pavements in the bush of the Sydney region.

to have caused its creation. Third, Phillip applied his own canon of art appreciation to these figures and appraised them according to the accuracy of their observation in the depiction of fauna.

In 1803, some 15 years after the establishment of settlements on the eastern coast of Australia, Matthew Flinders brought his coastal surveying expedition into the waters off Arnhem Land. On Chasm Island, Flinders discovered a rock-art site which he described to his artist William Westall (1781–1850), who subsequently recorded the site in two watercolours [4]. Westall's interest was aroused by the

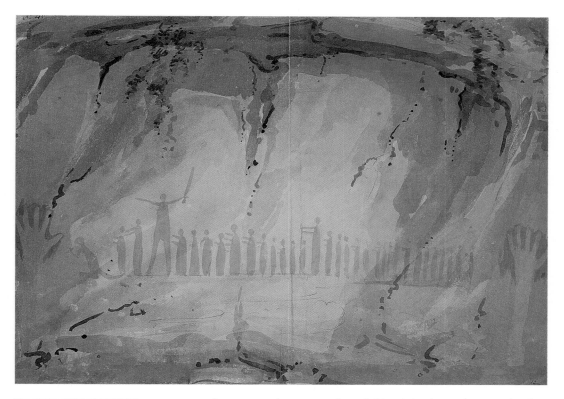

4 William Westall

Cave painting, Chasm Island

Westall's two watercolours of paintings on Chasm Island, off the Arnhem Land coast, were the earliest European visual records of Aboriginal rock art. Flinders thought the figures represented a chief leading a group of people, but research in recent years has revealed that the subject is more likely to be a representation of figures in a long canoe, spearing dugong.

prospect of encountering examples of Aboriginal art, despite the fact that Flinders considered the figures he had seen in the rock shelter to be 'ill-drawn'.[3] Flinders ventured an interpretation of the figures, but what Westall made of them we do not know—his drawing is factual, describing the setting and form of the painting, the surface of the rock, the faded ochre, and the surrounding stencilled hand-prints.

Aboriginal visual traditions held more interest for the French expedition of exploration to Australia in 1801–3 led by Nicolas Baudin than for Flinders's party. In addition to recording various decorations on bodies and bark shelters in New South Wales and Tasmania, the artists of Baudin's voyage, Charles-Alexandre Lesueur and Nicolas-Martin Petit, obtained drawings by some Aborigines they encountered around Sydney, drawings which bear a striking resemblance, both in form and iconography, to rock engravings.[4]

Whilst Baudin's party attempted to obtain some interpretative information from Aboriginal informants, most explorers, surveyors, and part-time ethnographers who described rock-art sites in the nineteenth century speculated wildly on their origins and meanings. The most famous example of such speculation occurred when the explorer Sir George Grey came upon a group of spectacular paintings on the Kimberley coast of Western Australia in 1837. Unable to recognize the figures as ancestral Wandjina (spirits of clouds who the local

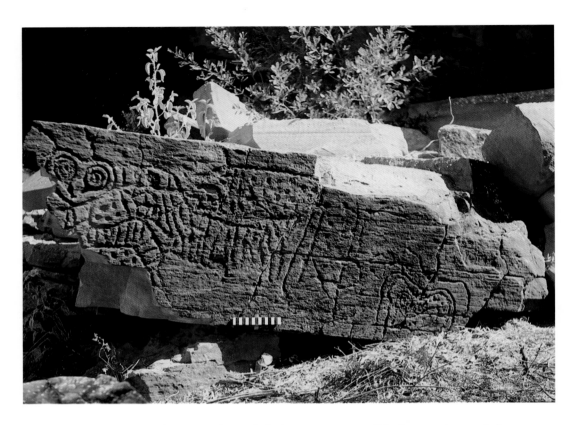

5 Rock engravings at Thomas Reservoir, Northern Territory

Situated in the Cleland Hills, 320 kilometres west of Alice Springs in Central Australia, the Thomas Reservoir is a waterhole surrounded by rocks. These rocks constitute one of the most significant sites to contain a wealth of 'Panaramitee-style' carvings. These consist of geometric forms, animal tracks, and a number of intriguing heart-shaped 'faces', such as can be seen on the far left of the rock slab. These engravings are thought to be very ancient, possibly dating from around 20,000 years ago.

Aboriginal people believe are responsible for creation and the pattern of the weather), Grey was at a loss to interpret the figures except by recourse to his sense of northern-hemisphere antiquity. Claiming that it was 'scarcely probable that they could have been executed by a self-taught savage', he concluded that the origin of the Wandjina paintings 'must still be open to conjecture'.[5]

Early in the nineteenth century, encounters with rock art tended to be sporadic and open to speculative interpretation, but since the late nineteenth century, awareness of the extent and variety of Australian rock art has been growing. In the latter decades of the twentieth century there have been greatly intensified efforts to understand and record the abundance of Australian rock art. We now know that rock art exists in thousands of sites and from one end of Australia to the other: deep within caves under the Nullabor Plain; on long-buried rock walls in Queensland's Cape York; on rock shelters in Arnhem Land and in the Kimberleys; on exposed rock pavements in the deserts of western New South Wales and South Australia, and on the windswept coastline of western Tasmania.

The systematic study of this art is a relatively new discipline in Australia. Over the past four decades new discoveries have steadily added to the body of knowledge. The most significant data have come

from a concentration on three major questions. First, what is the age of Australian rock art? Second, what is its stylistic organization (and is it possible to discern a sequence or a pattern of development between styles)? Third, is it possible to interpret accurately the subject-matter of ancient rock art, bringing to bear all available archaeological techniques and the knowledge of present-day Aboriginal informants? In the context of this book these questions can be compressed into one: what is the art history of Aboriginal rock art?

The question of the age of Australia's rock art is constantly being revised, and new discoveries are proposing earlier datings. At the time of writing, reliable scientific evidence dates the earliest creation of art on rock surfaces in Australia to somewhere between 30,000 and 50,000 years ago. This in itself is an almost incomprehensible span of generations, and one which makes Australia's rock art the oldest continuous art tradition in the world.

Whilst the remarkable antiquity of Australia's rock art is now established, the sequences and meanings of its images have been widely debated. Since the mid-1970s a reasonably stable picture has formed of the organization of Australian rock art. In order to create a sense of structure to this picture, researchers have relied on a distinction which still underlies the forms of much indigenous visual culture—a distinction between geometric and figurative elements. Simple geometric motifs—circles, concentric circles, lines, and animal tracks—constitute the iconography of the earliest rock-art sites found across Australia [5]. The frequency with which certain simple motifs appear in these oldest sites has led rock-art researchers to adopt a descriptive term—the 'Panaramitee style' (or the 'Panaramitee tradition')—a label which takes its name from the extensive rock pavements at Panaramitee North in desert South Australia, which are covered with motifs pecked into the surface.[6] Certain features of these engravings lead to the conclusion that they are of great age—geological changes had clearly happened after the designs had been made and local Aboriginal informants, when first questioned about them, seemed to know nothing of their origins. Furthermore, the designs were covered with 'desert varnish', a glaze which develops on rock surfaces over thousands of years of exposure to the elements.

The simple motifs found at Panaramitee are common to many rock-art sites across Australia. Remarkably, sites with engravings of geometric shapes are also to be found on the island of Tasmania, which was separated from the mainland of the continent some 10,000 years ago [6].

In the 1970s, when the study of Australian archaeology was in an exciting phase of development, with the great antiquity of rock art becoming clear, Lesley Maynard, the archaeologist who coined the phrase 'Panaramitee style', suggested that a sequence could be

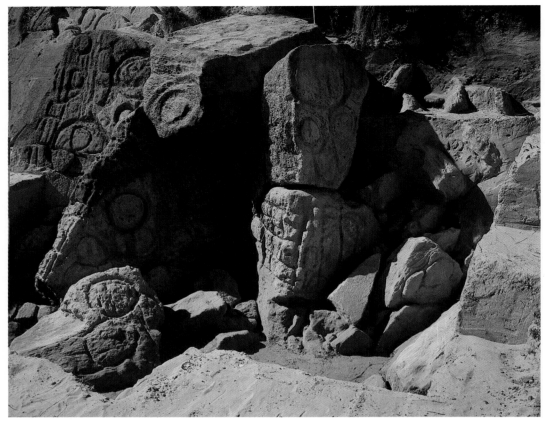

6 Rock engravings, Mount Cameron West, Tasmania

The site is part of an extensive series of carvings on rocky headlands at Mount Cameron West on the north-west coast of Tasmania. These engravings were exposed by shifting sand-dunes and a detailed analysis and excavation revealed that they were at least 1,400 years old. The forms are remarkably similar to ancient engravings on the mainland—circles, groups of lines, concentric circles, sometimes with bars and crosses within and, on rare occasions, animal-track motifs.

determined for Australian rock art in which a geometric style gave way to a 'simple figurative' style (outline figures, animals, and animal tracks), followed by a range of 'complex figurative' styles which, unlike the pan-Australian geometric tradition, tended to much greater regional diversity.[7] While accepting that this sequence fits the archaeological profile of those sites which were occupied continuously over many thousands of years, a number of writers have warned that the underlying assumption of such a sequence—a development from the simple and the geometric to the complex and naturalistic—obscures the cultural continuities in Aboriginal Australia in which geometric symbolism remains fundamentally important. In this context the simplicity of a geometric motif may be more apparent than real. Motifs of seeming simplicity can encode complex meanings in Aboriginal Australia. And has not the art of our century demonstrated that naturalism does not necessarily follow abstraction in some kind of predetermined evolutionary sequence?

In many of the most ancient rock-art sites in Australia, the superimposition of images over a palimpsest of earlier images has made it possible to hypothesize sequences. This is particularly true of some of the richest rock-art galleries in the world, which are to be found on

rocky outcrops across the tropical north of Australia—in and around the Kakadu National Park in Arnhem Land [7], in the Kimberley, and in an area around Laura, near Cooktown in northern Queensland, where there are some 500 painted shelters. In each of these rock-art complexes it is possible to 'read' sequences of superimposition.

Among the many researchers who have made a systematic study of Australia's rock art, George Chaloupka has produced a sequence based on a detailed examination of some 2,000 Arnhem Land sites.[8] Chaloupka has argued that stylistic changes in rock art coincide with great environmental shifts in the region: he described the earliest art period (50,000 to 8,000 years ago) as 'pre-estuarine', the art which followed the rise in sea level after the last Ice Age as the 'estuarine' period, and the period 1,500 years ago to the present as the 'freshwater' period (coinciding with the development of freshwater wetlands). The most recent past he described as the 'contact' period. Chaloupka's sequence was developed using an array of archaeological techniques—from the carbon-dating methods used to date worn ochre fragments in excavated shelters to dating based on the presence of now extinct species of fauna in older paintings.

The enormous stylistic variety of Arnhem Land rock art has given rise to complex typologies. Something of the range of the types of rock art can be seen if we compare the 'dynamic figures' (as Chaloupka termed them) of the pre-estuarine period with the so-called 'X-ray art' which developed in the estuarine period and has continued into the present. 'Dynamic' figures and related types of figures (such as those based on anthropomorphized yams) are

7 Rock art, Ubirr, Kakadu, Arnhem Land

This group of figures armed with spear-throwers and spears is painted in white on the rock at Ubirr in the Kakadu National Park. Although recent in terms of rock art – dating from one to three thousand years ago – this group shares many characteristics with much older 'dynamic' figures. The extreme economy of line and sense of vitality in such depictions has long been a deeply admired quality of much Australian rock art.

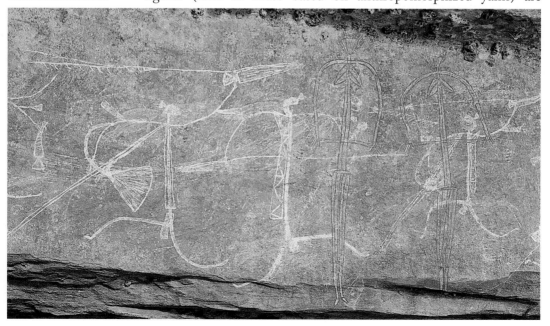

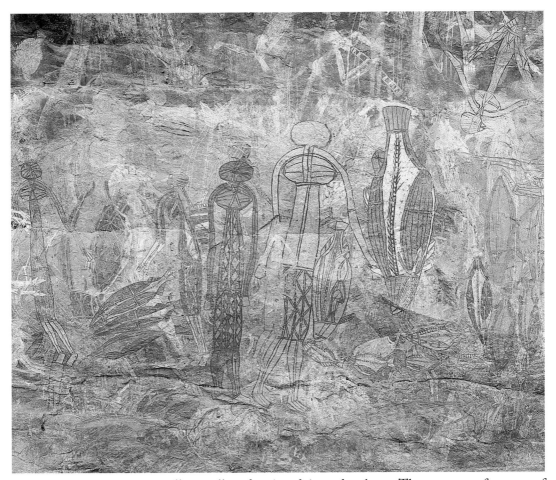

8 Rock art, Kakadu

The layering of images over a long period of time is well demonstrated in this rock shelter in Kakadu National Park in the Northern Territory. While the first layers of painted figures may be extraordinarily ancient, the most recent additions to the rock art in Kakadu can be as little as decades old.

usually small and painted in red ochres. They possess features of extreme exaggeration—elaborate, elongated head-dresses and huge, skirt-like pubic aprons. Characteristically these figures suggest vigorous movement: they appear to run across the rock surfaces with legs stretched wide. Many of the scenes depicted are hunting and fighting scenes in which male (sometimes female) figures clutch spears and boomerangs [**7**].

The 'dynamic' figures of Arnhem Land are closely related to the 'Bradshaw' figures, some of the most remarkable manifestations of rock art in the Kimberley region of Western Australia.[9] Bradshaw figures, named after the explorer James Bradshaw, who first encountered these figures in 1891, are also characterized by a complexity of bodily adornment and a delicacy of technique.

The 'X-ray' paintings, which in many Arnhem Land sites overlay the earlier forms, have become in the public imagination the best known of Aboriginal forms, of imagery. Aboriginal people tend to ascribe the creation of earlier paintings (such as the dynamic figures) to *mimi* or

spirits, but the more recent forms, such as 'X-ray' paintings, were those being practised at the time of the first European contact. In the illustration of a rock-art site at Deaf Adder Gorge in the Kakadu National Park [**8**], the most recent additions are a large number of freshwater fish, characteristically painted with the internal structures clearly visible.

The most recent phase of rock art across many sites in Australia saw the continued reiteration of imagery associated with specific sites and the incorporation of images such as boats, guns, sheep, and cattle. The earliest of these motifs in Arnhem Land pre-date the arrival of Europeans and record the long association of Arnhem Land people with the Macassans. These fishermen, from Macassar in the Celebes, came annually to the Arnhem Land coast to collect trepang (sea-slug) for the Chinese market. Not only did the Macassans come to Australian waters; they also made landfalls and set up temporary processing villages where they dried the trepang for transport.[10] Apart from appearing in various rock-art sites, Macassan boats (praus) and other elements of material culture have become deeply embedded in Aboriginal ritual in parts of coastal Arnhem Land. The Macassans, who probably began their journeys in the sevententh century, ceased visiting Australian waters in the earliest years of the twentieth century.

Understanding Aboriginal art
While European colonizers speculated on the meaning of rock art and set about making collections of the more portable 'curiosities', such as

9 Rock shelter, Victoria River region, Northern Territory

An important rock shelter in western Arnhem Land with paintings of the ancestral Lightning Brothers. These are relatively recent paintings which, according to the rock-art researcher Josephine Flood, 'resulted from the dislocation of traditional peoples following initial European incursions into Wardaman country, restricting access for local people to their traditional territories. In response, local people painted the land's identity in rock shelters, both as a re-affirmation of that identity and as a means to strengthen their rightful links to the land'.

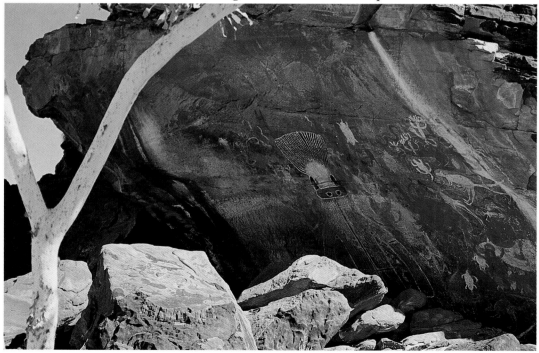

decorated artefacts and ceremonial objects, there were many characteristics of Aboriginal visual culture that were impenetrable to them. The way in which art was crucially linked to ceremonial enactment of a complex belief system was impossible to comprehend without a basic understanding of that system. Without an understanding of language—and there were over 200 individual languages across the continent at the time of colonization—there could be no understanding of the complex interrelationship between art, religion, personal identity, and social organization which characterized Aboriginal culture. Only at the end of the nineteenth century, after many traditional societies had been destroyed or seriously disrupted across large parts of settled Australia, did settler Australians begin to understand how Aboriginal art operated as a cultural medium.

Another element which made Aboriginal visual culture difficult for the colonizers to understand was the secret and sacred element of the beliefs encoded in it. This meant that, even if the means had existed for communication, certain information could not be readily shared with those who had not been initiated. None the less, European Australians who worked with indigenous informants during the nineteenth century were aware of the importance of creation myths, and towards the end of the century tried to unravel the complex relationships between these stories, social organization, and totemism. It was not until the 1890s that the pioneering anthropologists Baldwin Spencer and Frank Gillen (who worked with the Arrernte people of desert Central Australia) elaborated the fundamental organizing concept of the indigenous world-view. This concept, common to all Australian indigenous cultures, has, for convenience, been called 'the Dreaming'.

The Dreaming refers to a time in which the great ancestor figures created the land, the patterns of the environment, and the laws which structure Aboriginal society. In the course of their earliest existence the Dreaming ancestors travelled through the world and created the landscape. Through acts of transformation they made themselves into the features of the present landscape—rivers, waterholes, mountain ranges, planets, and constellations. They were also the original creators of the law—the ceremonies, songs, and dances in which Aboriginal belief is embodied.

Through the Dreaming, the shape of the natural world is the major subject for traditional Aboriginal art. From the moment of conception an Aboriginal person has a connectedness to the realm of the spirit and specific Dreamings: through an individual's conception site he or she is connected in a particularly intimate way to a specific locality. The Dreaming also defines kinship relationships, which in turn sets the limits on subject-matter for art.

One of the complexities of the concept of the Dreaming lies in its sense of time, different from the linear time that governed the lives of

the colonists. An important characteristic of the Dreaming is its continuity: whilst it refers to the creative events of the past, the Dreaming is also alive in the present. Art is important as a temporal medium here, as Howard Morphy explains:

paintings, sacred objects, songs and dances are more than mere representations of the ancestral beings and their past. They are also thought of as manifestations of the ancestral past brought forward to the present; they are as concrete as the rocks and lakes that mark the passage of the ancestors across the surface of the earth.[11]

This quality of incipient power is fundamental to a great many aspects of Aboriginal visual culture. It requires that, in visual terms, much Aboriginal art be characterized by enlivening surface treatments such as the vivid body designs worn during dances, the herringbone patterning on shields and weapons, the distinctive cross-hatching of

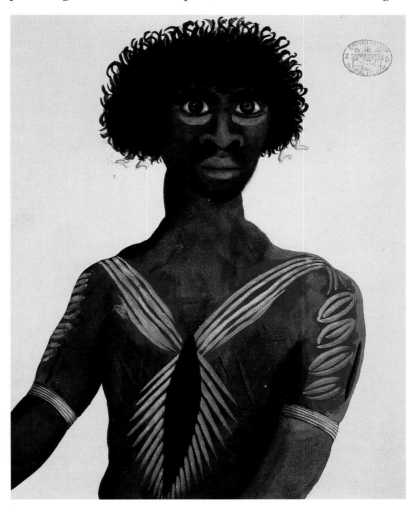

10 Unknown artist, Port Jackson

Balloderree, c. 1790

'Among his countrymen we have nowhere seen a finer young man' was the tribute paid to Balloderree by the First Fleet chronicler David Collins. As with many Eora people painted in the earliest phase of European settlement, Balloderree was closely associated with the settlers. His portrait conveys his fearlessness, the quality for which he was chiefly known. Like so many of his people, Balloderree succumbed rapidly to illness during the first years of the colony.

Arnhem Land bark-painting (discussed in Chapter 8) and the trademark 'dotting' of Western Desert paintings (discussed in Chapter 11). Traditionally the Aboriginal palette through which these visual treatments were executed exploited the seemingly endless possibilities of three basic ingredients—a range of ochres, charcoal (and, in some places, manganese) to create black, and pipeclay to create white. These are the colours of painting on bark and rock walls, but also the ingredients of body-painting for ceremonies and rituals.

It was difficult for the early colonists to grasp the deeper significance of these surface treatments: they did not imagine there were encoded and connected meanings behind each expression on bark or rock or body. For example, when the first colonists in Sydney saw the Eora people of Port Jackson painted for ceremonies [**10**], they were apt to interpret the designs as 'left to everyone's fancy'. In Watkin Tench's description of 1791, 'Some are streaked with waving lines from head to foot; others marked by broad crossbars … or encircled with spiral lines; or regularly striped like a zebra'.[12] That such designs were individually meaningful and were linked to other forms of visual expression eluded most early observers. But the First Fleet writer, David Collins, was alerted to the fact that patterning and form carried meaning when he was surprised to discover that Eora were able to identify precisely the origins of various artefacts he had collected in outlying areas. He observed that the Aboriginal people 'extend this peculiarity even to their dances, their songs and their dialect'.[13] Collins was thus made

11 Tommy McRae

Victorian Blacks. Melbourne Tribe. Holding corroboree after seeing ships for the first time, c.1890

One of the several surviving Tommy McRae drawings from the end of the nineteenth century in which the artist imaginatively reconstructed the first contacts between Australia's indigenous people and Europeans. Whereas such first-arrival events were recreated by non-Aboriginal artists from the side of the pioneer or explorer, Tommy McRae, uniquely, shows the first encounters from a distinctively indigenous viewpoint.

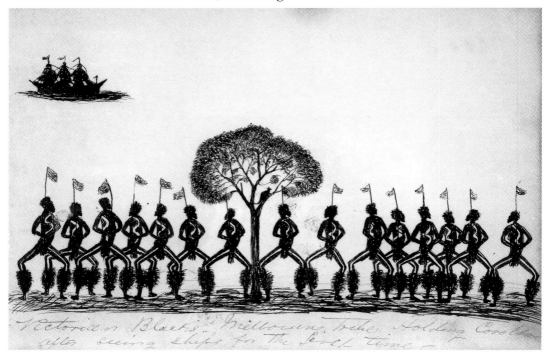

aware of one of the characteristics of Aboriginal culture—its tremendous variety of form and approach when viewed generally and its specificity and continuity within particular language and societal groups.

Aboriginal visual culture is a system of symbols and signs. The early colonists were not able to understand its operation, but there existed (and still exists in parts of Australia) a continuity which runs from body-painting to the decoration on carved trees or artefacts, paintings and engravings on rocks, and paintings on bark, paper, or canvas. At the beginning of the twentieth century, when Baldwin Spencer began to collect paintings on bark (discussed in Chapter 6) at Oenpelli, he could observe the similarities of style and content with the figures painted on rock-art sites. In the late twentieth century Kunwindjku artists working in the same area continue to create works with immediately recognizable stylistic traits and subjects linked to those on rock walls.[14] In addition to this continuity, there is also a history of innovation and change in both the content of the work and its mode of production (Chapter 11).

This history of change and adaptation led to the development of indigenous visual expression in environments across much of Australia where traditional cultural links had been severed. The fullest expression of this in the nineteenth century are the drawings of several Aboriginal artists working in the 'settled' parts of Australia, such as Tommy McRae [11], who recreated the traditional past through memory and reiteration, yet incorporated the visual culture of colonization. In recent years artists such as McRae have been seen as precursors of the indigenous artists of today.[15] His viewpoint and sense of identity were defined by his Aboriginality, yet he used neither ochres nor charcoal to produce his art. The authenticity of his art came not from materials or conventions; it came from his experiences and the power of his memories.

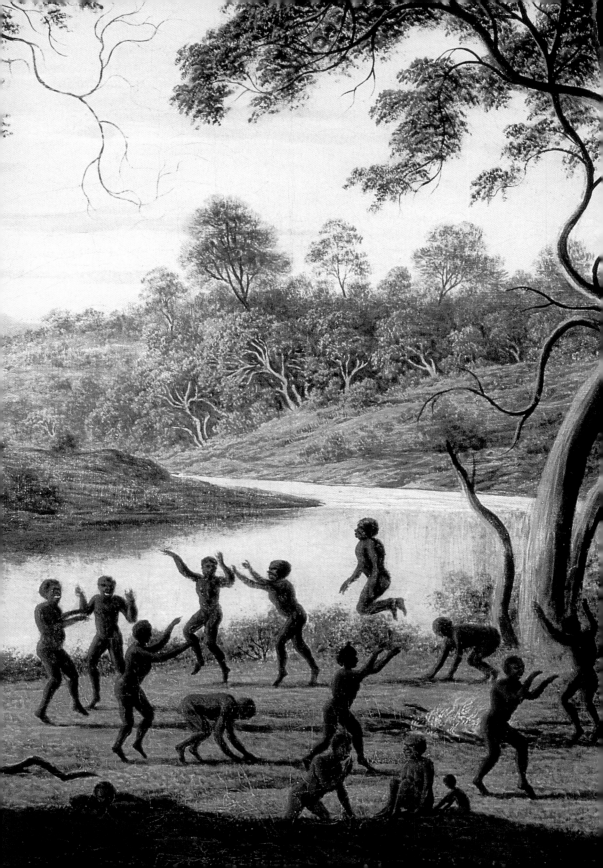

The Lines of Empire 1788–1835

2

The convicts who made up the first European immigrant population of Australia and the officers who kept law and order on behalf of the British Crown looked upon Australia as a place of temporary or permanent exile. They also saw Australia as a new world, and as a new world the continent provided promising subjects for documentary art. First of all, there were new plants and animals to be described; second, there was an indigenous culture which the settlers found exotic and barbarous; and third, there existed an undescribed landscape. The early art of Europeans in Australia consists of attempts to make sense of each of these novel subjects, mostly in the form of modest and simple drawings. Some of these were made by artists such as William Westall or by naval officers, or by artists of varying skill from among the convicts who were transported from Britain to be imprisoned in Australia.

Convict artists

Among the artists working in New South Wales and Tasmania in the first half of the nineteenth century, a large number had come to Australia as convicts. Under the various systems of transportation, convicts were usually 'assigned' as servants to work for the duration of their sentence and then, depending on their record, granted a 'ticket of leave' and ultimately a pardon. Convicts who reoffended in the colonies were sent to remote places of secondary punishment such as Norfolk Island or Macquarie Harbour. The miniaturist Richard Read and the watercolourist Richard Browne were examples of convict artists who advertised their services in Sydney after obtaining their tickets of leave. Between 1811 and 1817 Browne was in Newcastle, where he provided natural-history illustrations for the commandant, Lieutenant Thomas Skottowe. In much the same manner, in Hobart, W. B. Gould made natural-history drawings for the colonial surgeon, Dr James Scott. The French-born miniaturist C. H. T. Costantini, twice transported to Australia (in 1822 for forgery and in 1827 for theft) made views of the prison settlement at Macquarie Harbour for the commandant, Major Butler. Like Thomas Bock, Costantini and Gould established themselves as artists, specializing in portraits and flower-pieces respectively, after gaining their freedom.

Natural-history artists

Of the subjects which captured the imaginations of the earliest European artists, the novel flora and fauna of Australia were of particular interest, largely as a result of the involvement of Sir Joseph

Detail of 25

23

Banks with the enterprise of colonization. Banks had glimpsed the natural curiosities of Australia when he accompanied James Cook on his voyage of exploration in 1768–70. On that voyage Banks had looked on while the skilful plant draughtsman Sydney Parkinson laboured over the 400 plant drawings which recorded some of Australia's botanical bounty. But whereas Cook's *Endeavour* voyage was able to provide science with accommodation and specialist attention, the convict fleet of 1787 which conveyed the first colonists to Australia lacked a professional artist. As a result, and despite Banks's desire to have specimens recorded and collected by the colony's first governor, Arthur Phillip, there were no truly accurate natural-history drawings produced in Australia during the first decade of the settlement.

Most of the natural-history art produced in the early decades of European settlement in Australia is characterized by an endearing naïvety. This earliest body of art made in the colony of Sydney did not result from partnerships between artists and experienced naturalists, but was none the less conceived as part of a well-meaning effort to present the new and unusual—literally the 'non-descript'—to European science. Thus, while the body of drawings made in Sydney between 1788 and 1800 contains uniquely interesting and valuable depictions of the early settlement at Port Jackson, the great majority of drawings are natural-history drawings [12]. Most of the drawings made in the early colony are depictions of birds.

When the art historian Bernard Smith began to study the art of the earliest European settlement systematically in the 1950s, he was unable positively to identify the artist responsible for the majority of them.[1] Apart from the works signed by the convict artist Thomas Watling (the self-styled 'Limner of Dumfries') and the naval officers George Raper and John Hunter, the authorship of the drawings is unknown. For convenience, Smith invented a label for the author of the anonymous drawings—the 'Port Jackson Painter'. It cannot be predicted whether further analysis will reveal the identity of this artist or whether such identification would illuminate further the motivations or stylistic background to these drawings. After all, the drawings conform to the conventions of naval draughtsmanship to such an extent that they may have originated from any number of hands and have been copied by yet others.

The art of the earliest colonists was conventional in the sense that, however crudely the forms and descriptive devices were handled, they none the less conformed to the prevalent European modes of natural-history illustration. The art of the first professional natural-history artists to work in Australia showed not only the reasons why such conventions existed, but the extreme descriptive sophistication they could accommodate. This is nowhere better demonstrated than in the work of Ferdinand Bauer.

12 Unknown artist, Port Jackson

Diamond python, c. 1790
The boldly composed ink-and-watercolour drawing made by an unidentified artist is characteristic of the body of natural-history drawings made within the first 3 years of the establishment of the convict settlement at Sydney Cove in 1788.

Ferdinand Bauer (1760–1826) was the natural-history artist who accompanied Matthew Flinders on his 1801–3 voyage to Australia.[2] By contrast with Cook's artist, Parkinson, who spent little time ashore during the *Endeavour*'s brief landfalls, Bauer spent nearly 4 years in and around Australia, during which he was able to make more than 1,600 drawings of Australian plants and 230 of animals. From these sketches, which he annotated with a sophisticated colour key, he was able to produce extremely accurate finished illustrations after his return to Europe [**13**].

Bauer's industry and skill were noteworthy qualities even in his own lifetime. Banks marvelled at the subtlety and power of description of

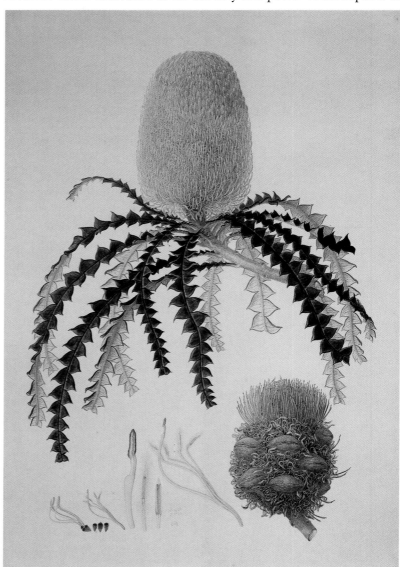

13 Ferdinand Bauer

Banksia speciosa, c. 1805–14
Bauer's watercolour was completed from annotated pencil sketches of a specimen of one of the most spectacular species of *Banksia*, collected at Lucky Bay on the Western Australian coast in January 1802. Characteristically the drawing includes details of the flowering parts of the plant which Bauer's colleague Robert Brown used in his description and classification of the species.

Bauer's work and Goethe found in it beauty, precision, and decisiveness. A more recent writer has pointed out that the special quality of Bauer's work resulted, at least in part, from the artist's collaboration with a leading botanist—Robert Brown—whose recognition of the taxonomic value of microscopic detail was unique in the early nineteenth-century scientific world.[3]

The fruitful partnership between Ferdinand Bauer and Robert Brown was similar to that enjoyed by the artist Charles-Alexandre Lesueur and the young zoologist François Peron on the French scientific expedition led by Nicolas Baudin which was in Australian waters during 1800–4.[4] Between them Lesueur and Peron amassed over 18,000 specimens on the voyage, mostly zoological. Lesueur returned to France with 960 drawings. Although the drawing illustrated here is the symbol of antipodean curiosity [14], the drawings which perhaps best represent Lesueur's qualities as an artist are those that depict the most vulnerable of specimens, particularly marine organisms, which, unlike robust vertebrates, lose all form and colour when they are taken from their vital medium.

The first natural-history artist to take up prolonged residence in Australia, John Lewin (1770–1819) arrived in Sydney in 1800 and remained until his death; he came specifically to explore the nondescript world of antipodean plants and animals. As a naturalist, Lewin was little more than an amateur and a less sophisticated artist than either Bauer or Lesueur. His importance to Australian art lies less in what he contributed to scientific knowledge than in what he achieved in his attempts to publish on Australian natural history. Lewin's set of etched and colour illustrations, *Prodromus Entomology*, was printed in London in 1805, but his *Birds of New Holland* had an Australian (as well as an English) edition and appeared in Sydney in 1813. It is a measure of the difficulties of subsistence in the early decades of European settlement that Lewin's was the first illustrated book to be

14 Charles-Alexandre Lesueur

Macropus fuliginosus, c. 1805
As the largest and most conspicuous of Australia's marsupial fauna, kangaroos and wallabies were the subjects of many natural-history drawings in the early nineteenth century. Lesueur made numerous drawings of different species during the Australian voyage of Nicolas Baudin. This work, showing the Western Grey Kangaroo, was painted on vellum from detailed sketches made in Australia and is typical of Lesueur's meticulous and finely observed natural-history art.

published in Australia. The descriptions which accompany the plates are simply the jottings of a field naturalist, yet the plates themselves, engraved by Lewin in Sydney, are closely observed, and, in the best of the handful of extant copies, are delicately coloured, probably by the artist's wife.

In his prints, as in his drawings, Lewin customarily presented the zoological specimen in its natural habitat, a marriage he was able to achieve through prolonged observation rather than the chance encounters of the short-stay resident. In the last years of his life he extended the scale of his watercolours to the size of display pictures, characteristically showing the specimen in a fully worked-up setting, and he began to paint in oils. *Fish catch and Dawes Point, Sydney Harbour* is the best example of Lewin's work in this hybrid genre.[5] Thought to be the first oil painting made in Australia, the work only partially fulfils its disparate ambitions to describe several fish species, to locate them geographically (on the shores of Sydney Harbour), and to create a cabinet picture in emulation of the European genre of the fish painting.

Portraits of Aborigines

Ethnography was not as codified a discipline as either botany or zoology in the early nineteenth century. The empirical spirit which was at the root of the study of plants and animals was the basis of the study of mankind, yet in the cultural dynamics of interaction between people, objectivity was hardly possible. The experience of the French scientific party led by Baudin highlights the dilemma of the ethnographic researcher, for, however much the researchers wanted to follow the thorough guidelines for objective observation laid down by the Société des Observateurs de l'Homme, social prejudices and failure to understand language remained barriers to a developed understanding of their subjects. Baudin's expeditioners sought to find Aboriginal people living in more or less traditional ways, and although they met New South Wales Aborigines, they reserved their most intense scrutiny for the more remote coastal Aborigines of Tasmania (or Van Diemen's Land, as the colony was known until the official name change in 1856).

Material culture was one subject which artists were able to depict with detachment. The drawings made in Tasmania by Lesueur and by the less accomplished artist Petit are characteristic in their attention to material culture—boats, dwellings, burial places, weapons, and tools. Petit also made some sensitive portraits of individuals whose names he recorded—Arra-Maida, Ouriaga, Paraberi, and Bara-Ourou. These portraits show a determination to record the details of coiffure and cicatrization, and the artist's attempts to create objective records produced a truth unusual in the depiction of Australia's indigenous people in the early nineteenth century.

Portraits are in general the most interesting art to result from the

ethnographic enterprise. Among the earliest drawings made after the European settlement were striking portrait drawings of men and women painted for ceremonies or for mourning, such as the portrait of Balloderree by an unknown artist [10]. Thomas Watling, the disappointed landscape artist, made portraits of a number of the Aboriginal people who were most closely involved with the colonizers in Sydney: Naubar, a boy orphaned by smallpox who was brought into white society by the surgeon-general, Colebee, and Bennelong. Watling's double portrait of Wearrung and Karrada is inscribed with a note that 'the likeness is very strong indeed, insomuch that every Native of their acquaintance at first sight exclaims and calls them by name'.[6]

Ethnographic portraiture made only sporadic appearances in Sydney after Watling's drawings of 1793. Early in the nineteenth century another convict artist, Richard Browne (1776–1824), made drawings of Aborigines connected with settlements around Newcastle, and he continued to make copies of these drawings after settling in Sydney in 1817. Browne's rickety style has often been regarded as caricature, but there is evidence to show that his crude and emblematic drawings of Aboriginal subjects, with their exaggerated facial expressions and spindly limbs, were considered by the artist's contemporaries to be accurate renderings of Aboriginal people.[7]

The intimate relationship between ethnography and portraiture found further expression in the works of Augustus Earle (1793–1838), who in 1826 visited the remote areas of the Hunter Valley and the Wellington Valley to the west of the Blue Mountains. Earle was an artist of great perceptiveness. He made a series of portraits, including the magnificent *Desmond, A New South Wales chief*, but would not pretend that Aboriginal life continued unaffected by European contact. In fact Earle's most powerful Australian portrait is his painting of Bungaree, the frequently depicted Aboriginal character who greeted visitors to Sydney with an elaborate mimicry of European military formalities [15].

Ethnographic portraiture had a late flourish in the mid-1830s in New South Wales in the drawings of the most underrated of all colonial artists, Charles Rodius (1802–60). In the same decade, in the island colony of Tasmania, when it appeared that the certain fate of the Tasmanian Aboriginal people was utter disappearance, Thomas Bock (1793–1855) painted miniatures, Benjamin Law (1807–90) sculpted busts, and Benjamin Duterrau (1767–1851) was inspired to produce his Aboriginal paintings. Bock's Aboriginal drawings are beautiful portraits, and he was asked to produce many copies for various ethnographic collectors. Law's busts were similarly reproduced and can now be found in ethnographic collections around the world. Duterrau's treatment of the subject consisted of sculptural reliefs in which Aboriginal faces are used to characterize emotions. He also

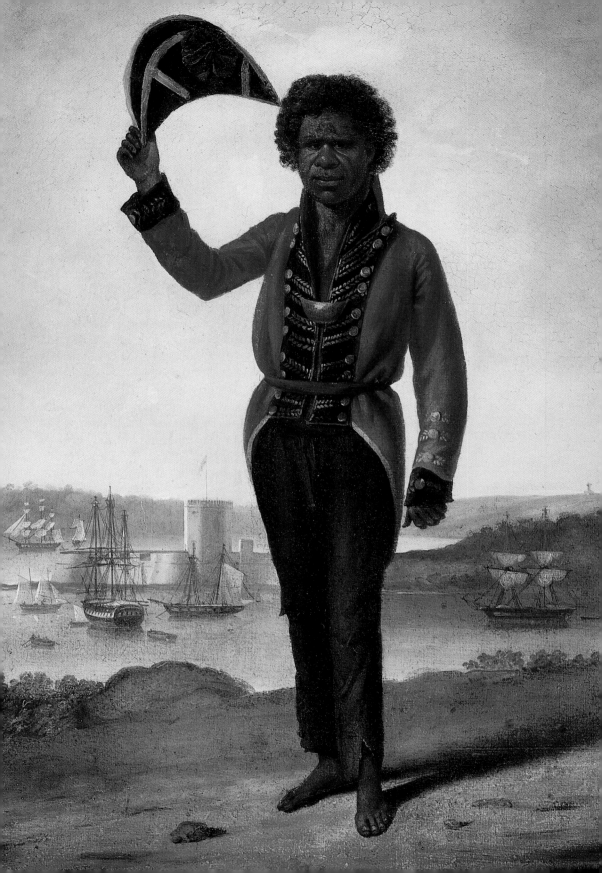

15 Augustus Earle

Bungaree, c. 1827

Although in 1801–2 Bungaree had accompanied Flinders on his circumnavigation of Australia, he was best known in Sydney in the 1820s for his extravagant mimicry of successive colonial governors. Earle depicts Bungaree in a parodic gesture of welcome, wearing his characteristic dress (cast-off uniform) and the breastplate inscribed with the words, 'Chief of the Broken Bay Tribe'. Fort Macquarie and Sydney Harbour form the backdrop.

ncluded recognizable Aboriginal people in his paintings of the work of the missionary 'conciliator' George Augustus Robinson [**16**]. Perhaps Duterrau's most powerful works are the single figure portraits of the band of Aborigines most closely associated with Robinson— Trucaninni, Woureddy, Manalargenna, and Tannelebouyer.

Ethnographic record-making extended beyond portraiture to the depictions of those ceremonies which Europeans were able to witness. Corroborees—Aboriginal gatherings held at night around fires with singing and dancing—furnished artists with their most exotic antipodean subject-matter. The compelling fascination of the corroboree is also frequently expressed in written accounts; for example, James Wallis, an artist closely associated with Lycett, wrote a piece to accompany the illustration of a corroboree in his *An Historical Account of the Colony of New South Wales* of 1821, which describes how 'the beauty of the scenery, the pleasing reflection of light from the fire round which they dance, the grotesque and singular appearance of the savages, and their wild notes of festivity, all form a strange and interesting contrast to anything witnessed in civilised society'.[8] The exoticism, the comparison with 'civilised society' which Wallis expressed was the ingredient that ensured the popularity of the corroboree subject. John Glover, who from his first arrival in Tasmania in 1831 was fascinated by the corroboree, appended such observations to his paintings of corroborees [**25**] as 'one seldom sees such gaiety in a Ball Room, as amongst these untaught Savages'.[9]

Topographical art

As a subject, the corroboree fell somewhere between ethnography and landscape painting. It certainly created more engaging art than the

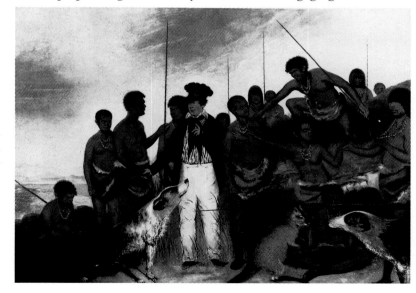

16 Benjamin Duterrau

The conciliation, 1840

Duterrau hoped to gain wide public interest in this grand historical composition, which depicts the missionary 'conciliator' George Augustus Robinson, in his bush dress, offering the hand of benign friendship to Maulboyheener (Timmy), a Tasmanian Aboriginal man.

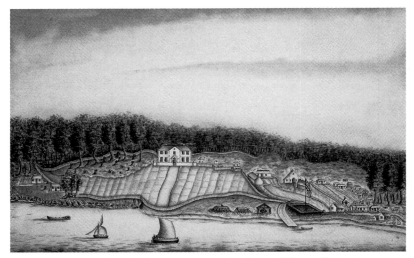

17 George Raper

View of the East Side of Sydney Cove, Port Jackson, 1790

George Raper was a midshipman on the First Fleet vessel *Sirius*. His view of the first Governor's house in Sydney gives precise details of bearing and location. Beside the stone structure, the cleared ground for gardens and the flagstaff are the unruly cluster of cottages that constituted the early penal colony and the uncleared forest beyond.

insipid topographical descriptions which proliferated in the early colonies. The first of these topographical drawings came directly out of the naval and military culture which underlay the structure of the settlements. And they often betrayed the eerie fragility of these settlements and their isolation from Britain. As naval topographical art derived from the need to recognize coastlines, the earliest drawings of Sydney were often views from the water looking towards the shore. Buildings or clearings occupied only that strip of land between the water and the first line of uncleared forest [**17**].

As Sydney and the other penal settlements of Newcastle, Norfolk Island, and Hobart Town grew in size and complexity, the viewpoint of topographical record-making shifted. Roads and buildings (in particular public buildings), flagstaffs and docks—all provided material evidence of progress. But progress was equally well demonstrated in the expanding frontier: farms and rural hamlets excised from the all-pervasive forest were equally able to exemplify the course of empire. The watercolours of the surveyor G. W. Evans (1780–1852) best demonstrate the possibilities inherent in the limited genre of topographical drawing. In Evans's depiction of Government House we no longer have the sense, so evident in Raper's 1790 drawing, that this building represents the precarious toehold of authority on a vast unknown landmass. Similarly, in Evans's views of the settlement of Parramatta to the west of Sydney, there is a sense of Anglicized pastoral landscape in the orderliness of the fences, granaries, and buildings rising in the midst of the woods.

Augustus Earle's view of Government House, drawn 38 years after Raper's and later published in London in his *Views in New South Wales and Van Diemen's Land* (1830), emphasized the completeness of the transformation of the landscape in paying particular attention to the garden [**18**]. The description which accompanies the plate attributes

18 Augustus Earle

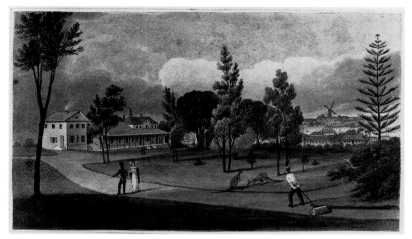

this transformation to one person—Mrs Macquarie, wife of Governor Lachlan Macquarie, who served in New South Wales for almost 12 years between 1810 and 1821. Mrs Macquarie was praised by the artist for her efforts to convert the landscape of Sydney 'which was barren, rocky and waste to a beautiful and picturesque landscape'.[10]

Joseph Lycett and Augustus Earle were the most important topographical artists to work on Australian subjects in the 1820s. Joseph Lycett, despite his convict status, gave comprehensive expression to the aspirations of the colonial administration in his *Views in Australia, or, New South Wales and Van Diemen's Land Delineated*, a series of coloured plates published in London between 1824 and 1825 and accompanied by eulogistic, adjective-rich texts, designed to attract emigrants. Earle, by contrast, was a more detached observer whose choice of subjects was generally less deliberately aimed at presenting a rosy view of the colonies.

Augustus Earle

Augustus Earle was the first European artist to work in Australia whose art has a voice. Often that voice is autobiographical—Earle frequently placed himself in his landscapes, and his works describe his own colonial adventures. Furthermore, his drawings and portraits seem to be an engaged commentary on colonial society. Earle arrived in Australia purely as a result of accident. He had intended to travel to India via South America, but was marooned on the Southern Atlantic island of Tristan da Cunha. After some 9 months of living as a guest of the island's miniscule population, Earle left on the next passing vessel— its destination, Australia. He lived for some months in Tasmania, then moved to New South Wales where he amused himself by, as he described it, 'strolling through the Colony', making watercolour drawings, oil paintings, and prints.[11] Earle's story has more significance than as a fascinating adventure-tale: it typifies a significant art-historical fact

of the first half of the nineteenth century, namely, that the early development of the art of European Australia was extremely haphazard. While we can discern shared patterns of thinking and commonly understood visual languages, the thin thread which constitutes the history of the art of European Australia was also shaped by accidental arrivals, fortuitous circumstances, and opportunistic career moves.

Earle saw himself as an outsider, travelling through the natural and social landscape. He had no particular interest in misrepresenting the social fabric of colonial society, so he was able to provide something he described as 'so little known in this part of the world'—a set of 'correct delineations' of Aboriginal people in Sydney.[12] Earle's precision was not so much ethnographic as societal: his *Natives of New South Wales as seen on the streets of Sydney* is a profoundly disturbing image of urban degradation. There is also a subtle, ironic quality in this work, typical of Earle's world-view: the kangaroo, symbol of natural Australia, is relegated to a pub sign.

The least ironic of Earle's works were descriptive watercolours, which were converted into panoramic paintings and shown at Burford's Panorama in London in 1829. These works were part of semi-official attempts to encourage emigrants to Australia and made the towns of Sydney and Hobart as appealing as possible: 'The scene is altogether delightful—the bright atmosphere, serene sky, hills, dales, sheets of water studded with vessels, a picturesque town under your eye, and blue mountains in the distance—such is Sydney and its vicinity ...'.[13]

Yet Australia was not able to hold Earle (particularly after he himself failed to obtain a grant of land). Despite the moderate successes and the official patronage he enjoyed, Earle's Australian career demonstrates the lack of depth in the early Australian art scene. The gallery of drawings which he opened in his studio in Sydney and his lithographs of Australian subjects were not particularly successful; after he left Australia he wrote: 'I came a stranger to the Colony, ... and after three years residence there, went away equally unnoticed and unknown.'[14]

Conrad Martens

The arrival of Conrad Martens (1801–78) in Australia in 1835 and his subsequent decision to remain there demonstrated that in the early 1830s Europeanized culture in Australia had reached a new phase of development: Australia could now maintain a professional artist.[15] As with Augustus Earle, Martens's coming to Australia was not a premeditated emigration, but the result of fortuitous circumstance. Yet, unlike the earlier visitor, Martens rapidly discovered that he could sustain an art practice in Australia and was able to do so right up until his death in 1878 (despite some lean years during the economic depression of the early 1840s).

Conrad Martens painted amiable, unpretentious watercolours. Following the admonition he wrote to himself in his sketchbook of 1836 'Paint in oil!', he added small, slick oil paintings to his range.[16] His success as a painter can be attributed to skill in bringing a sense of breadth to his compositions, the attractiveness of his principal subject—Sydney Harbour—and his status as a free settler. Yet he never strayed beyond the rather narrow definition of the picturesque within which he set out to work. The qualities which made his work safe in the early nineteenth century mean that his *œuvre* is repetitive and predictable: the principal claims of his work remain his technical proficiency and the historical interest of his subjects.

Martens demonstrated to Australian colonists that it was possible to paint Australian landscapes which transcended simple topographical description. He avoided the literalness of placing his principal subject in the distance or middle distance, and used the foreground to frame it with herbage. Everything was softened and there are no jarring elements of rawness. Martens's transformative skill can be seen at work in a painting such as *View from Rose Bank* [**19**], in which all the houses shown (or villas, as they were often referred to) were, in fact, very newly built.

Much has been made of the fact that before his arrival in Australia Martens had been appointed as the artist to replace Augustus Earle on Darwin's *Beagle* expedition and had been in the company of scientists on the voyage between Montevideo and Valparaiso. On board, Martens was regarded as 'school-masterly', and in his subsequent Australian work there is little evidence of a scientific breadth of mind. Martens's trees were not closely observed, and the widespread notion in Australia that colonial artists could only see the landscape 'through

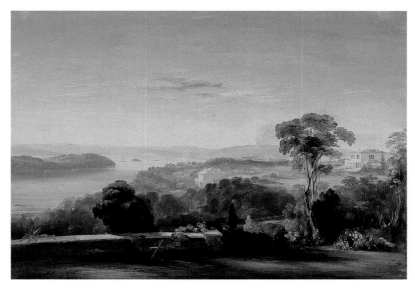

19 Conrad Martens

View from Rose Bank, 1840
One of Martens's most successful oil paintings, this is one of two views from the house Rose Bank, painted on commission in 1840, probably for its wealthy owner, Robert Campbell Tertius. Martens's depiction of a number of large houses overlooking Sydney Harbour succeeds in giving the impression of an Italianate ambience.

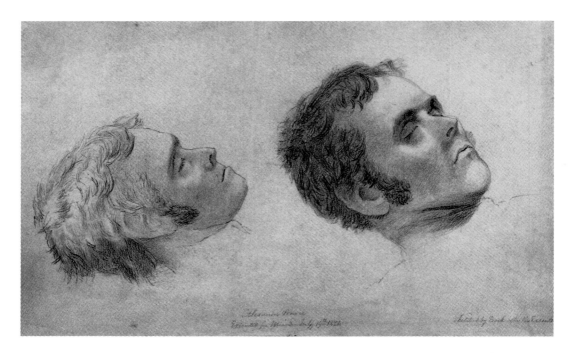

Thomas Bock was not the only convict artist who made post-mortem drawings of executed criminals in the early nineteenth century. Alexander Pearce, hanged in July 1824, was considered the most vicious of criminals, and scientists took great interest in his physical characteristics. Pearce admitted to killing and eating his companions in order to remain alive in the bush after he escaped from the prison settlement at Macquarie Harbour on Tasmania's west coast.

European eyes' can probably be laid at the feet of Martens. As Martens was prolific and his work was highly regarded even in his own day, a large body of it survived into the twentieth century. For many decades his work was the most widely known colonial art and was the subject of the first monograph on an Australian colonial artist, published in 1920.[17]

Portraits of colonists

Just as ethnography and topography were useful tools in affirming the course of empire, so, too, was portraiture. Official portraiture in Australia was like official portraiture everywhere—bound by established conventions. Informal and domestic portraiture was, on the whole, more interesting. Pictures of women, children, and families—portraits in which the distinguishing trait was delicacy—attracted the admiration of the colonial audience for art which could make comparisons with the work of the English models upon which the artists based their styles—fashionable masters such as Lawrence and Reynolds.

Perhaps the best colonial portraiture before the middle of the nineteenth century was in drawings and watercolours. Augustus Earle had made a handful of large-scale oil paintings in Sydney in the late 1820s—of Governor Brisbane, of Captain Piper, and of the Piper family—and the doctor Maurice Felton (1803–42) achieved some notice for his portraits painted in Sydney in 1840, but none of these works succeeded as well as the modest drawings of Hobart society by Thomas Bock and Thomas Griffiths Wainewright (1794–1847). Both

Bock and Wainewright were transported to Australia as convicts. Bock, in particular, exemplifies the range of art activity which the convict artist and later emancipist could engage in. He had been a Birmingham engraver before his conviction and transportation. His particular skill was put to the service of the colonial administration: 1824, the year of his arrival in Australia, found him engraving bank-notes. By 1825 he was advertising as a portrait painter to add to this more mechanical skill. He was asked to make drawings of the heads of hanged bushrangers [20]. Eventually, Bock moved on to a more genteel practice in which his skilled work in chalk came to be admired for its suavity. He was not an inconsiderable oil painter, although (as with many colonial painters) the full extent of his *œuvre* is a matter of conjecture. A group of portraits of the family of the pastoralist William Robertson are definitely by his hand, and reach a level of sophistication rare in any Australian colonial portraiture. At the time of his death in 1855 he had produced an impressive body of work, including, in addition to his staple portrait drawings, some nude studies, unique in colonial art, as well as some of the earliest attempts at photography in Australia.[18]

The triumph of talent over status which characterized Bock's career

21 Thomas Griffiths Wainewright

The Cutmear twins, Jane and Lucy, c. 1842

Neither of these daughters of the prison gatekeeper in Hobart survived early youth. The contrast between the convict artist and the innocent subjects was grist to the mill of the Romantic imagination. In his essay 'Pen, pencil and poison', Oscar Wilde imagined Wainewright's style to have been altered by crime, but just as there was no evidence of his having been a habitual poisoner, the truth of Wainewright's last ailing years in exile was more sadly prosaic.

could have been enjoyed by Thomas Griffiths Wainewright had his life not been circumscribed by illness. His ability to endow his sitters with a kind of Regency grace comes through in his small body of remaining drawings, almost all of which are now in a state of dilapidation. The well-preserved watercolour *The Cutmear Twins, Jane and Lucy*, painted in around 1842 while Wainewright was serving his sentence, is his masterpiece of delicacy [21].[19]

Colonial sketchbooks

Art on a small scale generally conformed to the pattern of art on a larger scale in colonial society. As with the world of oil paintings, small-scale works—collections of drawings and sketchbooks and albums—tended to be organized into the established genres of natural-history drawing (by far the most significant subject of small-scale drawing), portraiture, and topography. In the sketchbooks of amateur artists, however, a further element enters, a diaristic intention, which finds its most frequent expression in the record of the sea

22 Emily Stuart Bowring

A view from the cottage window, Burlington, 1855

The sketchbook of the wife of a farm manager records the landscapes of the great country estates of northern Tasmania. For the most part these are conventional views, but her 1855 landscape at Burlington, framed in a cottage window, is one of the most original of colonial drawings and perhaps reflects her own position in relation to the land—the view is from the farm worker's perspective, rather than the owner's.

voyage. Countless colonial sketchbooks record the predetermined voyage sequence—Madeira, Cape Town, Cape Raoul, Hobart, Sydney Harbour, and on to other destinations inland. A further expression of the diaristic nature of sketchbooks occurs, particularly in the sketchbooks of women, in views of the interior of houses, details of gardens, and life as seen from the drawing room or the verandah [22].

John Glover

The artist in whose work all the strands of the early colonial art enterprise are most completely brought together is the painter John Glover (1767–1849). Glover's work possesses an intimate, diaristic element, but it also bears the traces of an artist intent on embracing the benefits of emigration and the capacity for a fulfilling life in the new land of Australia. When the ageing Glover emigrated to Australia, at the end of a moderately successful career as a landscape artist in London, he did so, as he told his principal patron Sir Thomas Phillipps, in delightful anticipation of finding 'a new beautiful world, new landscapes, new trees, new flowers, new animals, birds etc.'.[20] Shortly after his arrival Glover sent an exhibition of 68 works back to London, where they were described as being 'Descriptive of the Scenery & Customs of Van Diemen's Land'.

Glover found qualities in the Australian landscape which eluded almost all of his more prosaic contemporaries. *View of Mills Plains, Van*

23 John Glover

View of Mills Plains, Van Diemen's Land, 1833

In his first years in Australia, Glover painted delicate and detailed renditions of the Australian bush. This painting of Patterdale, his property in northern Tasmania (then known as Van Diemen's Land), at Mills Plains, is dominated by the spreading gum tree, with the artist's house in the middle distance and forested hills beyond.

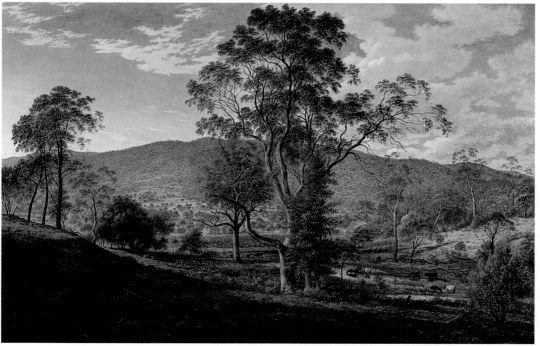

Diemen's Land of 1833 is one of a series of pastoral paintings of Glover's own property in northern Tasmania (which he named Patterdale, after a favourite painting-spot in England's Lake District), which was farmed by his sons [23]. On the back of this painting Glover wrote 'There is a trilling and graceful play in the landscape of this country which is more difficult to do justice to than to the landscape of England.'[21] Unlike his contemporaries, who found a dreary monotony in the seemingly endless and khaki-coloured forest, Glover there discovered grace and lightness. *Cawood on the Ouse River* (1835), a depiction of another bountiful Tasmanian property [24], is among the greatest Australian landscapes of the nineteenth century in its balance of light-filled distance, precisely observed landscape rendering, and harmonious composition.

Although both the paintings of Patterdale and Cawood celebrate bounty with an almost religious gratitude, Glover was acutely sensitive to the previous inhabitants of the land in Tasmania. Arriving in 1831, he had little opportunity to see Aboriginal people of the island in the bush—by the early 1830s the influx of settlers and government-sanctioned policies of destruction meant there were very few people still living there. By the conclusion of George Augustus Robinson's journeys in search of the remaining 'unconciliated' people in the mid-1830s, it was clear that the only Aboriginal people to survive were those already in settlements. None the less, Glover made numerous paintings of corroborees and scenes of Aborigines bathing in rivers. Glover

24 John Glover

Cawood on the Ouse River,
1835

Cawood was T. F. Marzetti's fertile property set on the Ouse River in central Tasmania. Glover's painting includes the substantial farm buildings, surrounded by fields in which grain is being harvested, and horses, cattle, and sheep graze. Such properties were admired for their broad park-like ambience, an impression heightened by Glover's making the buildings more distant in the final painting than in the 1834 drawing on which it was based.

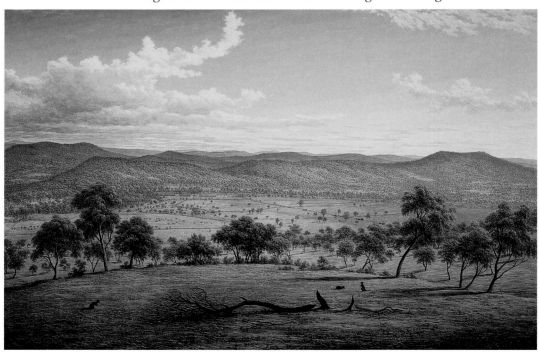

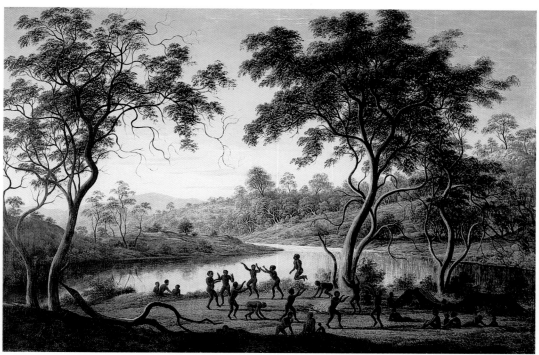

25 John Glover

Aborigines dancing at Brighton, 1835

Brighton is on the Jordan River in Tasmania, north of Hobart. Glover's painting is an imagined reconsruction of the traditional life of the Aboriginal people of Tasmania before the destruction of that life (complete by the early 1830s). The painting was originally owned by the missionary George Augustus Robinson, the central figure in Duterrau's 1840 painting, *The conciliation* [**16**].

seemed fascinated by both these aspects of Aboriginal life, perhaps because they represented a literal immersion in the landscape: just as nymphs in the classical tradition were emanations of watery places, Glover's Aborigines are like water spirits—spirits of the recently departed. In such paintings as *Aborigines dancing at Brighton* (1835) we can see the intention of Glover's Aboriginal paintings, which he described to George Augustus Robinson as imaginings of 'the gay, happy life the natives led before the White people came here'[22] [**25**].

Apart from his 1835 exhibition, Glover had apparently little presence, having no pupils to speak of and little desire or opportunity to exhibit work before the emergence of art exhibitions in Australia (which did not occur until the 1840s).[23] Glover's isolation, however, was not unusual: isolation was very much the typical condition of the European artist working in Australia before the middle of the nineteenth century.

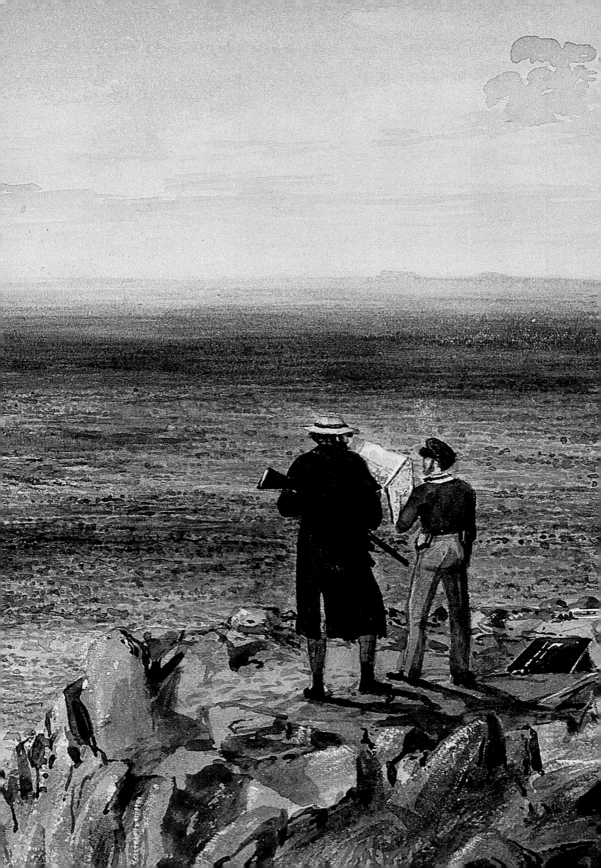

The Pursuit of
Knowledge 1835–70

3

Over the past century-and-a-half, exaggerated emphasis has been placed on the role of landscape as the defining motif in Australian culture, yet much of the best Australian art of the nineteenth and twentieth centuries, from the hands of both Aboriginal and non-Aboriginal artists, has resulted from a searching engagement with the natural world. Nowhere was this better demonstrated in the nineteenth century than in the works of naturalists, surveyors, explorers, and scientists, and of artists working in close association with scientists. Most of the works which resulted from such conjunctions of science and art are small in scale, intimate, and often informal, yet they often possess a richness and an honesty which seem to fly from Australian artists when they have attempted more ambitious projects.

When John Lhotsky (1795–1866) summed up the state of the visual arts in Australia for the readers of the London-based journal *Art Union* in 1839, he concluded that 'Australian sky and nature awaits, and merits real artists to portray it'.[1] Lhotsky, a naturalist, spent the years 1832–8 in Australia and was familiar with the work of a number of artists, but those he named in his article—John Glover, Charles Rodius, and Benjamin Law—he found wanting in close attention to their new environment. It is hardly surprising that Lhotsky found most artists unequal to the task, because his own extensive journeys in the colony gave him a broader appreciation of the variety of the landscape than was possible for most town-based artists. Lhotsky's 1839 piece was the first sustained attempt at Australian art criticism, and significantly it included the first statement of the idea that has been pervasive in Australian art ever since: that a distinctive Australian visual art will arise from the distinctive qualities of Australia's natural environment.

Natural-history illustrators

Although we now think of art and science as separate disciplines, the distinctions of vocation which grew up at the end of the nineteenth century did not exist to worry the devotees of the wonders of the natural world in the earlier part of the century. Furthermore, no sharp distinction was drawn between professional science and the work of amateurs. Natural history, in particular, was one area of enquiry which

Detail of 28

enjoyed great popularity in early nineteenth-century Europe among professionals and amateurs alike. Australia provided a fascinating study for the emigrant field naturalist and amateur botanizer.

Many of the amateur naturalists who drew and painted the plants and animals of Australia were women, several of whom made a significant contribution to Australian natural-history art. Their work was characterized by a disregard for specialization; they ranged freely across mediums and approaches. The Tasmanian colonist Mary Morton Allport (1806–95), for example, painted portrait miniatures, made landscape etchings, illustrated scientific papers, and decorated paper knives and chess tables with paintings of the native flora of Tasmania.

Mary Morton Allport's life story was similar to that of many middle-class women who emigrated to Australia with their families. She and her speculator farmer husband arrived in Tasmania in 1831, where they set up a farm, but were unsuccessful. After the family moved to town and established itself in Hobart, Allport began to make lithographs. The first of her lithographic illustrations appeared in the *Tasmanian Journal of Natural Science* in 1841 [26]. She also made large watercolours, which, like her natural-history illustrations, are characterized by an appreciation of minute detail. They present the specimens in appropriate bushland settings—as though the artist has been determined to show us the extent of her first-hand knowledge of habitat. This is the naturalist's equivalent of the assurances which frequently accompanied topographical works that they were done 'on the spot' or taken 'directly from nature', and it had been common in Australian natural-history depictions since the time of John Lewin. Allport shared with the earlier artist something of the desire to go beyond the perceived limitations of illustration into the creation of exhibition works.

Allport's close contemporary, Louisa Anne Meredith (1812–95), also came to Australia with her farmer husband. Unlike Allport, however, she had already had a recognized career as an artist before her emigration in 1839. In Birmingham she had exhibited miniatures and published illustrated books; indeed, she had been prolific, specializing in volumes of flower paintings and poetry. From Tasmania she continued to publish, writing candidly about colonial society and providing illustrations for large-format coloured books. The titles of these books indicate Meredith's amiable and populist approach to natural history: *Some of My Bush Friends in Tasmania* was published in London in 1860 (with a second series appearing in 1891); *Tasmanian Friends and Foes* in 1880. Despite the sentimental and occasionally anthropomorphic tendency of these books, their author insisted that the drawings were accurate. She fiercely rejected the criticism of taxonomists who found her illustrations lacking in the necessary precision.

Mary Morton Allport's *Opossum Mouse* is ingeniously devised to include a Tasmanian landscape background. Behind the tiny marsupial can be seen the distinctive plants which gave their name to Grass Tree Hill, on the Hobart to Richmond Road. According to Allport's friend Louisa Anne Meredith, the grass trees 'gave a peculiar character to the steep and rocky hills'.

Both Mary Morton Allport and Louisa Anne Meredith were able to participate in one of the most stimulating aspects of Tasmanian society in the early nineteenth century—its advanced scientific circles. Hobart was at that time the most important scientific community in the southern hemisphere (until it was overtaken by Melbourne in the 1850s). In Tasmania there had been a coterie of unusually interested amateurs from the moment of the colony's establishment, and several of the officials in semi-exile there, men such as the colonial surgeon James Scott, had been responsible for commissioning fine works of natural-history drawing from the hands of convict artists such as W. B. Gould (1803–53) and Thomas Bock (1793–1855). Interest in scientific matters was also stimulated at the highest official level, particularly during the governorship of Sir John Franklin, whose wife, Lady Jane Franklin, had high aspirations for the culture of the island colony (she even established a museum, with a Grecian portico, incongruously set in a forlorn tract of scrub outside Hobart). During the Franklins' tenure (1837–43) two events occurred which indicate the special qualities of Tasmanian scientific attention. The first of these was the establishment of the Philosophical Society of Tasmania (later to become the Royal Society of Tasmania, the earliest such society to be formed after that of the mother country). The second event was the sojourn in Tasmania of John Gould (1804–81) and his wife Elizabeth Gould (1804–41), ornithological illustrators *par excellence.*

The Goulds were in Tasmania between 1838 and 1840, working towards *The Birds of Australia* (1840–8), a work for which Elizabeth provided a number of the plates before succumbing to mortal illness after the pair's return to England.

New South Wales, too, had artists whose work was similar in range to that of the Tasmanian kindred spirits—the short-lived naturalist Louisa Atkinson (1834–72), and the Scott sisters, Harriet (1830–1907) and Helena (1832–1910). The art of these sisters was of a significantly different order when compared with the popular natural history of Louisa Anne Meredith, for they were specialist illustrators and were employed to illustrate major books of zoology. The sisters worked together on the sumptuous plates for their entomologist father's *Australian Lepidoptera and Their Transformations* (1864) (for which Harriet painted the moths and Helena the butterflies), and they prepared the illustrations for Gerard Krefft's *Snakes of Australia* (1869) and the same author's *Mammals of Australia* (1871).[2] Their illustrative work was regarded highly for its precision and finish. They, too, had other ways in which they used their skills, producing a series of distinctively Australian wildflower Christmas cards.

The art of the surveyor

Thomas Livingstone Mitchell (1792–1855) was another artist who produced fine lithographic illustrations as part of his wide-ranging professional activities. Indeed, Mitchell introduces another very significant variety of empirical artist in Australia. Mitchell was principally a surveyor (in his pre-Australian career he was a soldier) and he held the post of surveyor-general of New South Wales from 1828 until his death in 1855. During that period he made a number of long journeys into the interior country which he recorded in his two-volume *Three Expeditions into the Interior of Eastern Australia* (1838) and *Journal of an Expedition into the Interior of Tropical Australia* (1848). These works were illustrated with plates after Mitchell's drawings.

The primary purpose of the surveyor's work was to describe accurately the various tracts of country which make up the continent of Australia. However, Mitchell's books, like all records of colonial exploration, are constructed as narratives, which not only describe the landscape traversed but also betray deeply felt responses rooted, in his case, in those late eighteenth-century ways of seeing, the Picturesque and the Sublime. These responses also tended to dictate the choice of landscapes with which artists chose to illustrate their work. Mitchell summed up his experiences as a surveyor of inland Australia as 'admiring Nature in her wildest grace'; he found there a landscape where the painter and poet might find original ideas.

Similar responses can be found throughout the literature of exploration in the nineteenth century. For example, the men who

27 E. C. Frome

First view of the Salt Desert—called Lake Torrens, 1843

The most extraordinary image to result from Frome's journey into the interior of South Australia was his tiny drawing of a surveyor on horseback, telescope raised to his eye, staring into the distance at the utterly flat surface of a vast salt lake. It is neither picturesque nor romantic; to the nineteenth-century imagination such a desolate void was simply terrifying.

accompanied the surveyor of the newly established colony of South Australia, E. C. Frome (1802–90), into the interior in 1843 found scenes which evoked 'romantic' appreciation among the seemingly unpromising rocky hills of the Flinders Ranges [**27**].[3]

Art in South Australia: S. T. Gill and George French Angas

Whereas Frome and Mitchell were surveyor-artists, two other draughtsmen working in South Australia in the first decade after its establishment had no official role, but none the less accompanied explorers on surveying expeditions. S. T. Gill (1818–80) worked in South Australia from his emigration in 1839 until 1852, when he moved to Victoria, where he became known as the foremost recorder of the Victorian gold-fields. Among Gill's best South Australian work is the series of watercolours painted as a result of his journey into the Flinders Ranges with J. A. Horrocks in 1846. Gill joined the expedition 'for the purpose of filling his note book', and his watercolours are among the small masterpieces of Australian art.[4] They are remarkable for their freshness and their precision; Gill himself seems to have been interested primarily in the narrative element of the journey. And as a narrative, Horrocks's expedition was not short on interest. Horrocks was accidentally shot in the face during the expedition and, after agonizing days of journeying, eventually died—all of which Gill recorded in a set of watercolours which he raffled in Adelaide in 1847 [**28**]. Gill's experience of the arid country of the inland was valuable, for, when he was commissioned to do finished watercolours to illustrate Charles Sturt's *Narrative of an Expedition into Central Australia* (1849), he produced images of vivid fidelity to the colour and light of the interior.

The other South Australian artist whose experiences of Australia were established by travel in the bush was George French Angas

28 S. T. Gill

Country north-west of Tableland, 1846

The two figures in this drawing are Horrocks, the leader of the exploring party into the desert areas of South Australia, and S. T. Gill, the expedition's artist. Gill described this view as an 'uncheering scene … one immense space of dry sandy country, covered with a low, dry, crisp scrub, without the slightest vestige of grass or probability of water'.

(1822–86), son of the founder of the land development enterprise, the South Australian Company. He travelled to South Australia in 1843 and made copious drawings which he exhibited to considerable acclaim in London and from which he published rather undistinguished and apparently unremunerative view-books. Angas's artist's impressions of the Antipodes, *Savage Life and Scenes in Australia and New Zealand,* appeared in 1847. In this he described himself as 'a disinterested observer, who went to the Antipodes actuated by an ardent admiration of the grandeur and loveliness of Nature in her wildest aspect'. This included, according to the artist, 'savage life and scenes in countries only now emerging from a primitive state of barbarism'.[5]

Angas looked upon his art largely as something he could sell and disseminate through prints and books. In this he hoped to exploit a fascination with novelty, but by the 1840s it was too late to be effective on that score; he conceded that there were a number of artists before him who had thoroughly worked over the antipodean ground. Only when he reached the gold-fields did Angas strike the pay dirt of genuinely topical subject-matter. There were, however, other aspects of originality in his work. Among the most interesting of these was his study of Aboriginal rock engravings around Sydney—the same rock engravings that had fascinated Governor Phillip.[6]

Another aspect of Angas's work which sets him apart from other view-makers was his serious devotion to a specific branch of science—conchology. Angas amassed a large collection of shells which he believed to be the largest outside Europe and, on the strength of his collections, was appointed secretary and accountant of the Australian

Museum in Sydney in 1853. He published in his field of study, and some of his finest artwork is to be found in a hand-painted manuscript illustrated with 30 jewel-like watercolours of the sea-slugs of Port Jackson.[7]

German artists in the interior

Artists working in Australia in the 1850s whose interests ranged widely and whose work seems to comprise, in equal measure, scientific sophistication, curiosity value, and romantic response to the phenomena of nature included a number with German backgrounds and training.[8] These artists were closely linked in a vigorous German-speaking intellectual community at the centre of which were such scientists as the meteorologist and explorer Georg von Neumayer (1826–1909) and the botanist Ferdinand von Mueller (1825–96), who was responsible for establishing Melbourne's Botanical Gardens and Herbarium.

William Blandowski (1822–c. 1876) was the most elusive of the German scientist-artists in Australia, partly because following his 10-year sojourn in Australia (1849–59) he took the bulk of his drawings back to Germany, where they were subsequently dispersed. The most enduring remains of his interesting work can be found in the 27 completed plates for a projected *magnum opus* entitled *Australia Terra Cognita* (1855–9). This work was intended to be a compendium of the artist's observations of remarkable geology, zoology, and ethnography. The few plates which were engraved to illustrate antipodean landscapes are characterized by a sense of wonder. The composition of the huge granite boulders of Pattowatto silhouetted against a setting sun possesses an almost surreal air, with the apparently bizarre conjunction of a horse (presumably included to give scale to the boulders) and, somewhat incongruously, Aborigines smoking possums out of a hollow tree.

In Blandowski's work and in that of his artist-assistant Gerard Krefft (1830–81), and in the delicate watercolours of Ludwig Becker (1808–1), the immense interior of the continent begins to be expertly and minutely investigated. Blandowski and Krefft journeyed to the junction of the inland Darling and Murray Rivers in 1856 and 1857, where they collected and described animals new to science. Ludwig Becker's most memorable work was made on the Victorian Exploring Expedition (popularly known as the Burke and Wills expedition) in 1860–1, which sought to cross Australia from south to north and which traversed great tracts of inland desert country.[9]

Becker's work is unique because the dry desert interior of Australia was rarely the subject of art in the nineteenth century. Only in the twentieth century did the red and ochre outback, stretching to a flat horizon, become the defining motif of Australian landscape. It was not until it became the common currency of twentieth-century painters such as the Aboriginal watercolourists of Hermannsburg, Russell

Drysdale and Sidney Nolan, that the inland came to be seen as the essential Australian landscape. To the nineteenth-century European emigrant the inland was a 'ghastly blank'.

Becker was a man of broad-ranging scientific interests and a miniaturist's eye. Lady Caroline Denison described him as 'one of those universal geniuses who can do anything; is a very good naturalist, geologist &c. draws and plays and sings, conjures and ventriloquises, and imitates the notes of birds so accurately that the wild birds will come to him at the sound of a call'.[10] When he volunteered to accompany the Burke and Wills expedition, he had been in Australia for a decade, during which time he had lived in Tasmania and on the Bendigo gold-fields, from where he wrote papers on astronomy and meteorology for the Philosophical Institute (the forerunner of the Royal Society) of Victoria, and painted landscapes in watercolours.

Becker's drawings from the Burke and Wills expedition are a testament to his concern for the minute and the subtle in nature [29]. Even after the expedition became something of a forced march, Becker used every available hour to make drawings of tiny lizards, shells, beetles, and moths—his microscopism extended even to the ticks found on lizards. He drew landscapes with wonderful atmospheric effects—mirages and fata morgana and the blazing meteor he saw falling to earth on the night of 11 October 1860. His response to nature was investigative, yet also profoundly aesthetic. In one of the last letters he wrote from the expedition, before he died from the combined effects of illness and exhaustion, Becker described his satisfaction with the scene

29 Ludwig Becker

Portrait of Dick, the brave and gallant native guide, 1860
Becker's drawing of the 'brave and gallant' guide, Dick, is one of the most beautiful portraits of Aboriginal people made in the nineteenth century. This portrait was made on the Burke and Wills expedition as a record of the heroic action of the guide who had just returned, exhausted, from a nine-day journey on foot to bring news of the fate of the beleagured forward party to the expedition's base camp.

Nᵒ 33.

Portrait of Dick,
the brave and gallant native guide.
Darling Depôt Decb 21.⁶⁰

L Becker

before him on the Darling River, a scene 'rich and poetical' which he needed no help from 'fancy or imagination' to depict.[11]

Blandowski and Becker were as interested in ethnography as in other forms of enquiry: their drawings of Aboriginal life possess the same sense of precise observation that characterizes their zoological work. In his engraving of a corroboree scene, Blandowski noticed the way in which each of the dancers had a distinctive pattern of body-painting—a highly significant detail which eluded most other European artists who painted corroborees, such as Joseph Lycett or John Glover. Becker's interest in the corroboree led him to transcribe songs which were sung by an Aborigine at the Darling River camp.[12]

Eugene von Guérard

The combination of breadth of feeling and painstaking attention to detail in the mid-nineteenth century reaches its most satisfying balance in the work of Eugene von Guérard (1811–1901).[13] Unlike many of the other men and women examined in this chapter, von Guérard was by profession an artist—an easel painter. He was undoubtedly the best landscape painter in Australia of this time and much of the success of his work relied on a combination of the meticulously observed with the grandiose. This quality was recognized and admired in his own day, as can be seen in the comment made in 1858 which described how every von Guérard landscape 'is an accurate portrait of the scene it professes to portray; every tree and flower has not merely its local character, but its botanical peculiarities; and yet the whole is a picture in the fullest sense of the word, and a fine picture'.[14]

Von Guérard's only predisposition towards the pursuit of natural history as a discipline in its own right was in the area of conchology, but as a collector he was far more interested in the productions of culture than those of nature. He possessed large collections of coins and Aboriginal artefacts. One of his earliest Australian paintings, *Aborigines met on the road to the diggings* (1854), shows a group bristling with weapons, indicating something of his interest in objects of material culture, which he collected for European museums and used to decorate his city studio in Melbourne.[15]

Von Guérard was devoted to principles of truth and precision. Before his emigration to Australia, the Austrian-born artist had had the benefit of training (in Rome and Düsseldorf) which combined the sweep of Italianate tradition with a distinctively German attention to detail. To these aspects of his training must be added the example of his artist father Bernhard, a court miniaturist by profession.

By the time von Guérard arrived in Australia in 1852 as a gold-seeker, he was a well-formed artist. Prospecting was to yield him little of value, and after almost two years' digging at Ballarat he gave it up. When he began to paint Australian landscapes in 1854 (he had made

many drawings and a couple of paintings during his gold-digging years), he concentrated on views of homesteads painted on commission but quickly developed a range of landscape views which described the specifics of Australian physical geography. He was particularly attracted to volcanic Victoria—the crater lakes and conical hills of the western districts [**30**]. Von Guérard enjoyed success as an artist from the mid-1850s until at least 1870, after which his work began to decline in popularity, although by that time he was established as the first head of the art school and curator of the National Gallery of Victoria.

The reasons for von Guérard's success are complex and significant. First, his arrival in Victoria coincided with the enormous gold-led explosion in the population and wealth of the colony. Second, his art benefited the early development of art institutions in Australia—exhibitions and art schools. Third, and perhaps most important, he painted during the emergence of a critical culture for the visual arts in Australia, almost the single-handed invention of the Melbourne journalist James Smith. Last, von Guérard painted from within the conducive milieu of Melbourne's predominantly German intellectual leadership.

Through the German community von Guérard came into contact with von Neumayer, who was himself devoted to furthering the work of the towering figure of German geography, Alexander von Humboldt. Neumayer invited von Guérard to accompany him on two of the numerous expeditions he was undertaking to record variations in the Earth's magnetic field (a key variable in Humboldt's view of global

30 Eugene von Guérard

Basin Banks about twenty miles south of Mount Elephant, 1857

This painting resulted from von Guérard's 1857 journey to Camperdown in Victoria's western districts, an area with several volcanic crater lakes. The two lakes in the painting, Gnotuk and Bullen Merri, were then known as Basin Banks. Fascinated by these lakes and the conical Mount Elephant (in the middle distance), von Guérard made a number of drawings which were the basis of subsequent paintings and prints.

31 Eugene von Guérard

North-east view from the northern top of Mount Kosciusko, 1863

Although painted in 1863, this painting is dated 19 November 1862, the day of the artist's visit to the summit of Mt Kosciuszko, Australia's highest mainland mountain. The entire party of five expeditionaries, led by Georg von Neumayer, is included in the painting. The narrative is as complete as the topographical description; the storm which rapidly overtook them as von Guérard completed his sketch appears in the sky in the west.

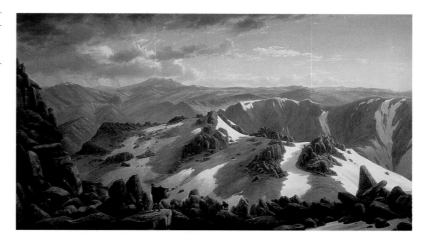

meteorological and biological variation). These two journeys took von Guérard into the remoter wilderness parts of Victoria—in April 1862 into the south-east of the state and in October to December of the same year into the north-east, where the party crossed into New South Wales and visited the summit of Australia's tallest mainland mountain, Mount Kosciuszko.

The artistic results of the Kosciuszko journey are characteristic of the range of von Guérard's *œuvre*.[16] The journey was recorded in the artist's small field sketchbook which he later used as source material for larger, more finished drawings and a series of paintings and lithographs in his collection of Australian landscapes. The field sketchbook precisely describes various aspects of the topography traversed by the party. Written annotations identify subjects, record the dates, times, and weather, note colour and texture. It is typical of the sketchbooks which the artist carried on his journeys throughout parts of Australia (there are approximately 33 of these still in existence) and continues the habit which he had developed as a tourist in Italy during his youth.

The three major oils which resulted from von Guérard's Kosciuszko journey were painted in the subsequent three years: *North-east view from the northern top of Mount Kosciusko* [**31**] was painted in 1863 (the artist inscribed the work with the date of his ascent of the mountain); the brooding and serious *Mount Kosciusko seen from the Victorian border* in 1866; and *Valley of the Mitta Mitta with the Bogong Ranges* also in 1866. These were widely admired paintings and the latter two were acquired by the National Gallery of Victoria shortly after their completion, although neither work, it must be said, possesses the delicacy of execution which characterizes the best of von Guérard's painting and drawing.

Indeed, von Guérard's drawings tell us a great deal about his artistic programme and aspirations. His drawings were not confined to field sketches, but extended to folios of larger and more finished works in

pencil and pen and ink. Perhaps the best of these drawings are contained in the two sets of landscape drawings which von Guérard was commissioned to produce in 1857 and then a decade later. Taken as a whole, these drawings represent a compendium of his interests—the strings of volcanic crater lakes of the western districts of Victoria, the abrupt peaks of the Grampian mountains, rainforest gullies, waterfalls, and a particular obsession with the sources of Australian rivers—but the range of topographies encompassed by these drawings reminds the viewer (in a particularly Humboldtian fashion) that no landscape can be taken as typical in a continent as large as Australia.

At the point when he was well used to public success, von Guérard lamented the taste for landscape painting 'copied or taken from nature'.[17] He saw this taste as uncongenial to the production of the greatest art. Yet it must be admitted that 'copying from nature' produced the best Australian art of the century and fidelity to nature underlay all his own work. In 1870 von Guérard was forced to defend his meticulous approach from negative criticism when the leading Melbourne taste-maker of the late nineteenth century, James Smith, wrote that von Guérard's paintings 'offer a minutely laborious description of almost every leaf upon the gum trees, and of every vein and crevice in the rocks, which would make them delightful illustrations of a treatise on the botanical or geological features of the colony'. In an unpublished reply to Smith's criticism, von Guérard stated his conviction that in their attention to accurate detail 'his paintings would have greater value, where it will be doubtful if those which can be taken equally well for a misty English or an Australian landscape will have the same future'.[18] To the critic's charge that obsession with detail is incompatible with greatness, the painter replied that whilst on the one hand his works were an 'elaborate copy of [Nature's] details', he had, in his more successful pieces, indeed caught a glimpse of 'divine poetical feelings'.

James Smith's criticism—which incidentally did not permanently damage the relationship between the artist and critic—was a new note in his writing about von Guérard. When von Guérard began to exhibit landscapes in the 1850s, Smith had regularly pronounced him Victoria's leading landscape painter and continued to do so throughout the 1860s. Smith also provided the text for the artist's compilation of lithographs, *Von Guérard's Australian Landscapes*, which appeared in parts in 1866 and 1867.

Von Guérard's rivals: Nicholas Chevalier and Louis Buvelot

To some degree Smith's tiring of von Guérard's work reflected a change in taste in art (one not confined to Australia)—a change away from empiricism towards subjectivism. The two major landscape painters of the 1860s whose work could readily be compared with von Guérard's

and which embodies this shift in taste were Nicholas Chevalier (1828–1902) and Louis Buvelot (1814–88). Neither of these artists possessed the precision of von Guérard, nor his penetrating attention to detail, yet both were popular and successful. Indeed, Buvelot's position in Australian painting had certainly eclipsed that of von Guérard by 1870, and he continued to enjoy a reputation as a landscapist among later generations.

The urbane and cultivated Chevalier arrived in Australia in 1854 and left in 1868 to join the Duke of Edinburgh on his round-the-world journey. Like von Guérard, Chevalier was invited during his Australian years to accompany Neumayer on his investigative journey into the remote areas of Victoria, and his painting of the Western Victorian landmark Mount Arapiles, painted in 1863 as a result of one of these journeys, is one of Chevalier's most successful Australian landscapes. By contrast, the painting which won him the Victorian government's £200 prize for landscape painting in 1864 embodies the worst features of Australian colonial landscape painting. The overblown painting of the Buffalo Ranges in Victoria, with its rustic buildings and waterwheel, was the inevitable result of artists striving consciously to make grand statements in which the Australian landscape was forced into an unequal comparison with that of Europe. More interesting than any of his Australian landscapes are Chevalier's works made in New Zealand, the results of his three visits to that country between 1865 and 1869.

Louis Buvelot established himself very quickly after his arrival in Australia in 1865 as the main rival to von Guérard and Chevalier in landscape painting, although the Swiss-born artist began his Australian career as a portrait photographer. In 1866, when the works of these three artists were exhibited together in the fine arts court of the Melbourne Intercolonial Exhibition, James Smith weighed up the merits of the three artists, succinctly describing the differences in their approaches:

M. von Guérard offers us a literal interpretation, idiomatic but mannered; M. Chevalier an agreeable paraphrase; M. Buvelot a free translation with something of a foreign accent ... M. von Guérard sees things as they are; M. Chevalier as they might be; M. Buvelot as they would look under foreign conditions of atmosphere ... M. von Guérard's style is distinguished by its fidelity; M. Chevalier's by its vivacity; M. Buvelot's by its sobriety.[19]

Whereas Smith had come to think of von Guérard's work as a faithful transcription of the Australian landscape, he recognized a 'foreign accent' in Buvelot's bush landscapes. This quality was to be found, according to the critic, in Buvelot's technique, which aimed at breadth of effect, rather than depiction of detail or finish. This technique was ideally suited to attention-seeking in the context of crowded exhibi-

tions, and exhibitions were increasingly important for this generation. Furthermore, Buvelot's subjects were easy on the eye: he preferred quiet and pastoral views.

Buvelot came to Australia from Switzerland, where he had been employed as a drawing teacher in La Chaux de Fonds. During the 1850s and early 1860s he regularly exhibited landscapes in the principal exhibitions held in Neuchâtel and Lausanne. In his native country the painting of spectacular mountain scenery was slowly giving way to a Barbizon-inspired taste for a more pastoral subject-matter—peasant hamlets, dairying, watermills by streams—and this change somewhat approximated the change which Australian taste underwent in the 1860s. The only other painter in Australia to exploit this taste was William Ford (1820–86), whose richly painted pastoral pictures were exhibited in Melbourne in the 1870s. Ford's best-known painting is a gentle picnic scene of 1875, *At the Hanging Rock*.[20]

Buvelot's drawings reveal the distinctiveness of his approach. The pencil drawings are broad and textural, concerned with the disposition of masses and with light and shadow. Whereas in his drawings von Guérard had added a pale modelling to give sufficient coherence to his forms, Buvelot built up the entire composition from discontinuous patches of tone. Drawings of tracts of bush at Macedon made in 1872 embody a robust suggestiveness about the light in the Australian bush which von Guérard was rarely able to achieve. In many senses

32 Louis Buvelot

Waterpool near Coleraine (Sunset), 1869
Buvelot's large painting resulted from a 6-week journey to Coleraine in the far western districts of Victoria undertaken in late 1867. According to Buvelot's wife, the artist 'studied the pool in all its aspects from every side, so great was his love for the spot'. The work was bought in 1869—one of the first acquisitions of Australian art for the National Gallery of Victoria, Melbourne.

Buvelot's visual language seems closer to the work of Conrad Martens in the 1840s, when 'breadth' and 'effect' (not to mention compositional balance) were measures of aesthetic success, than to the austere precision of von Guérard.

Buvelot's broken, free brushwork and his preference for the familiar subject-matter which he was able to find close to Melbourne in the Yarra Valley won him rapid recognition. In 1869 his *Winter morning near Heidelberg* and *Summer afternoon, Templestowe* were acquired by the Museum of Art of the Melbourne Public Library (the future National Gallery of Victoria). As with Chevalier and von Guérard, Buvelot's work was at its best on a medium scale—the one exception being his *Waterpool near Coleraine (Sunset)* (1869) [**32**]. As the writer Marcus Clarke recognized when he wrote a text to accompany a photographic reproduction of this work, published in 1874, this is a poetic rather than a descriptive work. Clarke was able to weave about the painting a fantastic interpretation of the painting as a depiction, not of a place, but a mood embodied in the landscape:

The time-worn gums shadowing the melancholy water tinged with the light of fast-dying day seem fit emblems of the departed grandeur of the wilderness, and may appear to poetic fancy to uprear in the still evening a monument of the glories of that barbaric empire upon whose ruins the ever-restless European has founded his new kingdom.[21]

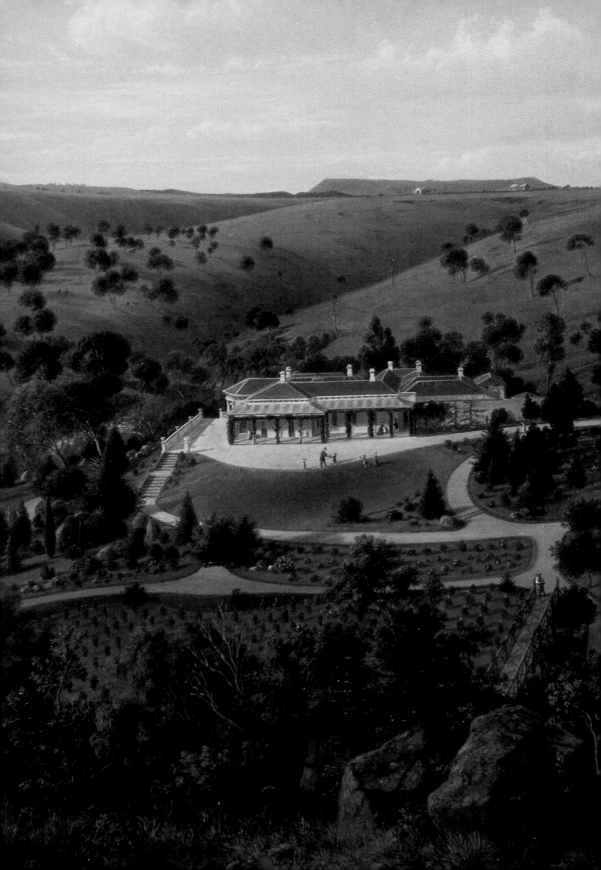

Colonial Art-worlds 1851–88

4

With its establishment as a separate political entity from New South Wales in November 1850, and the exploitation of rich gold deposits discovered in 1851, the colony of Victoria boomed: the celebration of abundance became a keynote of colonial art for the next half-century. Victoria's principal city, Melbourne, had been established in 1835 and its town plan laid out in 1837; by 1853 it was sufficiently well established to mount its first art displays. In 1857 the members of the Victorian Society of Fine Arts mounted their first exhibition. While the exhibition was not a complete success—something of a false start for artists' organizations in the colony—it none the less heralded the development of an art-world in Melbourne of a richness and seriousness not previously seen in Australia.

Art exhibitions

Public exhibitions were central to the mid-century art-world, and the critical milieu which developed around them was important in the development of Australian art. Until the 1850s, exhibitions of art in Australia were rare. Group exhibitions which included substantial numbers of works by colonial artists began only in the 1840s. In Tasmania, where there had been a foray into art exhibiting in 1837, a committee of leading Hobart citizens, inspired by the watercolourist John Skinner Prout (1805–76), mounted two exhibitions—in 1845 and 1846—which set out deliberately to improve local appreciation of the visual arts.[1] These exhibitions also gave the amateur artists who were in Prout's sketching circle the opportunity to display their efforts alongside European works (including some genuine Turners, the property of Tasmania's bishop, Francis Russell Nixon). In Sydney, exhibitions were mounted by the Society for the Promotion of the Fine Arts in 1847 and 1849. Adelaide's first art exhibition was held in 1847 and followed up in 1848. The provincial centres of Launceston and Parramatta also saw art exhibitions in the late 1840s.

Typically, these exhibitions included European works, usually with wildly optimistic attributions, copies of European works, and Australian productions. Whereas the European works were usually lent, works by local artists were often for sale, but in a limited market,

Detail of 34

59

sales were few. A constant theme of disappointment runs through written descriptions of nineteenth-century exhibitions in Australia. Anna Maria Nixon, wife of the art-loving bishop, lamented the small attendance for the 1845 Hobart exhibition, writing: 'alas, the Hobartians have proved themselves very unworthy of such an intellectual treat'.[2] The same could have been said of the Sydney audience, who bought not a single picture in the 1849 exhibition, forcing the organizers to try to rescue the situation by means of an often-used nineteenth-century standby—a raffle of works, or art union.

From the 1850s, exhibitions in Australia fell into two types. First, there were enormous exhibitions, based on the Great Exhibition of 1851, which sought to record, in an encyclopædic fashion, the full extent of colonial production. These exhibitions were astonishing in the sheer number of exhibits: today their catalogues are evidence of the variety of visual culture (in its widest sense) in the nineteenth century. Second, there were exhibitions which were devoted specifically to fine art. The story which these latter exhibitions tells is a different one. It is a story of the increasing distinction between professional and amateur art practice in Australia, a demarcation which was virtually complete by the 1880s.

The Melbourne Exhibition of 1854 established the style for the exhibitions which followed in many cities and regional centres for the rest of the century. It was mounted in connection with the Paris Exhibition of the following year. The Fine Arts were one of eight categories of exhibit, and the group of works listed in the catalogue was wide-ranging, encompassing sculpture, copies of old masters, and religious paintings. The original works by colonial artists included eight by Eugene von Guérard and three portraits by William Strutt (1825–1915), all of politicians in the nascent legislature of Victoria. There were numerous works by amateurs and by women, mostly natural-history sketches. The indefatigable enthusiast Ludwig Becker contributed some of his own drawings and Australian gold jewellery made after his designs, but he also exhibited a drawing made by an Aborigine and 'part of a necklace of native seeds, worn by a chief of the Murray tribe'. The eclecticism represented by the exhibits in the 1854 exhibition was typical of the intercolonial and international exhibitions which were a regular feature of cultural life in the second half of the century, and which culminated in the great Melbourne Centennial Exhibition of 1888.

William Strutt

In the 1854 exhibition most of the colonial works of art were for sale. For professional artists, exhibitions were important, but they were intermittent and artists could not rely on them to sell their works. More reliable income came from commissions of works of art, from the

publication of prints, and from providing illustrations for newspapers and journals.

William Strutt worked in each of these areas of activity. Indeed, his career could be said to exemplify the fortunes of art in Victoria around the middle of the century. Strutt was a very well-trained artist, the best-trained artist to come to Australia in the nineteenth century, having been schooled in Paris in the 1830s. He arrived in Melbourne in 1850, and although he had not emigrated as a gold-seeker, he recognized the potential of gold as a subject, making drawings which were distributed as prints by the publisher Thomas Ham and later collected into a finished album, *Victoria the Golden*. But it was in portrait painting that Strutt was to enjoy most success.

Strutt was one of the founding members of the Victorian Society of Fine Arts, and was represented in the Society's 1857 exhibition by several portraits. Although he continued to receive portrait commissions throughout his years in Australia, he harboured broader ambitions and from the date of his arrival had aspired to paint large-scale works depicting the significant events he witnessed during his years in Melbourne. He was only partially successful in realizing these ambitions. Despite the hopes of friendly politicians, commissions of large-scale depictions of the opening of Victoria's Parliament were never funded beyond the preparation of preliminary drawings.[3]

It was not until he returned to England that Strutt was able to exploit fully the pictorial potential of colonial subjects in the paintings for which he is now best known—*Black Thursday, February 6th, 1851*, completed in 1864, and *Bushrangers, Victoria, Australia, 1852* of 1887. The closest Strutt came to creating a heroic painting when he was living in Australia was his masterful and penetrating portrait of the explorer Robert O'Hara Burke, painted in 1862 [**33**]. It is one of the great Australian portraits of the century.

Black Thursday was Strutt's most ambitious statement about the drama of frontier life, the subject being the catastrophic bushfires which swept through Victoria in the artist's first year there.[4] A painting of so essentially Australian a subject should have found a ready buyer, or such was Strutt's hope, but it was not purchased for an Australian public collection until well after the artist's death (and then more for its historical than for its art value). Strutt's failure to find an Australian buyer for *Black Thursday*, despite the efforts of some influential backers, is often taken as evidence of the supreme indifference of colonial governments to the visual arts. Yet it must be admitted that, despite Strutt's ambition for *Black Thursday*, it is remarkably unmoving. The painting reveals Strutt's miniaturist's hand: it is a sequence of detailed and beautifully painted incidents which fail to transform the large canvas into a convincing representation of flight in the face of disaster.

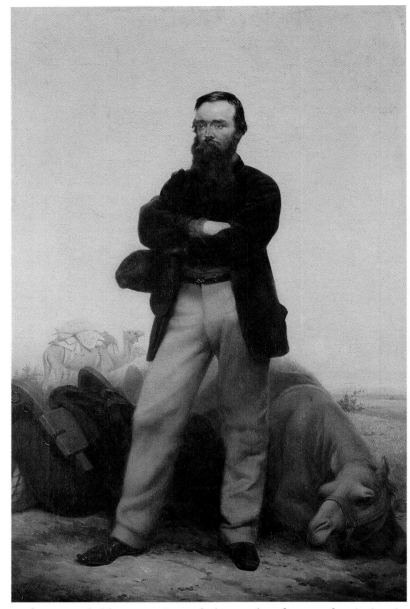

Strutt probably overestimated the market for grand painting in Australia. It is useful to contrast his sense of disappointment with the relative success of artists whose staples were less ambitious. Strutt had a profound sense that he was a witness to history in the making—he knew he was experiencing beginnings, and Melbourne's continued growth as a city bore out his confidence. An illustrator such as S. T. Gill, on the other hand, had fewer pretensions and greater public success. Gill had come to Victoria from South Australia early in 1852, and his populist and humorous work documenting life on the

gold-fields was clearly successful, judging by the number of variant versions and prints after Gill's drawings which now exist. Furthermore, Gill was able to capitalize on Victoria's developing sense of its own historical importance, which began to be felt strongly in the late 1860s. In 1869 the newly established Melbourne Public Library commissioned Gill to produce a set of 50 drawings depicting life on the gold-fields based on the drawings he had made during the height of the gold-rushes of the early 1850s.

Paintings of property

Along with portraiture, landscape painting was the most fruitful field for the colonial painter in Victoria in the middle decades of the century. It was the staple which had sustained Eugene von Guérard during his first decade in Australia and was an important source of patronage for Louis Buvelot, Thomas Clark (*c.* 1814–83), and Robert Dowling (1827–86). Ironically, as one art historian has pointed out, homestead paintings in Victoria were more common in the 1860s, when the tenure of pastoralists throughout the colony was insecure, than in the 1870s, when the security of the squatters' hold on the land was established by legislation.[5] It could be argued, therefore, that homestead paintings were one strategy of cementing proprietary claims on the land, similar in that regard to the earliest topographical watercolours of Port Jackson.

Eugene von Guérard was the outstanding homestead painter working in Victoria in the 1850s and 1860s. His view of *Glenara*, painted in 1867, is typical of his homestead portraits [**34**]. The painting was commissioned by Walter Clark, a member of the squatter class (squatters were settlers who had come into Victoria from New South Wales or Tasmania and taken up large pastoral runs initially without legislative sanction). Von Guérard's eye for detail served him well in paintings of

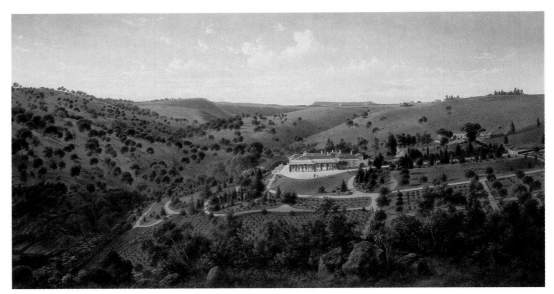

34 Eugene von Guérard

Glenara, 1867

Walter Clark's Glenara was a villa set amid an ambitious garden overlooking the Maribyrnong River in Victoria. In the foreground the Clark children enjoy the fruits of their father's labour, having plucked a bouquet from the well-tended garden. Although at first sight the landscape seems otherwise empty, a detailed examination reveals that this landscape is peopled with 17 figures.

pastoral properties: each tree is loving rendered, as is each blade of grass in the rich pastures.

Homestead portraits, like the house paintings which had been the basis of Conrad Martens's practice in the 1830s, presented a particular problem for the artist: what is the best way in which to render the house and yet also to render the best aspect of the landscape? Von Guérard was not alone in solving this by regularly resorting to creating paired views—one looking towards the house and one looking away from it. Such a solution ingeniously allowed for the inclusion of those elements which were the sources of pastoral wealth (woolsheds, stock, pasture) and the results of that wealth (houses, gardens of introduced plants, leisure). Occasionally von Guérard was able to fulfil both demands in the one composition, as in *Glenara*.

Other artists who were property specialists were Thomas Clark, the self-taught Tasmanian Robert Dowling, and Louis Buvelot, who produced a sequence of paintings depicting the adjacent wool stations of Mount Fyans and Terrinallum in 1869. Whereas Clark and Buvelot do not diverge from the conventional, Dowling was highly original in that he centred his 1850s paintings around groups of Aborigines, the original inhabitants of the land encompassed by the western districts properties of Minjah and Merrang.[6]

Sculptors: Charles Summers, Thomas Woolner, Theresa Walker

Whilst homestead and property views, along with portraits, were the principal sources of patronage for painters in the 1860s, there were further opportunities for artists to obtain patronage in Victoria through governmental and official channels. The 1869 exhibition

mounted by the Melbourne Public Library and Museum was unlike previous exhibitions in demonstrating an unprecedented level of official support for the visual arts in Australia: it was the fruit of the gold- and wool-generated wealth of Victoria and of Melbourne's civic pride. The exhibition, with its handsome catalogue designed by the landscape gardener and illuminator Edward La Trobe Bateman (c. 1815–97), represented the beginnings of serious collecting for public galleries and museums in Australia. Much of the credit for this must go to the Anglo-Irish judge and man of cultured intellect Sir Redmond Barry (1813–80), who was instrumental in the establishment of Melbourne's public library, art gallery, and university.

In materialistic and patrician Victoria, sculpture benefited greatly from public patronage. The 1869 exhibition included a number of busts by Melbourne's leading sculptor of the decade, Charles Summers (1825–78). His 15-year Australian career closely resembles that of William Strutt. Like Strutt Summers relied on portraiture as a staple; like Strutt he hoped for grand commissions, which did not all eventuate. However, Summers was the recipient of the most significant public art commission in Victoria in the nineteenth century—the monumental sculpture to commemorate the Burke and Wills expedition [35].

The only nineteenth-century sculptor to approach Summers in quality was the Pre-Raphaelite emigrant Thomas Woolner (1825–92). Woolner's stay in Australia was much briefer than that of Summers. He arrived in 1852 (his emigration is the subject of Ford Madox Brown's painting *The Last of England*) along with La Trobe Bateman and the painter of fairy pictures Bernhard Smith (1820–85), but Woolner remained only two years. During that time he specialized in portrait medallions of leading citizens, including Governors Fitzroy and La Trobe. These were relatively inexpensive to produce but were useful promotion, and Woolner used them as a stop-gap while he sought large-scale commissions. The two most promising of these were the proposed statues of Queen Victoria in Melbourne and the champion of colonial rights W. C. Wentworth in Sydney.[7] Woolner left Australia when both projects foundered for lack of funds. But, as in the case of Summers, Woolner's Australian sojourn brought unexpected dividends in later years. After Woolner was well established as a sculptor in London, he was commissioned to create busts for Australia and in 1874 received a publicly funded commission for a large statue of Captain Cook, unveiled (before a crowd of over 70,000 people) in Sydney's Hyde Park in 1879.

Portrait medallions were also produced by Theresa Walker (1807–76), whose Australian years embraced Adelaide, Sydney, Hobart, and Victoria.[8] Rather than casting in plaster or bronze, Walker worked in the unusual medium of wax, and on a small scale. For the most part her subjects were the same as those modelled by Woolner—governors,

clergymen, and explorers. But among her best medallions are her profiles of the two South Australian Aborigines Kertamaroo and Mocatta, of which she made multiple versions, and her highly unusual essays in self-portraiture [**36**].

Theresa Walker's wax profiles of Aborigines were not considered primarily as ethnographic sculpture, which is not to say that ethnographic interest was absent from the artist's motivation. A more distinctly ethnographic motivation did result in one last large body of sculpture in the 1860s. In addition to busts of leading public figures, Charles Summers's works in the 1869 exhibition included a series of 16 busts, based on direct casts from life, of Aboriginal people living at Coranderrk, an Aboriginal settlement near Melbourne. In 1863, when Summers visited it, the Coranderrk Aboriginal Station had only recently been established. It was then, and remained until its closure in 1917, the closest Aboriginal settlement to the city of Melbourne and was therefore the most accessible site for European artists and photographers interested in Aborigines.

Summers's Coranderrk busts do not have the monumental quality of his heroic celebratory statues. They are closer in mood to the busts of Trucaninni and Woureddy which Benjamin Law executed

36 Theresa Walker

Self-portrait, c. 1840

Theresa Walker's speciality was the modelling of wax portrait medallions. While most of the sitters for these medallions were the important or influential citizens of her acquaintance—governors or bishops—Theresa Walker made self-portrait profiles on more than one occasion. She exhibited such medallions frequently—in London, Adelaide, Sydney, Melbourne, and Geelong.

in Tasmania in the 1830s; they share the same ethnographic and quasi-fine-art motivation which lay behind Law's practice. Exhibited along with the Summers busts were sets of photographic portraits of Aborigines made by the German-born photographer Charles Walter, also at Coranderrk.

Early photography in Australia

In the 1854 Melbourne Exhibition, photographs were included in the category of Fine Art. These photographs were mostly city views. Along with portraits (a field in which photographs were not at first seen as satisfactory substitutes for paintings and drawings), city views constituted the main subject for the earliest photographers in Australia. While it is impossible to quantify the more general effect photography had on the visual arts, photographs certainly took over the topographical function which had been a significant dimension of drawings and prints until the end of the 1840s. City views also proved ideal subjects for photographers because buildings and streetscapes could be rendered in precise detail, in available light, and were not compromised by the long exposure times necessary in early photographic processes.

The most complete form of topographic representation—the panorama—was ideally suited to the photographic medium. Numerous panoramas of Australian cities were produced in the second half of the 1850s—Sharp and Frith's view of Hobart, Walter Woodbury's 1857 view of Melbourne, the Freeman Brothers' Sydney view of 1858, and O. W. Blackwood's 1858 11-part, 180-degree panorama of Sydney, praised for its clarity and its triumph over technical difficulties. The authority of Blackwood's view derived not only from its technical and artistic success, but also from the location of the

camera—on the roof of Government House, the topographical heart of Sydney.

Photographic practice and other visual-art practices were linked closely in the mid-nineteenth century. Artists whose careers were well established before the advent of the photograph in 1839, such as Thomas Bock and Conrad Martens, were closely interested in emerging photographic techniques, and many pioneering photographers, such as Blackwood, had trained as painters. Until the 1860s there was a preparedness to accept the photographer as an artist. It has been suggested that the division between photography and the other fine arts, which became a feature of the visual arts in the later nineteenth century, developed only as a result of the explosion of photography as a mechanical reproductive medium in the 1860s.[9]

A thoughtful critical response from 1858 shows the way in which the medium could be embraced as another art form, comparable with painting. The Melbourne *Argus* review (entitled 'Sun Pictures of Australia') of Richard Daintree and Antoine Fauchery's album *Australia* was full of admiration for the photographers' 'transcripts of nature'. The reviewer wrote:

The collection under notice are admirable specimens of this branch of art, for art it is; as, irrespective of the skill requisite to manipulate successfully, the manipulators must also possess the artistic faculty in choice of subjects, in the selection of the most picturesque point of view, and in discerning the most favourable aspects or accidental dispositions of light and shade. With this faculty Messrs. Fauchery and Daintree appear to be endowed, and it appears to advantage in more than one of the pictures now before us.[10]

It is hardly surprising that the *Argus* reviewer (probably James Smith) was impressed by the artistry of Daintree and Fauchery, for their album must be regarded as one of the masterpieces of world photography of the 1850s.[11] In the 53 plates comprising the *Australia* album [37], Daintree and Fauchery encompassed not only Aboriginal subjects, but also city views, bush landscapes, gold mines and miners, and portraits of political and religious leaders. The work was the only album of photographs offered for sale in Australia in the 1850s, and although Fauchery considered it to be incomplete as a record, the choice of subjects is representative of the subjects of interest to photographers mid-century. Of particular interest is the depiction of landscapes, such as the view of Ferntree Gully—'Nature's affidavit to the truth' of von Guérard's painting of the same location—which contrasts strongly with the numerous plates depicting gold-mining activity. As the photographic historian Anne-Marie Willis has written, 'mining presented a kind of landscape not widely represented by painters, so photographers had few compositional devices on which to draw. Many

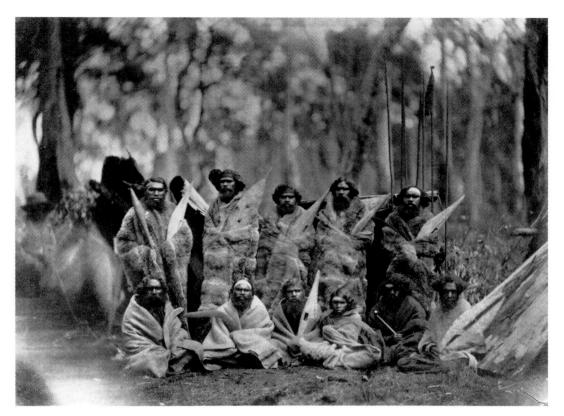

37 Richard Daintree and Antoine Fauchery

Group of Aborigines, 1858 from the album *Australia*

The 1858 reviewer of Daintree and Fauchery's album of photographs described such photographs as 'stereomonoscopes' and drew attention to the compelling presence created in the figure groups by the photographers' use of a shallow depth of field. This 'relief' quality contrasts with the deadpan flatness of much mid-century photography. The people in this powerfully composed group (mostly) wear traditional possum-skin cloaks and carry a range of distinctive Victorian artefacts.

of these photographs … seem almost brutal in their descriptiveness'.[12] The remote gold-mining settlement Solferino, photographed by the travelling portrait photographer J. W. Lindt (1845–1926) in the early 1870s, demonstrates the apparently unpromising pictorial possibilities of such a landscape [**38**].

Like the early colonial artists in New South Wales, whose motivation was to make records, photographers tended to arrange their works in distinct subjects. Ethnographic recording was given a considerable boost by photography, and the curiosity and scientific value of pictures of Aborigines were exploited by photographers. Lindt's most successful enterprise of the 1870s was a series of rather stagey depictions of Aboriginal people photographed in the Grafton region of New South Wales. The Melbourne photographer Charles Walter (1831–1907) produced his first set of portraits of Aborigines in the mid-1860s as a commission for the Melbourne Intercolonial Exhibition, a lead-up to the 1867 Paris Universal Exposition. He subsequently produced several albums of photographs, including *Aborigines of Australia Under Civilisation*, the title of which speaks clearly of the agenda of colonial policy.

Also included in the Melbourne Intercolonial Exhibition were a group of remarkable ethnographic portraits by the Tasmanian

photographer Charles Woolley (1834–1922). Woolley's subjects were the five surviving full-blooded Tasmanian Aborigines who were living at a settlement at Oyster Bay on the eastern coast of the island. The interest of these photographs stemmed from the fact that the photographer was seen to be capturing something about to pass out of history, which was also at least part of Walter's project at Coranderrk. Like Bock's watercolours of three decades earlier, Woolley's photographs were widely replicated and reproduced in publications.

Among the other ethnographic projects of note in the middle of the nineteenth century were the Reverend George Taplin's photographs taken at the mission he established at Raukkan (Point McLeay) in South Australia and used to illustrate his 1874 book, *The Narrinyeri: An account of the tribes of the South Australian Aborigines,* and the photographs of Paul Foelsche (1831–1914). An amateur photographer, Foelsche became the first police inspector of the Northern Territory in 1869 (a position he held until 1904). Foelsche's photographic record therefore covers a significant period in the spread of colonization in the frontier territory.

Aboriginal artists: William Barak, Tommy McRae, Mickey of Ulladulla

Besides being simply a convenient location for photographers and sculptors with an interest in ethnography to visit, the Coranderrk

Aboriginal Station, near Melbourne, was a place where Aboriginal artists worked. Its status as a site of interest for visitors led to the development of a tourist art industry there, which continued from the 1870s until the turn of the century. The settlement had been established to operate as a viable agricultural enterprise, and the sale of artefacts appears to have been crucial, in its initial stages at least, to the various income-producing activities carried on at the settlement.

The small-scale artefact industry at Coranderrk was just one of several such enterprises in the south-eastern parts of Australia. As their traditional lands were occupied by pastoralists, dispossessed indigenous people tended to congregate in camps around rural towns or were compelled to live on reserves or stations, usually run by Christian missionaries. The people who lived at Coranderrk came from many parts of Victoria and continued to make artefacts tradition-ally used in their societies—men fashioned boomerangs, throwing sticks, clubs, and shields, while women made possum-skin rugs and baskets (they also crocheted collars and carved walking-sticks). In other settlements and missions in southern Australia Aboriginal people carried on other traditional craft skills, as in the case of the woven plant-fibre objects produced in the mission stations such as Raukkan on the South Australian coast and the delicate shell necklaces made at Aboriginal settlements in Tasmania and on Flinders Island in Bass Strait.

In terms of the art produced there, Coranderrk was unique, largely through the presence of one artist, William Barak (c. 1824–1903).[13] He was a hereditary leader of the Wurundjeri people, whose traditional lands encompassed much of the city of Melbourne and the Yarra Valley, including the site of Coranderrk. From the mid-1870s onwards, Barak was effectively the leader of the Coranderrk community and was recognized in his old age as 'the last chief of the Yarra Yarra tribe'. Barak made artefacts, but he also made drawings, in a unique style and technique which combined materials traditionally used by Aboriginal artists—ochres and charcoal—with European materials, pencils, and watercolours. Barak lived at Coranderrk for some 40 years, from 1863 until his death in 1903, and much of his work appears to have been produced in the last two decades of the nineteenth century.

The great bulk of Barak's works depict ceremonies [39]. His art acted as a remembrance of the lifestyle into which he had been born but which he witnessed being destroyed over his lifetime. In his old age Barak had something of a role as a teacher and was sought out by Aboriginal people and non-Aboriginal researchers for information on traditional beliefs and practices. His art can be seen as a part of this vital interest in the Aboriginal past of Victoria. Interestingly, while most Aboriginal art of the twentieth century revolved around the relationship of people to particular tracts of land, a nineteenth-century

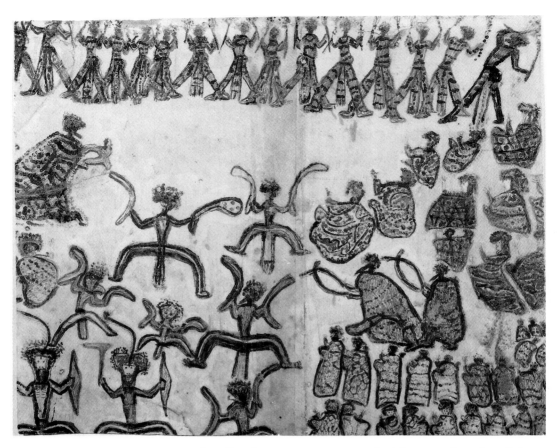

39 William Barak

Ceremony, c. 1880s

In this depiction of a corroboree, space is evoked by the placement of the rows of dancers. In the lower left of the composition, men wearing traditional aprons dance with boomerangs, clubs, and parrying-shields. Around them cloaked men and women sing and beat out rhythm. The work is charactertistic of Barak's distinctive style that used ochres and charcoal on paper or cardboard over a pencil underdrawing.

artist such as Barak was more concerned with remembered traditions. Only one of his extant works was specifically about a particular landscape [**40**].

In Barak's works the participants in ceremonies wear decorated possum-skin cloaks, the traditional dress of Aborigines across the southern parts of Australia before the distribution of blankets and the destruction of possum habitats caused their disappearance. This transformation can be seen, incidentally, in Fauchery's 1858 photograph [**37**], which shows men wearing the cloaks with the fur side out, whereas they were usually worn reversed in order that the skin side, richly decorated with incised designs, could be seen. Very few of these decorated cloaks now exist, but a magnificent and extremely rare example, 'of genuine native design', collected at Lake Condah in 1872, is in the collection of the Melbourne Museum. A comparison of the cloak with Barak's drawings shows the way in which the artist imported some of the overall patterning characteristic of these cloaks into his compositions.

Barak's work raises complex questions about the relationship between the art produced in new circumstances—such as a settlement

or mission—and the traditional visual culture of Aboriginal people.[14] Despite this complexity, it can be said with certainty that before European colonization, the Aborigines of south-eastern Australia possessed a visual culture which encompassed both pattern-making and figuration. Geometric patterns (or 'scrolly shapes', as one European commentator described the designs on possum-skin cloaks) were almost certainly symbolic of individual identity and of the land; geometric sets of lines carved on a club or incised into the surface of a possum skin were more than simple patterns—they were known in some instances to refer to particular tracts of country. Figurative art was also produced, yet much of it was so fragile or fugitive in form that it is now very difficult to obtain a clear impression of its appearance. For example, numerous nineteenth-century commentators refer to Aboriginal people cutting large figures in the ground—'turf figures' (none of which survive), cutting large figures of animals from sheets of bark (only one example now survives), and decorating the insides of bark shelters with incised and drawn images (only a handful of faded examples datable to the nineteenth century now exist).

Another Aboriginal artist who worked in Victoria in the latter part of the nineteenth century was Tommy McRae (c. 1835–1901), a contemporary of William Barak and the pattern of whose life resembled that of the Wurundjeri elder. McRae also experienced the European

40 William Barak

Samuel de Pury's vineyard, 1898

Barak made this drawing of the Yeringburg vineyard as a memento which he sent to Samuel de Pury after the vigneron had returned to Switzerland. Along the lower edge of the composition is a faded inscription in which the subject is identified as Bald Hill (Gooring Nuring) near Lilydale, with the vineyard in the centre surrounded by a creek.

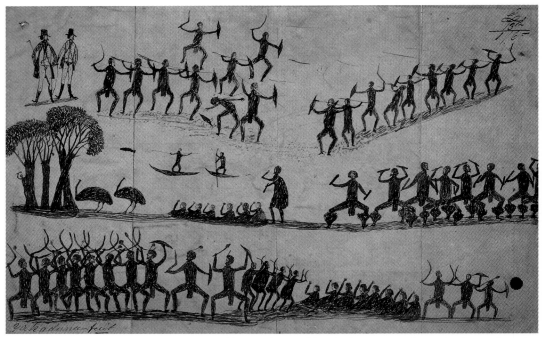

41 Tommy McRae
Scenes of Aboriginal life with squatters, 1865

One of a number of drawings by Tommy McRae collected in the 1860s by Theresa Walker, this is a characteristic composition incorporating remembered scenes of traditional dances, ritualized fights and hunting. The inclusion of European squatters, apparently looking on, is a frequently occurring motif in the artist's work and reflects the pastoral expansion into traditional lands which was the major change which took place during McRae's lifetime. The drawing is inscribed with McRae's tribal name, Yackaduna.

colonization of his traditional lands: his art, made in the latter decades of the century, was, likewise, mainly a record of traditional life, but it frequently incorporated depictions of squatters and their houses. Interestingly, the earliest extant works by the artist were collected by Theresa Walker when she was living briefly in northern Victoria [**41**]. Whether Theresa Walker's interest had any role in promoting Tommy McRae's work is unclear. Certainly by the 1880s McRae was well known as an artist. After he settled with his family on an Aboriginal reserve on the shores of Lake Moodemere, near the Murray River town of Corowa, visitors to the area sought him out and bought his books of pen-and-ink drawings as examples of authentic Aboriginal art.

McRae employed a distinctive silhouette technique to render ceremony subjects, hunting scenes and the interactions between Aborigines, Europeans, and Chinese. His work was appreciated in his own day for its vitality, a judgement borne out by the statement of one of his enthusiasts, the amateur ethnographer Kate Langloh Parker. She commented, in connection with the work of McRae and other Aboriginal draughtsmen, that 'the difference between their art and mine is that however roughly theirs is done it has a look of life mine never has'.[15] Indeed, McRae's work manages to suggest an entire world with the most economical of means. He was an acute observer of gesture and attitude.

Many of McRae's drawings are concerned with the early settler history of Victoria [**11**]. Perhaps the most remarkable of the drawings in McRae's *œuvre* are those that illustrate the story of William Buckley,

a legendary figure in the early European colonization of Victoria. Buckley, an escaped convict, lived in the bush with the Victorian Aborigines for 33 years and became known after his re-entry into European society as the 'white blackfellow'. McRae produced a number of drawings on the Buckley theme. He was clearly fascinated with this character who bridged the (seemingly unbridgeable) gap between Aboriginal and settler society to such an extent that, after being initially thought to be a spirit, he became fully integrated into Aboriginal society, marrying, producing children, and learning a new language to the exclusion of his native English.[16]

The only other named Aboriginal artist to have produced a sustained body of work to rival that of Tommy McRae or Barak in the nineteenth century was known simply as Mickey, a native of Ulladulla on the southern coast of New South Wales. Like McRae, Mickey of Ulladulla (*c*. 1820s–1891), also known as 'Mickey the Cripple', lived on an Aboriginal reserve rather than at a mission, so he, too, had a certain freedom to accept the patronage of local people who sought his work.

The circumstances of the production of Mickey of Ulladulla's works are somewhat obscure. His earliest works seem to have been made in the 1870s, and he was producing drawings until close to his death. In 1893, five works by the artist were posthumously exhibited at the Chicago World's Fair, on which occasion the exhibitor of two of them, the assistant bailiff in the town of Milton, just inland from Ulladulla,

42 Mickey of Ulladulla

Boats, fish; native flora and fauna, c. 1888

The large steamer in this pencil-and-watercolour drawing is the *Peterborough*, which transported passengers and goods along the south coast of New South Wales in the 1880s. It was a familiar sight in the fishing port of Ulladulla, where the elusive artist lived towards the end of his life. As with all of his marine views, this one includes both the forest and the scene below the surface, with sharks and teeming schools of fish.

was awarded a bronze medal. The medal citation described the pair of works as 'unique and valuable as a specimen of primitive art, being un-influenced by the white man'.[17]

Mickey made drawings and specialized in two subjects—corro-boree meetings and fishing activity off the coast [**42**]. Like Barak and McRae, he worked in a completely individual style which, as far as we know, bore little relation to the traditional art of his people, or to the art produced in the Europeanized milieu of the fishing town where he lived. The theme that links all three artists, and a number of other Aboriginal artists who made drawings in the nineteenth century, is the reiteration of the ceremony, which has been described as 'the aesthetic locus' of Aboriginal art.[18] And, in a way that is remarkably similar to Tommy McRae, Mickey's fish and animal drawings are acutely observed and rendered, showing a lifelong and close familiarity with the natural world through hunting. While in Tommy McRae's drawings men and women spear fish from aboard bark canoes, in Mickey's works the fishing boats are those provided by the Board for the Protection of Aborigines. With these drawings of waters teeming with fish, and of forests with native animals, both artists celebrate abundance.

What should Australian Artists Paint? 1885–1900

An 'Australian style'?

The 1880s and 1890s: those rich decades, clustered around the centenary of European settlement in 1888 and the achievement of a federated Australian government in 1900, present the historian of Australian art with a difficulty. The difficulty arises from the entrenched idea that Australian painting was the invention of artists who came to prominence during these years. This idea was tentatively expressed as far back as the 1890s, but gained ground in the twentieth century with the publication of William Moore's *Story of Australian Art* (1934; the first book-length survey of the field) and in the two books by Bernard Smith, Australia's most influential post-war art historian—*Place, Taste and Tradition* (1945) and *Australian Painting* (1962). In his narrative William Moore marked a dividing line between the 'first artists' (characteristically for its date, European pioneers not Aborigines) and the 'Australian School'. The origin of the Australian School he dated to 1885. This same year was chosen by Bernard Smith as the starting-point of his chapter 'Genesis' in *Australian Painting*. Both of these historians chose this date, which saw the return of the painter Tom Roberts (1856–1931) to Australia, as the beginning of the influence of contemporary European practice (specifically outdoor painting in oils) on both Roberts and a group of his fellow artists. This group has become known as the Heidelberg School, a name taken from the village near Melbourne where they camped to paint *en plein air* in the late 1880s.

After a century of placid acceptance, Australian scholarship began increasingly to challenge and modify the orthodoxy of the view that Australian art sprang into existence with the Heidelberg School. In the last decades of the twentieth century several aspects of the myth were assailed. First, the richness and variety of earlier nineteenth-century art was revealed; second, the distinctive 'Australianness' of the style in which the Heidelberg painters worked—an international style of academicized Impressionism—was called into question; and third, the masculine world-view presented by the Heidelberg artists has been modified by an examination of the work of late nineteenth-century

women painters.[1] The quieter, greyer, more subtle aspect of the art of this generation has been brought into a better historical balance. Furthermore, a number of recent writers have challenged the claims of naturalism made by the Heidelberg School artists and have stripped away the varnish of sentimental attachment to the blue and gold of pastoral Australia, to reveal the elaborately constructed nature of their art.[2]

The reasons why the Heidelberg School became accepted as a national style are complex and must be seen against the background of nationalism and federalism which emerged in Australia in the later nineteenth century. Furthermore, twentieth-century art-world politics have been a powerful factor in establishing the myth of their primacy. The Heidelberg School's claims were argued most forcefully in the early twentieth century by the artist of the group who lived longest into the century, Arthur Streeton (1867–1943), whose work had advanced strongly in the market and who from 1929 until 1935 held an influential position as the critic for the Melbourne *Argus*. Fortuitously, too, sustained art publishing in Australia only began in the second decade of the twentieth century, by which time the artists who had come to prominence in the 1880s were well-established names.

The development of art institutions

Yet, for all the necessary art-historical correction and revision over the past three decades, there remains something excitingly original and indubitably important in the art of the 1880s and 1890s. The achievements of these decades had their roots in the 1870s, when something which could be described as an Australian tradition began to be recognized. Before the 1880s European artists working in Australia were not able to see themselves as part of an Australian tradition—they were

Art teachers

Aside from official or publicly funded art schools, private art schools have been significant in the development of Australian art. Perhaps the most important of these was the school established in Sydney by the English-born painter and illustrator Julian Ashton (1851–1942). Ashton began teaching at the Art Society of New South Wales and in 1896 set up his own art school on French principles, called the Académie Julién. Ashton emphasized the importance of outdoor sketching in landscape painting and drawing as the basis of all visual disciplines. The school thrived during Ashton's lifetime and has continued until the present. An authentic French teacher was Berthe Mouchette, who taught young women, first in Melbourne through the 1880s, then in Adelaide from 1892. The Italian-trained Anthony Dattilo Rubbo arrived in Sydney in 1897 and his *atelier* was attended by a generation of devotees of Post-Impressionist technique such as Grace Cossington Smith and Roland Wakelin. In Perth the painter and specialist maker of embossed leather and silver objects J. W. R. Linton set up the Linton School of Art in 1899, but in 1902 was offered a position at the Perth Technical School, where he was responsible for the early training of some significant Western Australian artists, including Kathleen O'Connor.

more apt to see themselves as working in exile or, at the very least, at a considerable remove from the places they considered the centres of culture. In the 1870s the situation began to change. There was a new professional footing for art training in Australia. In 1870 the National Gallery School in Melbourne was established and then, in 1875, the school of the New South Wales Academy of Art was set up under the direction of two sculptors, Giulio Anivitti (1850–81) and Achille Simonetti (1838–1900). A decade earlier a School of Design had been established in South Australia, and was put on a new footing in 1892 when it came under the control of the Board responsible for the Art Gallery of South Australia. In addition to these schools, artists' societies and artists offered private tuition.

While their teachers were inevitably overseas-trained artists, the students who took advantage of art training were often Australian-born, or they had emigrated as children or young people. Such students harboured no acute nostalgia for the northern hemisphere. Many of them recognized Louis Buvelot, in particular, for his truthful rendition of the Australian bush. Perhaps the first to see Buvelot in this light was the Melbourne *Herald* critic who wrote in 1872 that 'the names of Buvelot and von Guérard stand side by side, and … they will remain the founders of our school of landscape painters', and went on to proclaim Buvelot's pre-eminence as the only one of these 'pioneer artists' to have achieved mastery of the character of the Australian landscape.[3] Tom Roberts was much later to sum up the feelings of many artists that Buvelot 'began the real painting of Australia'.[4]

Tom Roberts and the artists' camps

Tom Roberts was the most significant figure in Australian art in the 1880s. He was born in England and came to Melbourne aged 13. He

43 Tom Roberts

Allegro con brio, Bourke Street West, 1885–6
The view from a city building on to the hot and dusty street below was a completely original view of urban Australia. The historian Humphrey Macqueen has pointed out the significant detail in the centre of the composition—the cart bearing the words ICE: 'That notice contrasts with the glare from the road, sky and buildings on the south.'

served an initial apprenticeship as a photographer's assistant, then went on to become one of the success stories of the recently established National Gallery School. In 1881 he left Australia for 4 years' study in London at the Royal Academy Schools, and travelled on the Continent, where his crisp high-toned style found conducive subjects in the Spanish light. On his return to Australia in 1885, Roberts set up a studio in the centre of Melbourne, from which he operated a successful portrait-painting practice. In addition, Roberts began regularly painting out of doors [**43**]. With fellow painters Frederick McCubbin (1855–1917) and Louis Abrahams (1852–1903), Roberts set up camp in a bush paddock at Box Hill, a semi-rural area to the east of Melbourne. This camp, which has something of legendary status in the history of Australian art, was recorded in Roberts's evocation *The artists' camp* (1886). In addition to a tent with artists making tea, the painting includes a feature which, while not an entirely new sight in Australian painting, would soon become familiar as artists began to paint regularly out of doors—the oil sketch propped against the tent-pole to dry.

In the summer of 1887 the same group of artists again camped at Box Hill, this time in the company of Arthur Streeton, who was Roberts's junior by 11 years. Roberts had met him painting on a Melbourne beach. In subsequent years the two artists camped at Mentone on the edge of Port Phillip Bay and at Eaglemont, an estate near Heidelberg, where an abandoned homestead building provided a focus for outdoor painting. When Tom Roberts visited Sydney in 1888, he met the young English illustrator Charles Conder (1868–1909), who had arrived in Sydney in 1884. The two artists painted side by side at Sydney's Coogee Beach. When Conder moved to Melbourne later that year, the principal trio of the Heidelberg School was established. Over the next two years—until Conder's return to England early in 1890—Roberts, Streeton, and Conder frequently painted together; they were years of youthful enterprise for which Streeton, in particular, was to harbour an intense and lifelong nostalgia.

The '9 by 5 Impression Exhibition'

The defining event of the careers of these artists was the '9 by 5 Impression Exhibition', mounted in Melbourne in 1889. Seven artists' work was included in the exhibition—Roberts, Streeton, and Conder between them contributed almost all of the 182 works; there were minor contributions from McCubbin, the sculptor Charles Douglas Richardson and two obscurities, R. E. Falls and Herbert Daly. The exhibition consisted almost entirely of 'impressions', many painted on cedar panels. Conder's *Impressionists' camp* [**44**] is a typical '9 by 5' painting: it is an informal, unforced impression, celebrating the simple camaraderie of shared painting experiences.

The aims of the exhibition were clearly set out in the catalogue. Its cover, designed by Conder, shows a woman from whose naked torso the bands of Convention slowly unwind and drift upwards into blossom-laden branches. Inside a statement headed 'To The Public' was printed:

An Effect is only momentary: so an impressionist tries to find his place. Two half-hours are never alike, and he who tries to paint a sunset on two successive evenings, must be more or less painting from memory. So, in these works, it has been the object of the artist to render faithfully, and thus obtain first records of effects widely differing, and often of a very fleeting character.

The exhibition based its claims on naturalism, but as knowledgeable commentators recognized at the time, this naturalism was tempered with an admiration for the high priest of artifice, the American/English artist James McNeill Whistler. Whistlerian attitudes are discernible in many of the titles of the 9 by 5s, and in the way in which Buxton's Rooms were transformed into an aesthetic *salon* for the occasion of the exhibition. The deliberately polemical nature of the exhibition was also in accord with the type of public statement favoured by Whistler. Indeed, the exhibition reveals the combination of naturalism and artificiality which lies at the heart of the Heidelberg painters' work, a contradiction which accounts for the best (and sometimes the worst) qualities of the work of Roberts, Streeton, and Conder. The artists themselves were conscious of their position as proponents of naturalism from within a highly artificial milieu, as is shown in their jointly penned reply to James Smith's scathing attack on the exhibition in the *Argus* newspaper: 'For the question comes, how much do we see, and how much are our ideas and judgements of works made up by comparing with those we have already known, cared for, and are familiar with?'[5]

The highly constructed nature of the work of the Heidelberg

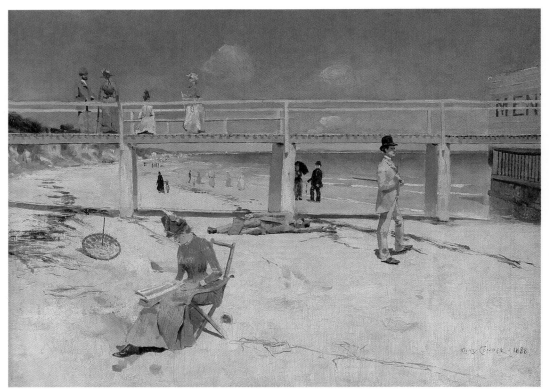

45 Charles Conder

A holiday at Mentone, 1888

Mentone, a bayside suburb of Melbourne, like Coogee in Sydney, was a favourite spot for holiday enjoyment and a favourite painting locality for the artists of the Heidelberg School. The 20-year-old Conder painted this Japanese-inspired composition of the beach and the footbridge leading to the swimming baths shortly after his arrival in Melbourne from Sydney.

School painters is exemplified in the best painting in the patchy *œuvre* of Charles Conder, *A holiday at Mentone*, painted late in 1888 [**45**]. In this high-toned work Conder succeeded brilliantly in suggesting the dazzle of an Australian beach in summer. In general, however, Conder's work showed the least naturalism of any of the outdoor painters of the 1880s; he had a feeling for trivia and used the bush and the seaside as the settings for quaint little human dramas. More than one writer has noted the stage-set quality of his Mentone painting; the viewer almost expects witty dialogue to break out at any moment.[6] There is a self-consciously Japanese quality to the composition. So taken by artifice, it is no surprise that after Conder left Australia in 1890 he charged with cocked top-hat into bohemian London and demonstrated to the full his preference for decorative paintings and lithographs, and a love of the life of Paris.

Heroic subjects

The struggle between empiricism and the demands of picture-making which is handled with such grace in Conder's painting is manifest in Arthur Streeton's large-scale and more grandly ambitious work *Golden Summer, Eaglemont* painted in 1889 [**46**]. This work derived from a small study (included in the '9 by 5 Impression Exhibition'), which comprised simple smears of buttery paint on a small canvas.[7] The more

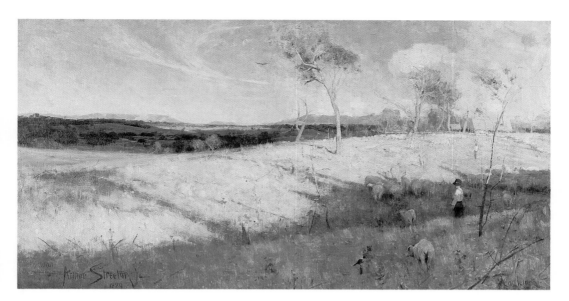

46 Arthur Streeton

Golden Summer, Eaglemont, 1889

The most ambitious composition to result from the painting camps at Eaglemont, this work was a great success for the young Streeton. When it was first exhibited in Melbourne in May 1889 it was recognized as an empathetic and idealized landscape; in 1891 it became the first painting by an Australian-born artist to be hung in the Royal Academy in London, and it went on to receive a *mention honorable* at the Paris Salon of 1892.

thoroughly worked-over surface of the larger work is a testament to Streeton's struggle to maintain the force of his original impression.

But it is in '*Fire's on*' (1891), another large work, that Streeton's lyricism finds its most powerful expression [**47**]. '*Fire's on*' was a subject which came to him accidentally as he was searching for suitable painting sites in the Blue Mountains. ('I look up and down at my subject; is it worth painting?' he wondered in a letter to Roberts.) The painting succeeds in conveying the impression of heat and brilliant light which Streeton recorded in his letters as the work was being painted.[8] Yet despite its impressive scale and its brightness, it is not garish, or a particularly optimistic painting, for it has at its heart the tragedy of a dead man being taken from the half-blasted tunnel. Streeton laboured on the painting over many weeks at the tunnel site. The nuances of colour and light he was able to record in this setting for human events endow the work with a truthful quality which he was never able to achieve in any subsequent work.

Streeton moved to Sydney in 1891, probably feeling that its art-world held out greater possibilities, and there followed his Melbourne practice of camping out to paint. The harbour and coastal beaches offered him delightful painting-spots for small-scale sketches and the occasional large canvas. On the Hawkesbury River to the west of Sydney, Streeton painted delicately coloured paintings in which he looked very closely at the subtle relationships of colour and tone in the landscape. One of the finest works to result was a sweeping view of the river which Streeton gave the grandiose title (from Shelley) '*The purple noon's transparent might*' (1896). But his paintings were beginning to exhibit an easy technical proficiency which eventually led him away from paying close attention to the subtleties of nature. Only on rare

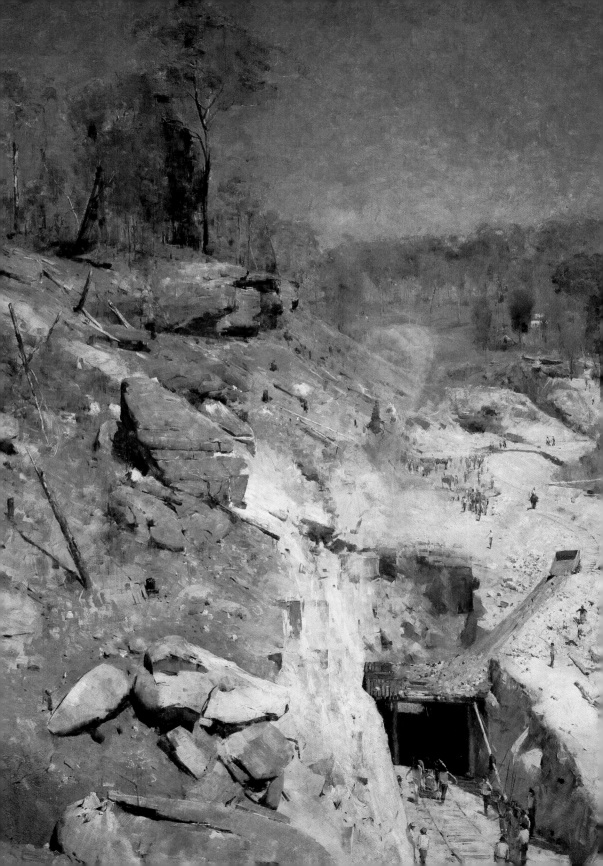

occasions did he succeed in realizing the vision which he intended to capture when he wrote to Roberts in a burst of poetic enthusiasm worthy of Walt Whitman: 'I fancy large canvasses all glowing & moving in the happy light & others bright decorate & chalky & expressive of the hot drying winds & the slow immense Summer ...'.[9]

Streeton differed from his fellow painters in the fundamental simplicity of his subjects. He painted a number of 'pastorals', and this genre was, for him, sufficient to sustain even the large-scale painting of which he dreamt. The older artists of his circle, Frederick McCubbin and Tom Roberts, whose practice was figure-based, looked for a deeper engagement with the Australian landscape than one based on emotion or on sentimental attachment: both of these artists produced their greatest paintings when they sought the stories which gave cultural meaning to particular landscapes. This is particularly true of Frederick McCubbin. The first work in which he achieved a wholly satisfactory merging of figure and setting was *Lost*, painted in 1886 [**48**]. The work depicts a child engulfed in the sapling scrub, and was painted in the suburban bush-blocks of Box Hill, where McCubbin was later to find settings for his other tableaux of bush-life pathos, *Down on his luck* (1889) and *A bush burial* (1890).

As painters of bush life, it is not surprising that McCubbin and Roberts were singled out for mention by the American critic Sidney Dickinson in his appraisal of the contemporary art of Australia. Dickinson, who lived in Australia briefly in the late 1880s, proposed influential views to meetings in Melbourne art circles. In his 1890 essay entitled 'What should Australian artists paint?', he argued that it should be the ambition of Australian artists to 'present on canvas the earnestness, rigour, pathos, and heroism of the life that is about them'.[10] He encouraged those artists who had made 'some efforts in this direction' not to be discouraged by indifference or by outspoken criticism. He was probably thinking of the defence Tom Roberts was compelled to mount for his major painting *Shearing the rams* when it was displayed in Melbourne in May 1890. The painting was generally well received, but some in more conservative circles failed to understand it—or, rather, failed to agree with Roberts's belief that 'by making art the perfect expression of one time and one place, it becomes art for all times and all places'.[11]

Shearing the rams was the most complete expression of Roberts's fascination with the subject of shearers working in the woolsheds of the great pastoral holdings in New South Wales and Victoria. In 1888 he had begun to make studies at Brocklesby Station in the pastoral district of Corowa, which, after another season of work and careful planning, culminated in the large shearing composition. Although landscape appears to play only a marginal part in *Shearing the rams*, Roberts was intensely conscious of the connectedness of his subject to the pastoral landscape. He knew that a painting can only encompass one image, and could never, like the written word, evoke a whole environment. He was one of the few artists of his generation to recognize this crucial difference. However, in 1895, Roberts succeeded in combining Australian bush settings with moments of historical narrative. In the largest and best-known of a series of paintings made at Inverell in northern New South Wales, *Bailed up*, the drama of a coach hold-up has been carefully staged for the viewer's benefit.[12] *In a corner on the Macintyre* [49] reveals its subject to the viewer more slowly.[13] As the eye investigates the detail of the work, the figure of a bushranger is discovered crouching behind a rock, and, in the middle distance, two tiny plumes of gunsmoke. But this shoot-out never threatens to become the focus of the painting. It does not detract from the lightness of touch with which Roberts's drying brush described the subtle nuances of the rock face, figuring each pink blush and blue-tinted crack.

In a corner on the Macintyre is a fascinating example of the artist endowing the landscape with historical resonance. It was painted at a time when European Australia was most actively celebrating its history, from a viewpoint which excluded a contemporary recognition

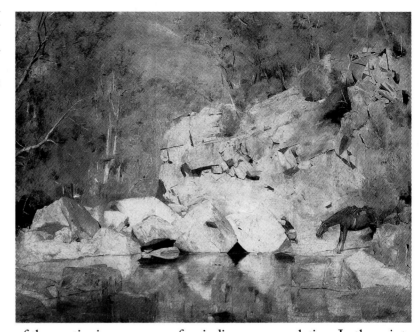

of the continuing presence of an indigenous population. In the paint-
ing of the period Aborigines were never the subject of large-scale cele-
brations of history within the landscape. Roberts painted a few small
portraits of Aboriginal people and a newspaper appraisal of one of
these works (a head of the Corowa man Charlie Turner) predicted,
typically, that 'its value will grow year by year with the gradual
disappearance from our midst of the original possessor of the soil'.[14] A
similar message is clearly found in the work of H. J. Johnstone
(1835–1907). His lugubrious paintings of waterholes, the largest of
which is *Evening shadows, Backwater of the Murray, South Australia*,
painted in 1880, included small groups of Aborigines; the melancholy
inferences of departing day are clearly to be read as applying to natives
and nature. Generally, it must be said, there was never a point at which
white artists in Australia were less interested in Aboriginal people than
in the 1880s and 1890s, except perhaps as the butt of cruel humour.

Landscape painting at the end of the nineteenth century

It is possible to discern a number of broad approaches to landscape
emerging in the 1880s and 1890s which carried through into the
twentieth century. Having no regard for indigenous rights to the soil,
and in a context of centennial celebration, artists searched for ways to
depict a relationship between the emigrant people and the natural
landscape. One way to express this relationship was to place recogniz-
able historical types in the landscape—the squatter, the swagman, and
the bushranger; another was to paint rural labour—tree-fellers or
farmer families buried waist deep in grass, tending sheep and beehives;

and a further expression of the relationship was through the use of allegory and symbolism. This last strategy tended to produce rather banal and self-conscious art, such as the attenuated fantasies of Sydney Long (1871–1955). In Long's work the landscape is presented as a stage on which dances and idylls are played out; the bush could be a series of stage flats, painted with stands of art nouveau trees.

A more profound exponent of the aestheticized landscape was David Davies (1864–1939). Davies had studied at the National Gallery of Victoria School and had been a part of the generation of students to be swept away by the pleinairism of McCubbin and Roberts. What distinguished his work from that of his older peers, however, was an influential stint of study and outdoor painting in France and St Ives between 1890 and 1893. On his return to Australia, Davies painted a series of paintings of the moon rising over empty paddocks near his studio in the outer suburb of Templestowe (close to Heidelberg). The largest of these paintings, *Moonrise* (1894), is a subtle field of khaki, ochre, and mauve grass and umbrous weeds [50]. The composition is highly organized: every detail is placed with exquisite care; the proportions of the earth to the thin strip of sky is typical of the Whistler-inspired landscapes of the 1890s. The success of *Moonrise*

50 David Davies

Moonrise, 1894

The subject of the painting was found in Templestowe, an area adjacent to Heidelberg, where the artist lived in the mid-1890s. It is the largest of a series of Templestowe nocturnes Davies painted between 1893 and 1897. It immediately became his most admired painting after it was bought by the National Gallery of Victoria in 1895.

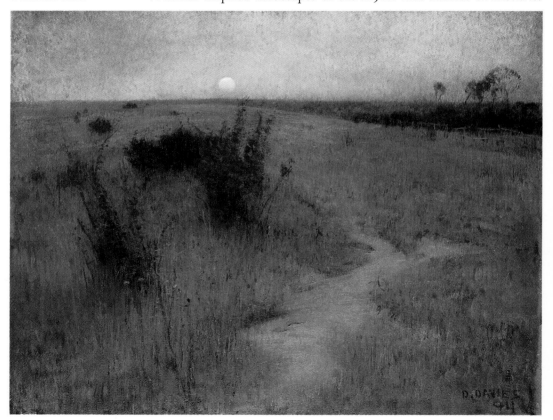

notwithstanding, Davies left Australia permanently in 1897 to work again the picturesque painting-spots of England and France.

A close contemporary of David Davies and fellow student of the School of the National Gallery of Victoria, E. Phillips Fox (1865–1915) also studied and painted in Europe for almost 5 years, between 1887 and 1892. The formal part of his European training took place at the Académie Julian and at the École des Beaux-Arts in Paris, but the more influential elements of his European sojourn (judging from the works exhibited on his return to Melbourne in 1892) were his painting trips to the artists' colonies of St Ives, Le Pouldu in Brittany, and the well-trodden roads around picturesque villages close to Paris.

At the beginning of 1893 Fox established the Melbourne School of Art in collaboration with the rather uninspired painter Tudor St George Tucker, who had also studied in Paris. The majority of the students who studied with Fox and Tucker and who attended their summer schools were women; the predominantly female ambience of the school is the subject of one of Fox's most original compositions, *Art students* of 1895 [**51**]. In this painting Fox has his students working on portraits, yet it was in landscape painting that most of these women continued to make names as painters. Two of the students in Fox's painting are, in some ways, typical. Christina Asquith Baker (1868–1960) was best known for her flower pieces and nocturnes, while Ina Gregory (1874–1964) continued to paint out of doors until well into the twentieth century.[15] As late as 1942, one commentator reviewing Gregory's work found an 'old world charm and grace' which evoked the 'golden age of Eaglemont'.[16]

By the mid-1890s art students were regularly painting outdoors. In 1894 Fox and Tucker took their students to paint at the picturesque property Charterisville on the outskirts of Melbourne. This collection

Australians in Europe 1

Towards the end of the nineteenth century several artists who were to be significant in the history of Australian art travelled to Europe, where they stayed for decades. After establishing his reputation in Australia, Streeton went in London in 1897 and largely remained there until the early 1920s; Roberts, who was born in England, lived there from 1903 to 1923. Roberts's early painting companion John Russell spent some formative years in Australia but his art was centred in France, where he painted in the circle of French Impressionists and Post-Impressionists (including, famously, van Gogh). The brilliant student Rupert Bunny had only modest success in Paris, where he went to study in 1885 and where he lived until his return to Australia in 1933. No Australian artist of his generation achieved the international success of the sculptor Bertram Mackennal, who studied in London in the mid-1880s, and then, finding Australia unable to support significant sculptural practice, returned there in 1891. Mackennal's sculpture was well received and he was regarded highly in English art circles; he became the first Australia-born artist to be elected to the Royal Academy and, in 1921, the first to be knighted.

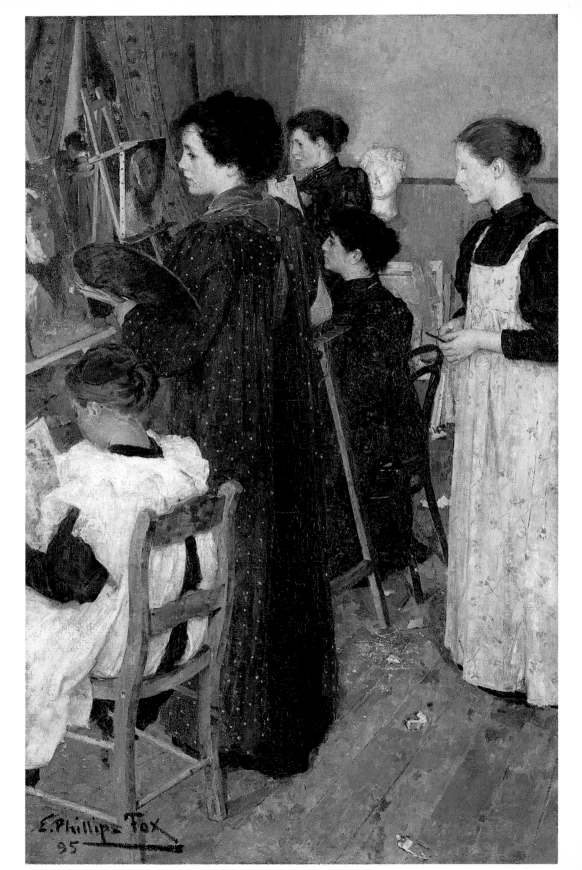

of rural buildings set in an overgrown garden, had originally been set up as an artists' colony by Walter Withers (1854–1913), another Paris-trained pleinairist with a passion for the low-toned and crepuscular. Withers, like Fox and his students in the 1890s, painted the kinds of subjects which were the currency of academicized Impressionism in the northern hemisphere—labourers tending smallholdings, wooden cottages, light effects (particularly evenings and grey twilights), and moonrises. Among the most consistent exponents of such subjects were Jane Sutherland (1855–1928) and Clara Southern (1861–1940) **[52]**. The latter artist was completely at home for the remainder of her career painting the bush around Warrandyte, an area to the north of Melbourne which she described as a landscape worthy of Corot (late Corot, naturally—soft, grey, and gentle).[17]

Photography at the end of the nineteenth century

The history of painting in Australia is inevitably linked to the histories of photography and printmaking, but the relationship is a complex one. Many painters were involved with photography: Louis Buvelot, for example, began his Australian career in 1865 as a portrait photographer, H. J. Johnstone was a highly successful portrait photographer, and Tom Roberts started out as a photographer's assistant. With the possible exception of H. J. Johnstone, whose style was flat and 'photographic', it is not easy to discover any profound empirical use of the medium in the work of these landscape painters, such as can be discovered in the work of, say, the American artist Thomas Eakins.

In the last decades of the nineteenth century a number of Australian photographers specialized in subjects that have much in common with the viewpoints of their contemporary painters. Bush pioneers were found in photographs as often as they appeared in paintings, and the

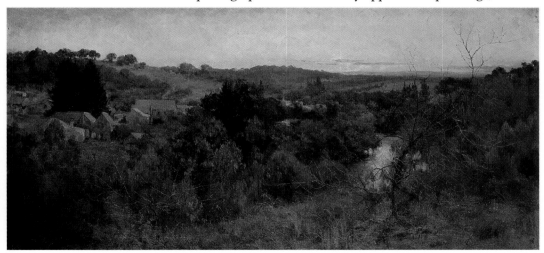

picturesque spots beloved of picnickers were the settings for staged photographs as well as staged paintings. However, there were certain purposes (such as ethnographical and expeditionary recording) which photography continued to serve long after such subjects had ceased to be of interest to audiences for painting.

The interests of painting and photography were brought together in the artists' camp which was set up in Grose Valley in the Blue Mountains in 1875 by the minor artist but significant art patron Eccleston du Faur.[18] The 1875 camp included the photographers Joseph Bischoff and Alexander Brodie, and the landscape painter W. C. Piguenit (1836–1914), whose grand paintings of wilderness scenery in Tasmania were greatly admired. Du Faur's intention was to demonstrate the grandeur of Australia's wilderness landscapes and encourage tourism to the more remote forested areas of the Blue Mountains. It

appears, however, that he was disappointed in the photographic results.

By the time Nicholas Caire (1837–1918) and J. W. Lindt (1845–1926) had established themselves as Victoria's leading producers of photographic views, the awe-inspiring visions of wilderness of which Bischoff and Piguenit were exponents had given way to a taste for a more intimate landscape of beauty spots and picturesque corners. Caire and Lindt had careers which were remarkably similar, Caire having begun as a hairdresser in rural Victoria and Lindt as a country piano-tuner and travelling portrait-photographer in northern New South Wales (see Chapter 4). Having successfully taken up view photography, both eventually gravitated towards the lucrative market in Melbourne.[19]

By 1876, when he set up a studio in Melbourne, Caire had a substantial stock of subjects taken throughout Victoria. After settling in Melbourne, he began to work in the mountainous areas to the east of the city, particularly around Marysville and Healesville, which had long been attracting tourists, not on account of spectacular views but for their rainforest scenery [53]. Caire's enthusiasm for the area was shared by Lindt who, in 1894, bought a tract of forest on Black's Spur and built a tourist chalet there—the Hermitage—complete with gardens and walking-tracks through the forest. There can be no more direct demonstration of the links between photographic view-making and tourism than Lindt's Hermitage. In 1904 Caire and Lindt collaborated on an illustrated guidebook describing the beauties of the Black's Spur and Healesville district.

Caire was also deeply interested in the giant trees which grew in Victoria's mountains. During the 1880s he searched them out and photographed them, and in the early years of the twentieth century, when they were being progressively destroyed by logging, bushfires, and storms, he wrote articles lamenting their disappearance. In 1887 he travelled through Gippsland and photographed small farms carved out of the forests of immense trees. His photograph of a huge stump with a weatherboard cottage nestling against it, which he entitled *The tree and the house built out of it*, graphically portrays the transformation of the forest landscape.

Reflecting historical themes portrayed by contemporary painters, Caire and Lindt photographed picturesque bush characters—swagmen, timber-getters, bee-keepers, and gentlemen campers. Yet while Caire and Lindt worked with subjects closely allied to painting, they also worked in some fields which were still largely the preserve of photographers. Both photographers followed the earlier precedent set by Charles Walter and Fred Kruger, and went to photograph the Aboriginal settlements of Coranderrk and Lake Tyers, recording the mix of agricultural and traditional pursuits which were carried on there. Lindt, who had earlier made a series of portraits of Aboriginal

people of the north coast of New South Wales, continued to work in the field when he was appointed as photographer for a government expedition to New Guinea in 1885. Lindt's New Guinea photographs were considered in his day to have been his greatest works, and today they remain remarkable specimens of photography and of vivid portraiture.

Whilst the market for picturesque views was dominated in Victoria by Caire and Lindt, in Sydney by the phenomenally successful Charles Kerry (1858–1928), and in Hobart by J. W. Beattie (1859–1930), many photographic businesses continued to rely on portraiture as a staple. Among the most interesting portrait-photographers working in Australia was H. Walter Barnett (1862–1934), who was intimately associated with the painters Tom Roberts, Arthur Streeton, and Charles Conder. Like these painters, Barnett concentrated his activity between Sydney and Melbourne, where he set up the fantastically lucrative portrait salons Falk Studios. Barnett not only photographed many of the subjects who sat for Roberts's paintings, such as the grizzled Sir Henry Parkes and the elegant Brasch sisters; he also provided patronage and guidance to the Heidelberg School painters. Barnett left Australia in 1896, at the same time as Streeton, to seek success in London. Whereas Streeton's success in the larger pond of Edwardian Britain must be regarded as limited, Barnett was able to build on his Australian success, almost overnight becoming one of the leading society portrait-photographers in London.

'Beautifying the objects of our daily life': Art and Decorative Art 1890–1920

6

The decorative arts

It is not possible to understand the shape of Australian art by looking at easel painting alone. This is particularly true of the decades around the turn of the twentieth century when the most interesting Australian art was found among a great range of fundamentally decorative mediums—watercolours, pastels, prints, ceramics, posters, and other species of decorative art, such as miniatures and paintings in the shape of fans. Painting itself came to be viewed at this time in the context of wider decorative schemes. The situation was neatly summed up in 1909 by the illustrator D. H. Souter in Australia's arts and crafts journal *Art and Architecture*: 'A picture is now a definite portion of the decoration, occupying a particular place in the design, and fulfilling a particular purpose.'[1]

In the same journal, in the following year the artist Alice Muskett wrote: 'There are far too many pictures painted, it seems to me ... it is a thousand pities this same energy and talent is not put into applied art of some kind.'[2] The turn-of-the-century ascendancy of the decorative arts lasted at least until the 1920s; the decorative and applied arts enjoyed a remarkable prominence in art exhibitions and respect in the art press. This democracy of art forms was an Australian manifestation of the English Arts and Crafts movement and was sustained by the most influential art journal of the period, *The Studio*, which was published in London from 1893 and widely read in Australia. Although much Edwardian art in Australia conforms to the gently art nouveau aesthetic of *The Studio*, an emphasis on the vernacular and the local led Australian designers to employ distinctive and recognizably Australian motifs in their work.

Detail of 59

Aboriginal art of northern Australia

One long-term consequence of the emphasis placed on the decorative arts at the end of the century was the possibility of a new appreciation of indigenous art forms among non-indigenous people in Australia. Whilst the basis of ceremonial indigenous visual expression was little understood in the wider community, there was a developing appreciation of the applied and decorative arts of Aboriginal and Torres Strait Islander peoples. This was in evidence at reserves and missions such as Coranderrk and Raukkan during the latter part of the century, where traditional artefacts, rugs, and, particularly, baskets were manufactured and sold. It was also strongly present in the objects collected for preservation by museums. Such pieces as the distinctive northern Queensland bicornual baskets [54] were highly regarded by collectors on account of their superb and complex artistry. The collections of the major anthropological researchers in more remote areas of Australia also reflected this appreciation of the decorative arts. The two collectors whose interest was strongest in this regard were also pioneers

54 Cardwell district, Queensland

Bicornual basket, before 1899
Such distinctive bicornual baskets were made only by the people of the rainforest in northern Queensland. The baskets are woven of split lawyer-cane and decorated with geometric patterns in ochres. Many examples preserved in museums have lost colour and the carrying strip, but have retained the elegance of form which has made them widely admired among the many styles of indigenous basketry.

of the modern discipline of anthropology—W. Baldwin Spencer (1860–1929) and A. C. Haddon (1855–1940).

Baldwin Spencer was one of the most powerful voices in Australian art in early twentieth-century Australia. Professor of Zoology at the University of Melbourne, Spencer was honorary director of the Museum of Victoria from 1899 and a longstanding Trustee of the National Gallery of Victoria. At the turn of the century Spencer was engaged in a pioneering study of the culture of the Aboriginal people of central Australia.

In his appreciation of the visual arts, Spencer was a man of his times. He once declared David Davies's *Moonrise* 1894 [**50**] to be probably the best landscape ever to be painted in Australia, and his substantial personal collection demonstrated a particular affection for the works of Arthur Streeton, Hans Heysen, and Norman Lindsay.[3] Yet he was also responsible for amassing—for the Museum—the largest and most important collection of Aboriginal art before the 1940s.[4] Spencer saw the collection of Aboriginal art he made for the Museum in a different light from his own collection of oil paintings. Yet he applied aesthetic judgements to both collections and was satisfied that the works of Aboriginal art that he collected were regarded as 'first-rate examples of first-rate artists'.[5]

Baldwin Spencer undertook several extensive trips to central and northern Australia. In the course of his fieldwork in central Australia, Spencer had as a guide an artist, Erlykilyika (Jimmy Kite), who made drawings and later carved small sculptures and tobacco pipes from gypsum. But Spencer's deepest engagement with indigenous artists came during his journeys in northern Australia. In mid-1911 he was in Darwin as a prelude to a year-long assignment in the Northern Territory, which included a brief to study and administer Aboriginal policy. In 1911 and again in March 1912 he spent time among the Tiwi people on Melville Island, off the coast of Arnhem Land, and later visited Bathurst Island. In addition to making extensive notes and some pioneering ethnographic films, he put together a large collection of objects for the Museum of Victoria. Spencer's 1914 book, *Native Tribes of the Northern Territory of Australia*, devotes an entire chapter to 'Decorative Art', comprising a close discussion of Tiwi mourning regalia and body-painting, bags and baskets, decorated graveposts, and weapons.

The bark basket from Melville Island illustrated here was one of scores of such baskets which Spencer collected for his museum [**55**]. He was fascinated by the distinctive qualities of Tiwi art which had developed as a result of the isolation of Bathurst and Melville Islands from the mainland. Spencer described Tiwi baskets as possessing 'the most striking and original decorative schemes'.[6] While admiring their decorative qualities, though, Spencer was aware that such baskets are

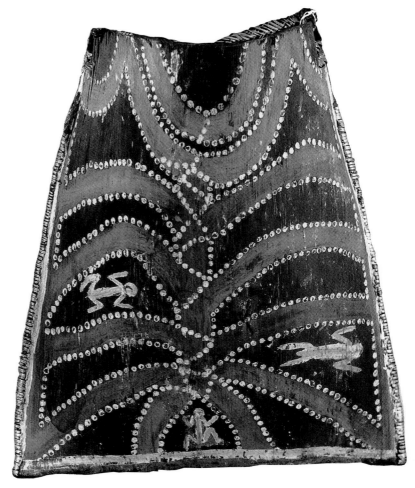

not merely functional, but possess a ceremonial dimension—they are made as part of the distinctive Tiwi *pukamani* mortuary ceremonies. These ceremonies also involve the making of carved and elaborately decorated graveposts, examples of which Spencer collected to show their extraordinary variety of form and decoration. His recognition of the visual interest of the Tiwi graveposts had echoes later in the century when, in 1958, the Sydney artist and curator Tony Tuckson visited Melville Island with Dr Stuart Scougall and commissioned a set of graveposts for the collection of the Art Gallery of New South Wales [111] (discussed in Chapter 10).

In July of 1912, Spencer spent time away from his duties in Darwin visiting Oenpelli in Arnhem Land. The results of this visit were additions to his own considerable photographic record, an example of which [56] demonstrates his skill and artistry as a photographer. But of greater significance was the beginning of a remarkable and immensely significant collection of bark-paintings. Spencer was captivated by the

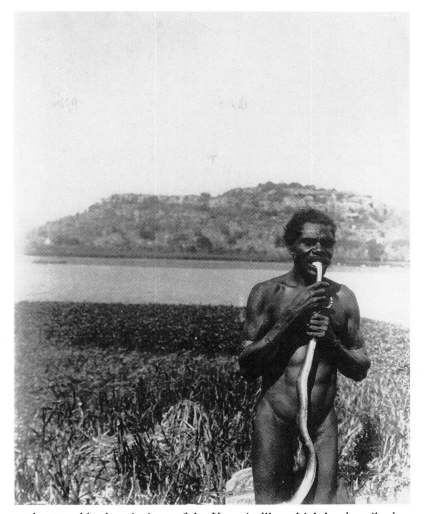

56 Baldwin Spencer

Kakadu man killing a water snake, 1912

In addition to his pioneering role as an anthropological researcher, Baldwin Spencer was an excellent photographer. This beautifully composed yet striking image was captured at the East Alligator River in Arnhem Land after a non-venomous water-snake had been speared and its backbone dislocated—'a very original way of killing snakes of which I had heard, but was rather sceptical about, until I saw the Kakadu men actually at work'.

rock art and bark-paintings of the Kunwindjku which he described as 'among the most highly developed and interesting' of any Aboriginal art. Having begun to stimulate production of paintings by local Gagadju artists, Spencer mused, 'If I could get a hundred or two they would make a fine show in the Atheneum Hall—a good deal more interesting than most of the Victorian Artists exhibitions'.[7] Although his statement has a ring of irony, Spencer did initiate a collection which grew to over 200 bark-paintings (now in the Museum of Victoria) and recorded a great deal of precise iconographical information from their creators.

The bark-paintings range from apparently straightforward depictions of wetlands water-snakes through characteristic representations of spirit-beings [**57**] to hunting subjects [**58**]. The bark-painting of a spirit-figure (*mimi*) spearing a kangaroo became one of the most widely reproduced objects of Aboriginal art in the twentieth century.

57 Gagadju, Arnhem Land

Bark-painting, 1912

This bark-painting was one of the large collection made by Baldwin Spencer in Oenpelli. He was told that the painting depicts the spirit-being 'named Yungwalia', who inhabits the caves in the Ranges. Tall and thin, the figure carries a club in his right hand and a bunch of feathers in his left.

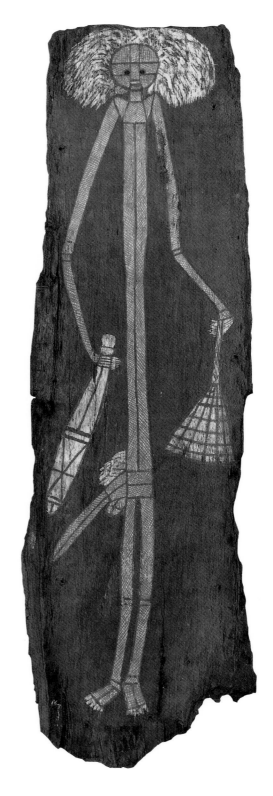

58 Gagadju, Arnhem Land

Bark-painting, 1912

This painting on bark was collected by Baldwin Spencer in Arnhem Land. The notes the anthropologist made at the time indicate that the kangaroo depicted, Madjiborla, is a rare black kangaroo found in the hills near Oenpelli. The hunter has around his neck a bag filled with the honeycomb he had been collecting when he came upon the kangaroo.

This work was widely reproduced in the early years of the twentieth century as a characteristic example of Aboriginal bark-painting.

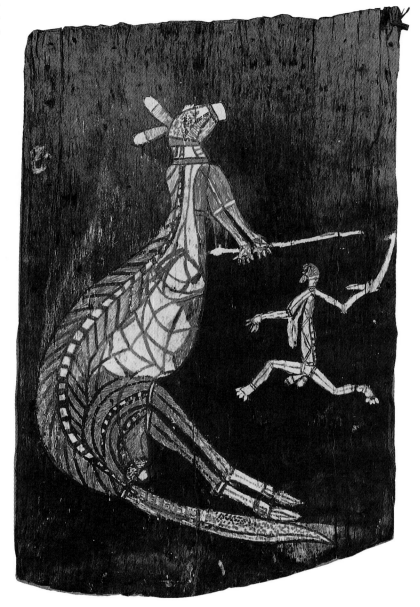

The painting, with its 'X-ray' depiction of the kangaroo, relates closely to Kunwindjku rock-art traditions, which were recognized but not extensively recorded by Spencer.

A. C. Haddon's expeditions to the Torres Strait Islands were similarly extensive and resulted in large and detailed museum collections. Haddon, like Spencer, was a biologist by profession and it was in that capacity that he first visited the Torres Strait in 1888–9. By the 1890s, however, Haddon's interests were firmly anthropological and, under the aegis of Cambridge University, he set up a field study and collecting

expedition to the islands in 1898. An entire volume of the massive six-volume study which resulted from Haddon's expedition is devoted to the arts and crafts and, as Haddon explained,

> The artistic sense of a people is exhibited alike in the forms of objects, the designs employed, and the scheme of decoration … On looking at a large number of artifacts it is evident that the [Torres Strait Islanders] have a decided feeling for form … The technical skill and sense of contour and proportion exhibited by such objects as the dugong harpoon are of no mean order when we bear in mind the tools with which they were created.[8]

Among the many distinctive forms of Torres Strait Islander art to fascinate Haddon and to be sought after by collectors the world over were the elegant decorated drums to which he referred and the elaborate dance-masks used in ceremonies. By the time Haddon made his in-depth study of the decorative arts of the Torres Strait, numerous examples of dance-masks could be found in museum collections all over Europe. The example of a turtleshell mask illustrated here [59] is typical of these ornate and spectacular pieces.

Two artist families: the Boyds and the Lindsays

The diversity of the Australian art-world of the early twentieth century, and the variety of its means of expression, is exemplified by the work of two clans of artists—the Boyds and the Lindsays. Members of both these very different families were to have a profound impact on the history of Australian art. The Boyd family (more a dynasty than a family) was prominent in Australian art circles from the 1880s when Emma Minnie Boyd (1858–1936) and her husband Arthur Merric Boyd (1862–1940) began regularly to exhibit watercolours in Melbourne and in England. The remarkable offspring of this marriage included the potter Merric Boyd (1888–1959), the painter Penleigh Boyd (1890–1923), and the writer Martin Boyd (1893–1972).

A superb example of the distinctive Torres Strait Island dance-mask from the island of Mabuiag, collected by the missionary Samuel McFarlane in the 1870s or 1880s. Many Torres Strait Island dance-masks combine animal and human heads; this mask probably originally had a representation of a shark's jaw along the lower edge.

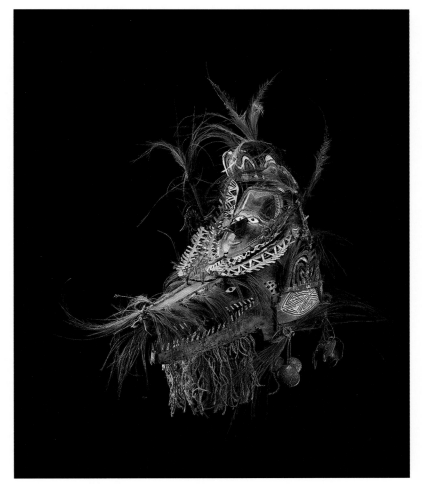

Whereas the work of Emma Minnie Boyd and Arthur Merric Boyd consisted for the most part of genteel interiors and outdoor watercolour sketches, the work of Merric Boyd was utterly distinctive and personal. In 1910 Merric Boyd decided to establish himself as a potter. This was completely novel in 1910, since until that time there existed no tradition of studio pottery in Australia. Much of what he learnt in the early years of experimentation he derived from trial and error and from working with commercial ceramic kilns, yet the style he developed around 1915 was far from the smooth blandness of commercial crockery.

Merric Boyd's career as a potter encompassed some 40 years of production. Many of his ceramics were decorated with landscape details by his wife, Doris, but the characteristic shapes of Boyd's pots were an organic extension of one of the most pervasive motifs in Australia in the Edwardian period—the clump of gnarled ti-trees against a bright landscape. (Ti-trees are the common beach and head-land trees around southern Australia.) It was a favourite subject in his

parents' watercolours. In Merric Boyd's jugs, wind-sculpted tree trunks become handles and clumps of foliage sweep around the surface of the vessels [**60**]. By the 1920s he had further developed a distinctive double-walled form in which gum trees form an elaborate lattice enclosing an interior vase. In the 1930s koalas began to inhabit these forest thickets, sculpted as knobs and handles. These flora and fauna subjects were more to Merric Boyd than superficially attractive decoration; they project the deep affection for the natural world which pervaded his life and which carried through into the many thousands of drawings he made in his last years, when ill-health forced him to abandon making pots.

Merric Boyd's brother Penleigh revealed the same sensitivity to nature in his best paintings. Penleigh was precocious, mounting successful exhibitions soon after his graduation from the National Gallery School, and his gentle landscapes were again popular in the aftermath of the First World War, in which he served on the Western Front. Boyd was a painter of singular motifs—a lone sapling, or massed wattle blossoms reflected in the waters of the Yarra River. The purchase of one of these wattle paintings, *The Breath of Spring*, by the National Gallery of Victoria in 1919 ensured that it would become his best-known painting, yet the restraint and simplicity of his winter landscapes demonstrate a greater sense of subtlety and evocation of mood. Penleigh Boyd's career was cut short by his death in a motor accident in 1923.

The other artist family of multifarious talent which emerged in the early twentieth century was the Lindsays of Creswick. The siblings Percy (1870–1952), Lionel (1874–1961), Norman (1879–1969), Ruby (1887–1919), and Daryl (1889–1976) all became professional artists working across a range of mediums. (Daryl was the least interesting as a painter but was an important director of the National Gallery of Victoria from 1941 until 1955.) The basis of the Lindsays' art was the tradition of 'black & white'—drawing for illustration. This is particularly true of the three most significant artists in the family—Norman, Lionel, and Ruby.

Lionel Lindsay began to make a living from illustration when he moved into Melbourne in 1893. Norman joined Lionel in 1895 and with the musician and artist Ernest Moffitt (1871–99) and the Dyson brothers, Will and Ted, they threw themselves into a lifestyle of Bohemian high spirits and a kind of amateur theatrical fantasy. They acted out and photographed absurd tableaux in the backyard at Creswick and dreamed of an Australian Arcadia—the bush inhabited by sun-tanned fauns and grinning nymphs. In the Lindsays' imagination pagan Greece and Rome were an idealized alternative to the Christian world. They harboured a deep and outspoken antipathy towards Christianity, which they considered a deadening and destructive force.

The Lindsays' fantasies were initially expressed in pen-and-ink drawings and it is not surprising that the brothers were soon taken up as illustrators and commercial artists. Their ultimate aspiration was to create high-quality illustrated books. They worked towards that end while at the same time earning a living from providing illustrations for, among others, *The Bulletin* and *The Lone Hand*. From 1906 Ruby Lindsay also had a career as an illustrator for these journals and for other titles which sprang up in the early years of the century, such as C. J. Dennis's *Gadfly*.

Illustration and 'black and white' art

Many Australian artists of the late nineteenth and early twentieth centuries began their careers as illustrators, and often continued to make regular income from illustration while pursuing careers as painters. A plethora of papers illustrated with wood-engravings, such as *The Illustrated Sydney News* (1853–94) and *The Australasian Sketcher* (1873–89), were a useful source of stable income for artists in the latter part of the century. Several significant Australian artists (including Julian Ashton, A. H. Fullwood, and the flower-painter Ellis Rowan) joined a group of American illustrators in the most ambitious illustrated publication of the 1880s, *The Picturesque Atlas of Australasia* (1886–9). J. F. Archibald's long-running paper *The Bulletin* (founded in 1880) placed heavy emphasis on illustration and was the vehicle which launched the cartooning careers of Phil May and 'Hop' (Livingston Hopkins). Many other artists—including George Lambert, the Lindsays, and the suave linearist D. H. Souter—provided high-quality 'black & white' art for this journal and its offshoot *The Lone Hand* (1907–21).

Although Lionel Lindsay often dismissed magazine illustration as 'hackwork', he professed a high regard for pen-and-ink work as an art form. Perhaps the natural outcome of this combination of interests was printmaking: Lionel began to experiment with woodcuts and etching around the end of the 1890s and by the 1920s both he and Norman had developed a high technical proficiency.

Lionel Lindsay's activity as a printmaker must be seen in the context of an enthusiasm for artists' prints which developed from the 1880s onwards and which centred around etching. His earliest etchings to elicit widespread admiration were views of Old Sydney; they continued a taste for the tumbledown aspects of Georgian Sydney (particularly that part which survived in the Rocks area) which had developed in the 1890s. The vogue for this kind of subject was really a late survival of the eighteenth-century Picturesque. In the Australian context the taste developed along with the sense of historical satisfaction which coincided with the centenary of European settlement. Etchers in the southern states also worked up Old Melbourne and Old Hobart themes.

The Old Sydney theme very quickly became a cliché. It can be seen as a nostalgic reaction to the alarming pace of urbanization, an attitude in keeping with Lionel Lindsay's increasingly strident antagonism to modernity in art and life (which eventually resulted in his shrill attack on modern art, *Addled Art*, published in 1942). Despite the fact that over half of the subjects in Lindsay's considerable *œuvre* of prints are Old Sydney subjects, his most original works are the fine wood-engravings of the 1920s. These prints had all the ingredients to prove popular with fine-print connoisseurs—technical mastery applied to decorative subjects.

Norman Lindsay's retreat into a fantasy world was more complete than Lionel's. In fact there has never been an artist in Australia whose work has been more obsessively devoted to the repetitious depiction of a completely imaginary world. In 1902 the public glimpsed that world when Norman Lindsay began to exhibit virtuoso pen-and-ink draw-ings in Sydney. In 1904 he caused the first of many scandals when he exhibited a large and elaborately finished drawing, *Pollice verso*, in which a writhing bacchanal of nude Romans give the thumbs down to a scrawny figure hung on a cross [**61**].

Pollice verso established the pattern of Lindsay's work until well into the twentieth century. Its crude polemicism was to be a characteristic of the theories of Art and Life which he was to spout in the 1920s; its overladen composition was a projection of his obsessiveness. And its reception confirmed in his mind the delusion that he was among the 'heirs to the ancient world'.[9] As early as 1901 he dreamed that his 'hairy satyrs, active nymphs with agile limbs and sensuous bodies' would 'drive this mumping mob of moderns to eternal damnation ... and give

61 Norman Lindsay

Pollice verso, 1904

When this work was exhibited in Sydney in 1904, it was described by the literary critic A. G. Stephens as 'a bad picture, a good drawing and a magnificent piece of penmanship'. After its acquisition by the National Gallery of Victoria in 1907, it became the most frequently discussed drawing by the illustrator and was often reproduced, most tellingly as an illustration to a Lindsay-inspired edition of Nietzsche's *Anti-Christ*.

us back the good green earth, the gardens, the statues, the naked girls …'.[10] Such sentiments indicate why his work was to remain a purely escapist fantasy. Although Lindsay was horrified to have it, the judgement made in London by William Orpen, a British painter much admired in Australia, that Lindsay was not so much a scandalous artist, but simply a bad artist, seems completely just.[11]

The purchase of *Pollice verso* for the National Gallery of Victoria by Baldwin Spencer and the painter Bernard Hall for the astonishingly high sum of 150 guineas indicates the high regard for 'black & white' art in the early years of the century. The admiration for illustrative art was a consequence of the artistic freedom which came about when photographic reproduction superseded the more laborious wood-engraving which had been the standard method of reproduction until the late 1880s. From 1895 a section devoted to illustration (mostly consisting of *Bulletin* drawings) was included in the exhibitions of the Society of Artists in Sydney. The adulation of the pen-and-ink technique of Norman Lindsay was a manifestation of the idea, put forward by A. G. Stephens in 1912, that it was now possible 'to defend a preference of black-and-white to painting'.[12]

In 1897 the Sydney-based Society of Artists exhibition included a section devoted to original designs for posters. The catalogue explained that in Europe and America 'they have included in the term artist, not only those who paint pictures, but all those who further artistic feeling by beautifying the objects of our daily life'.[13] Poster design, which went hand in hand with magazine illustration, was the starting-point for a number of artists in the Edwardian period.

62 Blamire Young

62 Blamire Young

Cover design for *The Lone Hand*, 1907

As an illustrator and poster-maker, Blamire Young had a great flair for designs which combined words and images. The flat poster-like cover he designed for the short-lived literary journal *The Lone Hand* is based on a photograph of a Victorian Aboriginal woman taken in the 1870s. It is typical of the artist's strong interest in the nineteenth-century history of Melbourne.

Among these was Blamire Young (1862–1935), a young Englishman who had looked very closely at the work of the Beggarstaff Brothers (James Pryde and William Nicholson) and who transformed their design ideas into an Australian idiom.[14] Young worked closely with the Lindsays in the 1890s and he came to share their love of decorative fantasy. Young's preferred medium was watercolour. In the early years of the century he painted historical colonial subjects, attempting to show the gently human, as opposed to the heroic, side of colonial life [**62**]. In ensuing years, his work lost its art nouveau suavity and, like Norman Lindsay's, it dissolved in a mist of wet-eyed nostalgia.

The etching revival of the 1880s, in which the Lindsays were leading practitioners, carried on into the twentieth century. By the beginning of the century there were many devotees and students. Among these Jessie Traill (1881–1967) was one of the most original. Traill studied etching with John Mather in the first years of the century, and between 1906 and 1909 studied further in England and Europe. She produced an enormous number of prints in the years immediately after her return and exhibited regularly with the Painter-Etchers' Society, which was formed in 1920. Among Traill's subjects were brooding city views—cathedrals, bridges, and tunnels—studies in light effects (including moonlight), and bush subjects [**63**]. In the early 1920s she

63 Jessie Traill

The jewel necklace, 1920

From the early years of the century Jessie Traill was fascinated by the screen of trees against the light, a favourite Edwardian landscape motif and an oft-repeated subject of her mentor John Mather. The subject of *The jewel necklace* was a landscape at Lake Cowal near the New South Wales inland town of Forbes.

became fascinated with the construction of the Sydney Harbour Bridge and produced some of her most memorable etchings on that grand and dramatic theme.

The First Australian Exhibition of Women's Work, 1907

The most complete expression of the status of the decorative arts at the beginning of the century was the First Australian Exhibition of Women's Work, held in Melbourne in 1907. This vast exhibition comprised all classes of the fine and applied arts and was particularly strong in those considered the special preserve of women, such as china-painting and art needlework (which included 1,009 exhibits). The idea of the exhibition was to encourage originality and innovation. The exhibition organizers pointed out that

the effects of the technical training, which women are now receiving in all branches of art, are beginning to show. Until recently women with a leaning towards art have been content with producing pictures, for many of which there has not been much demand. Now they can put their skill and ingenuity to profitable use in the various branches of design, and many a woman who might have starved as a picture painter may earn a competent living in a congenial way as an original designer or as a skilled draughtswoman.[15]

Identifiable exhibits from the 1907 exhibition and photographs of the displays suggest the strong influence of *The Studio* aesthetic. One distinctive feature, however, was the application of Australian nature motifs in many works. The leading designer in Australia in this field was Eirene Mort (1879–1977), a major exhibitor in the show, who entered hundreds of designs in different classes. She made extensive use of motifs drawn from eucalyptus leaves, gum-nuts, waratah shrubs, as well as native fauna, such as the elegant, crane-like brolga and the koala. By 1907 Mort had gained considerable experience, having been earlier commissioned by the great Arts and Crafts design-house Liberty & Co. to create a range of textiles using Australian floral motifs.

Despite the numerical balance of the Women's Work Exhibition favouring the applied arts, painting, watercolour, and drawing

were well represented. A characteristically Edwardian feature of the classification of works in the exhibition was the existence of a separate section for pastel drawing. The artist who was to emerge as Australia's most original pastellist, Florence Rodway (1881–1971), was represented in the exhibition by large-scale charcoal drawings (although she did not exhibit pastels on this occasion).

Like the enthusiasm for 'black & white' art, the vogue for pastel drawing developed in the 1890s. When Alice Muskett (1869–1936) returned to Australia in 1897 after studying in Paris, she declared that pastel drawing was 'quite the rage' when she left Europe. The medium was taken up sporadically by Muskett's teacher, Julian Ashton, and by

Tom Roberts (who employed it principally for portraits of women and children). But none of these artists took to the medium as their primary form of expression as did Florence Rodway. She quickly developed a style in which the subject was constructed from long vertical strokes over a brown or buff-coloured sheet. Using this distinctive technique, Rodway produced portraits—again mostly of women and children—in which the face of the subject was precisely defined and was surrounded by vigorous and gestural hatching [**64**]. These portraits are among the most developed examples of a modernist expressive art in Australia at this time, an approach which fits easily with the paintings of her close contemporary, Grace Cossington Smith. Rodway worked in this style until about 1914, after which her style became more conventional and tonal.

Perhaps the most single-minded pastellist in Australian art, however, was Janet Cumbrae Stewart (1883–1960), a product of Melbourne training during the first decade of the century, a regular exhibitor in the Victorian Artists' Society, and later a popular exhibitor in Melbourne's Athenaeum Gallery. Cumbrae Stewart appears to have only one subject—the languorous pubescent girl, nude, or semi-clad in exotic drapes. This subject allowed the pastellist to exploit the luscious bloom of the medium and its capacity to render the play of light on various surfaces.

Currents in Edwardian painting

Baldwin Spencer's comprehensive personal collection of art provides a snapshot of the main currents in Australian painting in the first decades of the twentieth century. His enthusiasm for Australian artists and his position as a trustee of the National Gallery of Victoria from 1895 until 1928 saw him exercise an enormous influence on the collection of the leading public gallery of its day. The artists who captured

Australians in Europe 2

In the first decades of the twentieth century several artists left Australia for extended periods to work in England and France. While retaining links with Australia and expatriate Australians, these artists were immersed in the English or French artworlds. The fine and often overlooked miniaturist Bess Norris Tait had a very successful London career in the genre after she went there in 1905. A fellow Victorian, Hilda Rix Nicholas, who later became known for her high-toned paintings of rural life on the Monaro plains, was initially attracted by French art and Moroccan subjects. She went to Paris in 1907 and continued to exhibit in France after her return to Australia in 1918. The circle of expatriate artists working in Paris during the middle years of the century included the New Zealand-born artist Kathleen O'Connor, who left Western Australia in 1906 and, beyond brief visits to Australia, did not return to Perth until 1955. Stella Bowen determined to leave her native Adelaide after early study with Margaret Preston, and did not return. She became absorbed into the artistic and literary milieu of England, compellingly and candidly described in her 1941 autobiography, *Drawn From Life*.

the greatest share of his attention were Arthur Streeton and Norman Lindsay, and the emerging generation of painters including George Lambert (1873–1930), the Adelaide gum-tree painter Hans Heysen (1877–1968), and the short-lived creator of jewel-like watercolours of nature's quieter corners, J. J. Hilder (1881–1916).

The first decades of the twentieth century are usually considered in the light of the expatriate endeavour of Australian artists. While it is true that a number of major Australian artists were working or studying in Europe during these years, the focus on London and Paris has led to a neglect of the domestic scene. It was more interesting than has been credited. It was a scene punctuated by visits and exhibitions of the work of the expatriates, but generally it could be said that the influence of Europe was a matter of experience brought back in the cultural baggage of the returning artists rather than in their exhibited works. This is certainly the case with George Lambert, who left Australia as a promising and brilliant protégé of Julian Ashton and who did not return until 1921, after which his influence was profound. Although Lambert only held one major exhibition in Australia during his expatriate years (in Melbourne in 1908), his English work became known through illustration and through its inclusion in collections such as Baldwin Spencer's.

Lambert spent his early student years in Paris with Hugh Ramsay (1877–1906), who returned to Australia in 1902 after a greater level of success than any of his fellow Australians, with the exception of the sculptor Mackennal and the photographer Barnett. His return, at the beginning of what looked like a brilliant career, was brought about by the onset of the tuberculosis which was to cause his death at the age of 28. By 1918, when the first memorial exhibition of Ramsay's work was held, Baldwin Spencer was able to observe that, 'small though his output was, he is undoubtedly one of the biggest artists in portraiture and figure painting that Australia has produced …'.[16]

Like George Lambert and Ambrose Patterson (1877–1967), the young Ramsay was captivated simultaneously by the painting of Velázquez (in the past) and John Singer Sargent (in the present). His subjects comprised, for the most part, his fellow artists and their friends, but his greatest subject was himself, captured in dozens of experimental self-portraits; these are, as a body, the most profound collection of self-portraits in the history of Australian painting. On the strength of his works included in the New Salon, Ramsay obtained some commissions, but his declining health made the necessary procedures of completing such works difficult.

The quality of Ramsay's work lay in his acute sensitivity to tonal nuance [65]. The surety with which he constructed his paintings from delicately gradated tone eluded his fellow artists. Yet he introduced to Australia a love of tonal painting which continued to be a characteristic

65 Hugh Ramsay

Two girls in white (The sisters),
1904

Hugh Ramsay's best-known
work is a painting of his own
sisters, which was painted in
Melbourne in 1904. With its
virtuoso treatment of surface,
its intriguing reflection of
world-weariness, and its
capacity for an imaginative
narrative interpretation, it is, in
psychological terms, the most
complex painting made in
Australia in the century's first
decade.

of the art of Melbourne in particular. The enthusiasm for tonal paint-
ing was further fuelled when his close contemporary Max Meldrum
(1875–1955) returned to Australia from France and began to propound a
theory of art which, he proclaimed, was built on scientific principles.
In 1916 Meldrum started up an art school where the first generation
of Melbourne artists strove to fashion their art according to what
Meldrum called *The Invariable Truths of Depictive Art* (the characteris-
tic title of his book). Meldrum's students did not draw, except with the
brush, and they were encouraged to 'consider with extraordinary care,
not only the individual aspects, of, say, a jam pot, a bottle, and a bit of
soap, but also to make an exhaustive and analytical inquiry into their
tonal and space relations to one another'.

Not everyone was as convinced as Meldrum himself that his
theories constituted a scientific theory, rather than a personal style. His
cause was not helped by his fiercely argumentative personality
(Baldwin Spencer was one of his enemies and described the painter as a
'conceited little megalomaniac') and the endless storm-in-a-teacup
fights for control of Melbourne's art societies only served to isolate his

students and followers and to confirm their dogged adherence to his formulas.

Some commentators have been inclined to treat the Meldrum style as a modernist style, on account of its belief in the objectivity of vision; yet it produced for the most part gloomy and dull paintings—oppressive portraits in gravy-coloured interiors. The most significant contributions of the Meldrum style to Australian art were made, in effect, when the artist was not trying to prove anything. These include Meldrum's own exquisite oil sketches [66], the fine Aboriginal portraits of his pupil Percy Leason (1889–1959), and the small landscapes of the only one of his pupils to transform the style into a strongly personal idiom—Clarice Beckett (1887–1935). Beckett's art is a subtly nuanced ensemble of greys and pinks—almost Whistlerian—and in similar spirit to Whistler she embraced modernity. All is harmonious in Beckett's paintings—cars, petrol pumps, roadsigns, and beach-towels are at one with the grey mists of the morning and the sunset-flushed clouds.

Order and Transcendence: Art between the Wars 1919–39

7

The Great War

The First World War was as catastrophic for Australia as for anywhere else in the British Empire. Australia recruited over 400,000 men to fight in the war, and of that number 60,000 did not return. The persistence of the war in the memory and the shadow it cast over its generation are facts which is now almost impossible to grasp, and there can be little doubt that ideas about modernity—hopes for the creation of a better world out of the ashes of the old—were given renewed urgency in the post-war years. Such ideas profoundly affected art and gave an edge to debates about culture.

The war also had a more direct and measurable effect on the art of Australia. In 1916 the Australian government decided, largely at the insistence of the historian C. E. W. Bean, to create a visual record of Australia's involvement in the war. By 1917 an official war-art scheme was in place and artists were commissioned to make records which formed the basis of the collections of the Australian War Memorial (initially named the Australian War Museum). War-art commissions continued until well into the 1920s and provided Australian artists with an unprecedented level of official patronage. The only comparable source of patronage was the Historic Memorials Committee of the Federal Parliament, established in 1911, which existed to commission portraits of the country's political leadership.

It must be said that the demands on the official war artists to create a documentary record did not result in the production of much great art. There were, however, some exceptions, most notably the water-colour drawings made by Arthur Streeton on his two visits to the devastated countryside of France in 1918, some isolated examples of portraiture, and the works of George Lambert.

Lambert was responsible for Australia's greatest painting of a military subject, *Anzac, the landing, 1915*, completed in 1922 [**67**]. Consistent with the commission to produce a painting of what most of

67 George Lambert

Anzac, the landing, 1915,
1920–2

The subject of this painting—a defining moment in Australian military history—reveals itself slowly, like a narrative. The landing from boats on the beach at Gallipoli is a tiny incident in the lower left-hand corner. As the eye traverses the khaki and ochre nuances of the landscape, the figures of hundreds of soldiers can be discerned, crawling up the steep cliff, pressing into the ground to avoid the Turkish fire pouring down from the heights.

the post-war generation considered the defining moment of Australia's nationhood, Lambert put immense thought and detailed research into this work. He visited Gallipoli in 1919 with Bean's Australian Historical Mission, and it was a profound experience. The Mission stayed at Gallipoli for a month and despite the bitterness of the winter weather, Lambert carried out extensive visual and topographical research. Everywhere on the battlefields he was confronted with gruesome relics embedded in the landscape. He wrote to his wife: 'The worst feature of this after-battle work is that the silent hills and valleys sit stern and unmoved, callous of the human, and busy only in growing bush and sliding earth to hide the scars left by the war-disease …'.[1]

The Australian War Memorial's patronage was important for a number of artists besides Lambert. During 1918 and 1919 Arthur Streeton painted large battlefield paintings based on his visits to France. Landscape is the dominant motif in Streeton's vast canvases as it was in Lambert's Gallipoli paintings. Only when we peer into the backgrounds do we see a dense confusion of shell-bursts signifying a distant battle. Again this is a reflection of the artist's own experience. 'True pictures of Battlefields', he told Baldwin Spencer, 'are very *quiet* looking things. There's nothing much to be seen—everybody & thing is hidden & camouflaged—its only in the Illustrated papers one gets a real idea of Battle as it actually occurs in the mind of the man whose never been there …'.[2]

Countless portraits of military leaders and painstakingly reconstructed but unconvincing battle paintings constitute much of the visual record of the war. As a museum, the War Memorial provided further opportunities for artists to create the displays. The first official war artist to be appointed, Will Dyson (1880–1938), suggested to Bean

68 Frank Lynch

Pozières, 1928–9

Among the most successful of the dioramas made for the Australian War Memorial in the post-war years was the depiction of the Western Front battle at Pozières modelled by the Sydney sculptor Frank Lynch. Whereas the intention of many of the Memorial's dioramas was to illustrate a particular moment in decisive battles, *Pozières* was, in the words of the war historian C. E. W. Bean, 'not a particular fact, but a conception of the mystery and strain of the Pozières battlefield'.

that the Memorial's galleries include extensive dioramas to make the impression of warfare more vivid. Bean was enthusiastic and a programme of diorama-building continued throughout the 1920s and 1930s.[3] The Memorial commissioned significant sculptors to model the figures, just as it had commissioned professional painters to make paintings based on the recollections of returned soldiers [**68**].

In the years immediately following the First World War, opposing positions made themselves apparent among Australian artists. While some continued to press on with War Memorial commissions, others looked to different subjects, agreeing with Julian Ashton, who wrote in 1919, that 'war … and its horrors are no fit theme for artists whose training is towards some form of beauty or other'.[4] Landscape artists such as Penleigh Boyd, Hans Heysen, and Elioth Gruner (1882–1939) sought refuge in the seemingly immutable facts of nature. Light, particularly morning light, was a common theme for landscape artists in the early 1920s—an intense symbol of hoped-for healing and renewal. The geometrical order of the world was central to the ideas of some artists who believed it their responsibility to discover and affirm

The Archibald Prize

The Archibald Prize is Australia's best-known art prize. The annual award for portrait painting resulted from an endowment left by the Sydney journalist J. F. Archibald, which allowed the trustees of the Art Gallery of New South Wales to award an annual prize for a portrait painting, from life, the subject being 'preferentially some man or woman distinguished in Arts, Letters, Science or Politics'.

The Prize was first awarded in 1921 (to W. B. McInnes for his portrait of the architect H. Desbrowe Annear) and has been awarded every year since (except in 1964 and 1980). It has always attracted large publicity and the decisions of the trustees are frequently regarded as contentious. The Prize has sometimes been the subject of highly visible court actions, the most celebrated of which was the Dobell case over the 1943 Prize. The most successful artist in the history of the Prize is Sir William Dargie, whose win in 1941 was the first of eight, the last coming in 1956 for his freely painted portrait of Albert Namatjira.

the fundamental connectedness of all things. Colour harmony was investigated as a part of this quest: Roy de Maistre (1894–1968), summing up his aims for paintings in his 1919 exhibition [**69**], described people's reaction to colour as 'the conscious realisation of the deepest underlying principles of nature [in which] … they find deep and lasting happiness'.[5]

69 Roy de Maistre

Waterfront, Sydney Harbour,
1919

Like most of de Maistre's colour experiments of the immediate post-war years, this is a very small panel, yet the intensity of its colour and design is achieved through its compression. The flat façade of the building creates a planar structure for the painting, echoed in the lozenges of surrounding colour.

Sydney modernism of the 1920s

Australian art in the 1920s presented no less complex a face than it had in the pre-war years. The period has often been seen by art historians as one in which modernism and its opponents battled for the hearts and minds of their generation, but the picture is by no means that simple: modernism as a concept was itself susceptible to many interpretations.

The complexity and flexibility of art-world alliances in the inter-war decades was highlighted in the career of George Lambert between his return to Australia in 1921 and his death in 1930. Lambert had left Sydney in 1900 as a promising student, and he returned a guru. During his years in London he made a living as a portrait artist and developed a decorative approach to his subjects. His work emphasized design and colour and always had about it a self-conscious air of artifice—all attributes of modernity. In its approach to form, however, Lambert's work adhered to traditional construction based on drawing. When he returned to Australia, he was to emphasize the place of drawing and design in painting; according to his contemporaries, his focus on form brought about a new rigour in Australian art and introduced the catch-phrase 'drawing for drawing's sake', which enjoyed a voguish popularity in the 1920s.

Lambert's paradoxical position in Australia demonstrates the lack of a clear definition of modernism in the inter-war decades. Some commentators considered him a modernist; others, with relief, saw him as antithetical to what were perceived as the excesses of European modernity in art. Virtually all commentators stressed the quality of his technique: regardless of how shallow they considered his subject-matter, they drew attention to the solidity of his drawing and the assurance of his paint-handling.

In 1926 Lambert exhibited with Sydney's Contemporary Group, whose first exhibition at Sydney's politely modern Grosvenor Galleries went under the name 'A Group of Modern Painters'. The work included in the exhibition represented a number of the most important figures in Sydney modernism of the 1920s, with the notable exclusion of Grace Cossington Smith (1892–1984), who did not participate until the group's second exhibition in 1929. Lambert included two works in the 1926 exhibition and one of these—a study of an egg and a cauliflower—one writer dismissed as 'just about ... as modern as Chardin'. None the less, the sympathetic critic Basil Burdett wrote in 1926 that Australia's contemporary artists, in their quest for clarity of form, marched under Lambert's 'austere baton'.[6]

The characteristics which unified the works of the 1926 exhibition were simplified compositions, decorative flatness, and clearly outlined shapes. To be considered modern in the 1920s meant adhering to ideas about the importance of colour, emphasis on rhythm, and, most

importantly, the reduction of forms to the essentials (a favourite idea of Lambert's). The principal organizer of the 1926 exhibition was Thea Proctor (1879–1966), an artist closely associated with Lambert and whose work demonstrates the close links between art and design in the 1920s. Proctor had spent most of the first two decades of the century in London, arriving there in 1903 and returning to Sydney in the same year as Lambert, 1921. She had made a decision very early in her career to concentrate on watercolour painting and drawing, and had become interested in lithography. Her earliest works were Conder-inspired fan-paintings, but she gradually developed towards a colourful, linear, and patterned style.

In 1920s Sydney, Thea Proctor epitomized the modern. She moved effortlessly between the worlds of art exhibitions, design, and decor. Her elegantly appointed studio, decorated with carefully chosen floral arrangements, was as important an expression of her artistry as her prints and drawings. Her work was fashionable and adaptable; her compositions were equally appropriate as woodcuts, paintings on silk, or striking cover designs for the leading lifestyle magazine of the day, *The Home* (published by Sydney Ure Smith between 1920 and 1942). Proctor had a preference for decorative subjects, pretty historical costume, and the world of ballet and harlequinade. When the magazine *Art in Australia* devoted an entire issue to Thea Proctor in 1932, a tribute from the Sydney writer Ethel Anderson summed up her work precisely: 'there is, in her silken universe, neither bar nor bridge nor choked-up fountain; no fruit barrows, no spattered grape skins, no paper bags *errant*. Indeed she is no realist. Her world owes everything to fancy, nothing to fact.'

Where Thea Proctor's works were all pattern and surface, the prints and paintings of her colleague Margaret Preston (1875–1963) were strongly designed and robust. Preston's art, like Proctor's, was rooted in a turn-of-the-century aesthetic: she gave equal attention to the arts of painting and printmaking. Wide travel in 1904–7 and 1912–19 had exposed her to a great range of art, including the Chinese and Japanese art which exercised a profound, though understated, influence on her own practice. By the time Preston settled in Sydney in 1920 she had become a passionate advocate for ideas of modernity in art, yet her positions were never adopted for the sake of fashion. Indeed, there was no artist in mid-twentieth-century Australia whose works more consciously combined modernism with a penetrating regard for the natural world.

Preston recognized what Proctor failed to grasp—that the materials chosen for art were in themselves a significant embodiment of content. Preston's vigorous woodblock prints, in which the form is ordered by black outlines and compositions held in by thick borders, are more successful expressions of commitment to modernity than Proctor's jazzy

flower-pieces painted on silk or her silvery pencil drawings. Preston's prints of the early 1920s were boldly cut and brilliantly coloured, but by 1927, as she explained, she was 'trying to produce form in its simplest manner, making all other qualities [especially colour] subservient to this'. *Implement blue*, painted in 1927 [**70**], was one of the paintings in which Preston attempted to bring this new rigour into her work. *West Australian banksia* [**71**] is a typical woodblock print of the same period; but whereas *Implement blue* is essentially static, the print is organized profusion.

During the period from 1920 until the late 1950s Preston was determinedly Australian in her use of native flowers as subjects. She believed that the modern artist had to be of her own time, but also, more significantly, of her own place. She wrote a great deal about the importance of Australian themes and subjects in art. Her

outspokenness was legendary, yet even at its most rigorous, her work manages to avoid the doctrinaire. When asked for her definition of modern art, Preston replied simply that it was the role of artists to be true to the time in which they live. She described her own age as 'a mechanical age—a scientific one—highly civilised and unaesthetic'. The ambivalence of this statement is in contrast to the views of a younger generation of Sydney modernists who more fully embraced both the mechanical and the scientific, and who sought theoretical principles and a rigidly geometric pictorial logic.

Two artists who exhibited at the 1926 exhibition, Roy de Maistre and Roland Wakelin (1887–1971), had become, by that time, devotees of a gentle Post-Impressionism which had overtaken the genuinely radical approach in their painting of the immediate post-war years. De Maistre and Wakelin, along with Grace Cossington Smith, had been pupils of Dattilo Rubbo (1870–1955), the teacher at Sydney's Royal Art Society who first introduced Australian students to the work of the French Post-Impressionists. Whereas Wakelin fell for Cézanne and became a derivative Cézannist like any other around the world, de Maistre and Cossington Smith became very interesting painters indeed.

De Maistre's best art derived from pictorial experimentation surrounding his interest in 'colour music' during the years 1916 to 1919. As a trained viola player, he was naturally susceptible to the widespread notion that colours corresponded to musical keys and that compositions could be developed visually as well as aurally. A profound dimension was added to his interest when he became acquainted with Charles Moffitt, a doctor investigating the use of coloured ward decor

in the rehabilitation of shell-shocked soldiers. Colour with a capital 'C' became de Maistre's study. 'Colour', he declared, is 'the very song of life … the spiritual speech of every living thing.'[7] He simultaneously developed a colour scheme for application in therapy and created paintings—purely abstract paintings—to which he gave titles such as *Rhythmic Composition in Yellow Green Minor*.

The pure colour of the colour-music paintings was also applied to landscape by de Maistre and Wakelin. A group of small studies of boat-sheds near Wakelin's house (which he named 'Cézanne') on the north shore of Sydney Harbour were simple in form and intense in colour [**69**]. These bright jewels were shown in an exhibition in Sydney in 1919, 'Colour in Art'. The exhibition was received with hostility in some quarters and support in others. Yet no matter how fervently de Maistre declared his belief in the scientific basis of colour–music equivalents, by the mid 1920s both he and Wakelin had lost faith. De Maistre briefly, but significantly, converted to Max Meldrum's brand of scientific seeing. In 1923 he won the highly coveted New South Wales Travelling Art Scholarship and worked in Europe until 1926. In 1929 he left Australia to live permanently in England. When de Maistre became interested in pure abstraction again in London in the early 1930s, he returned to his colour–music paintings, and, as the art historian Mary Eagle has observed, dated them '1918–1933 or 1920–1934, ignoring the wasted years between'.[8]

Grace Cossington Smith was a more subtle painter than either de Maistre or Wakelin.[9] She was no ideologue, yet she, too, worked to bring her art into line with her generation's need for structure. There is an extraordinary thread of coherence which runs through Cossington Smith's sketchbooks from her days as a student of Dattilo Rubbo until the 1950s (after which she had no need to draw—she approached the canvas directly). The thread which runs through her work is her sense of contentment with the world around her—the suburban world of Turramurra on Sydney's north shore where she lived for almost all of her life. In one sense her subjects are unambitious: they are the objects

73 Grace Cossington Smith

The Bridge In-curve, 1930
Of Grace Cossington Smith's numerous paintings and drawings of the Sydney Harbour Bridge under construction, this is among the most extended. The massive yet elegant form seems to surge above the more chaotic urban landscape below; in the upper part of the composition radiating bands of brushstrokes suggest energetic vibrations. The two massive cantilevered arcs of the bridge met in 1930; the completed bridge was opened in 1932.

of her affection—family members, Turramurra streetscapes, domestic interiors—yet she never allowed her concern with structure or with light to diminish [**72**].

As did many of her fellow painters in Sydney, Cossington Smith saw the Sydney Harbour Bridge as a subject which embodied the modernity of contemporary Australian life. During the war years she had painted city-crowd scenes, but the construction of the Bridge (begun in 1923 and continued until its opening in March 1932) gave her an engrossing form which expressed the dynamism of the city [**73**].

Modern landscape

Despite modernism's natural association with the city, with the energy of crowds, with bridges and buildings, with fashion and shopping, magazines, and parties, a fundamental concern with the non-urban landscape remained strong during the decades between the wars. In this context, modernism expressed itself primarily as an interest in form and structure and a declared anti-impressionist stance. Perhaps the best example of the shift to accommodate the demand for a sense of structure can be found in the works of the Sydney painter Elioth Gruner (1882–1939). The sensitive landscapist began the post-war decade with *Spring Frost*, an optimistic hymn of praise to the life-renewing force of the sun. The painting won him the prestigious Wynne Prize for landscape in 1919. When Gruner won the Wynne Prize (for the fourth time) a decade later, his 1929 painting *On the Murrumbidgee* was flatter and more detached—a succession of subtly modulated planes receding into an airless distance. Gruner loved the clarity of light in the Murrumbidgee country.[10]

The 1920s saw artists develop an interest in the previously unpromising landscapes of the interior of the Australian continent. This was facilitated by improved road access which allowed artists to travel in areas such as central Australia. Still later, in the 1930s, air travel created a completely new outlook on the landscape and was probably the strongest contributing factor in the creation of perceptions of Australia which prevail today—Australia as a vast, reddish-ochre desert (as opposed to the pastured Australia painted by colonial artists, or imagined by, say, Streeton—glowing with bright chalky light).

A new approach to the Australian landscape was exemplified by the inter-war work of Hans Heysen. In the early years of the century Heysen had appeared as the true heir to the pastoral vision of the Heidelberg painters, but his work underwent a dramatic change in 1926 when he moved away from painting the gently pastoral landscape of the Adelaide Hills to paint and draw subjects in the Flinders Ranges. The change was both a response to the 'severer study of form' which Lambert

74 Hans Heysen

In the Brachina Gorge, 1928
This charcoal drawing shows Heysen the draughtsman grappling with the unaccustomed lack of atmosphere in the dry Flinders Ranges of South Australia. A great deal of Australian drawing in the 1920s exploited the silvery-grey tones of the pencil, but Heysen preferred the tonal density of charcoal, and its requirement for a direct and sure hand to create a sense of vitality and freshness.

had introduced to Australian art and a response to the dry atmosphere and stark geology of the new landscape. As has been observed (by Ian Burn), these two things were linked—Heysen studied Lambert's battle paintings closely.[11] For a landscapist the bare desert hills in which Lambert's paintings were set would have been memorable.

From 1908, when he moved out of his city studio into the Adelaide Hills, Heysen had devoted his energies to painting the immense gum trees around his property at Hahndorf. In his oils and watercolours he set out to solve problems of depicting enveloping sunlight, heat-haze, and dust. But by the early 1920s he had worked through all of these problems. His work was beginning to stagnate, and the decision to seek new subjects in the desert areas of South Australia renewed his art. Writing to Sydney Ure Smith of his first visit to the Flinders Ranges, Heysen was ecstatic about a landscape of 'scenes ready made, which seems to say "here is the very thing you moderns are trying to paint"'.[12] Between 1926 and 1933 Heysen made several visits to the Flinders Ranges, where he made drawings and watercolours of the 'fine big forms' of the bare hills [**74**].

In the Flinders, Heysen's problem was to express a landscape in which, as he described it to Lionel Lindsay, 'there was no appreciable atmospheric difference between the foreground and middle distance; indeed, hills, at least four miles away, appear to unite ...'[13] Yet Heysen's approach to landscape was never simply formal, and in his Flinders Ranges work, associations begin to be projected on to the landscape. *The hill of the creeping shadow* was painted in the year following the Brachina Gorge charcoal drawing and it expresses a strange note of melancholy reminiscent of a nineteenth-century sensibility.

Heysen was one of many artists interested in the naked geology of the earth as an expression of a modern spirit in art. His daughter Nora (born 1911) used the Flinders landscape as a background to one of a series of superb portraits of the statuesque farm girl Ruth [**75**]. Nora was one of a number of younger artists of the 1930s who sought clarity of form and light to avoid what they saw as the blind alley of a structureless impressionism.[14] This was the stated aim of the Sydney painter Lloyd Rees (1895–1988) when, in the early part of the decade, he gave up painting temporarily to concentrate solely on drawing. He made a series of detailed and beautiful pencil drawings of rock-faces around Sydney, concentrating on the rocky headland of Balls Head [**76**]. Using a hard pencil on unyielding paper, Rees investigated each tiny fissure and shadow to create a distinctly Ruskinian result. As with Heysen's Flinders Ranges drawings, Rees's pencil works are airless and lonely. Although he occasionally included buildings and distant figures in his drawings, his interest was form precisely rendered.

76 Lloyd Rees

The hillside, 1932

In the early 1930s Lloyd Rees concentrated solely on drawing—landscapes of rocky outcrops around Sydney Harbour. The subject of this drawing was found at Waverton on Sydney's north shore.

In the late 1930s, Rees moved away from the rigorous approach embodied in his pencil drawings and began painting landscapes of an increasingly romantic cast. From that point on, light became his professed subject. Yet rocks and rock-faces remained a fascinating motif and the source of some of his best works, such as the monumental portrait of a bush rock-face, *The timeless land* (1965). In the late 1960s Rees developed an interest in the rocky outcrops at the summit of Hobart's Mount Wellington, and in 1976 and 1977 made a series of masterly drawings of the monolithic Uluru and Kata Tjuta.

Perhaps the most consistent seeker after the structured landscape— an artist whose work changed almost imperceptibly over three decades—was the Queensland watercolourist Kenneth Macqueen (1897–1960). He was one of the 'Group of Modern Painters' who exhibited in Sydney in 1926—'modern' by virtue of his commitment to distilling simple images from his experience as a farmer. Macqueen moved from Sydney to Milmerran on Queensland's Darling Downs in 1922. There he and his wife, the illustrator Olive Crane (1895–1936), managed to combine farming with art-making. Both artists were interested in design and the graphic possibilities of landscape motifs. Macqueen attempted oil painting, but found watercolour a more conducive medium for depicting the flat, broad rhythms of the pastoral landscape.

Photography between the wars: Cazneaux and Dupain

The complexities of definitions of modernism which beset painters in the inter-war period were paralleled in the work of the most conspicuous Australian photographer of these years, Harold Cazneaux (1878–1953).[15] Born into a family of photographers, Cazneaux's aesthetic was established in the early years of the century when Pictorialism was the dominant ideology in artistic photography. After moving from Adelaide in 1904, Cazneaux worked for Freeman and Co., one of the leading commercial studios in Sydney. At the same time he began to exhibit photographs of subjects favoured by his printmaking contemporaries—views of Old Sydney, Harbour ferries, and character studies of children. His photographs were heavily manipulated to achieve dense and often sombre tonal effects, and were carefully constructed to achieve the compositional coherence of a print or watercolour.

After establishing his own photographic studio in 1918, Cazneaux continued to develop a distinctive style which was, in accordance with the changed fashion of the day, out-doorsy and sunlit: his photographs bore titles such as *Sun Spots and Shadows*, *Sun Portrait*, and *Pergola Pattern*. Cazneaux became the most visible photographer in Sydney after he began to work regularly for the chic lifestyle magazine *The Home*—indeed, the first issue of the magazine had on its cover his 1915 composition *The Bamboo Blind* (a study of a child raked with sunlight from behind a window blind). The publisher of *The Home*, Sydney Ure Smith, was also responsible for several books illustrated with Cazneaux photographs. The most deliberately modern of these books were *Sydney Surfing* (1929) and a tribute to Sydney's symbol of modernity, *The Bridge Book* (1930). The text of *Sydney Surfing*, written by Jean Curlewis, is a jazzy hymn of praise to Australian beach culture and the surf lifesaving movement. The photographs frequently employ the overhead viewpoint afforded by the pier at Coogee Beach. Using techniques of selection and severe cropping, Cazneaux created patterned compositions of beach-towels, parasols, and tanned limbs against a background of pitted sand.

In the 1930s, following the lead of his long-time friend Hans Heysen, Cazneaux made several visits to South Australia's Flinders Ranges [77]. As in the early years of his career, the approach of the painter is everywhere in evidence. Like Heysen, Cazneaux introduced feelings of monumentality, stoicism, and melancholy into the Flinders Ranges landscape.

Max Dupain (1911–92) saw Cazneaux as 'the father of modern Australian photography [who] paved the way, struggling, in somewhat splendid isolation'.[16] While Dupain's earliest work was in the Pictorialist mode, he, too, moved towards a photography with a strong formal sense. By the early 1930s Dupain had abandoned the Pictorialist

77 Harold Cazneaux

The Spirit of Endurance, 1937
Cazneaux photographed this
monumental tree on his visit to
Wilpena Pound in the Flinders
Ranges of South Australia in
1937. He described it as 'My
most Australian picture'. Its
original title was *A giant gum of
the arid north*, but Cazneaux
changed it to the more
symbolic one in 1941 to reflect
wartime sacrifice.

aesthetic and was creating images of urban and industrial buildings
(particularly the silo buildings of Pyrmont) with sharp forms, stark
shadows, and dynamic compositions based on the interplay of vertical,
horizontal, and diagonal lines. The flair for form in these photographs
was to make Dupain a fine architectural photographer, and demand for
his photographic documentation of buildings continued throughout
his career. In 1963 he produced an elegant photographic record of
Australia's earliest architectural heritage, published as *Georgian
Architecture in Australia*.

Dupain's sense of form was applied to the human body as well as
to architecture. During the 1930s he began to make highly original
nude studies and, as a devotee of Surrealism for a brief season, he
experimented with solarization, double exposures, and photographic
montage. But his most successful realization of form was found in the
more naturalistic setting of the beach. The magnificent *Form at Bondi*
[**78**] was distilled from observation. The monumentality of the

photograph (also a feature of Dupain's best-known beach image, *The sunbaker*) is here given a tweak of realism in the costume-adjusting gesture of the woman.

Sculpture and idealism

In 1939 Max Dupain's partner in his Sydney photographic studio, Olive Cotton (born 1911), made a strikingly intimate portrait of Dupain entitled *Max after surfing*. The portrait paid tribute to Dupain's love of the beach, which led to the creation of his best photographs of the late 1930s. The beach culture to which he contributed was an embodiment of the decade's quest for modernity and health, its worship of the sun and the classical body. Such idealism was also a pervasive force in the sculpture and draughtsmanship of the inter-war generation. The influential Sydney sculptor and teacher Rayner Hoff (1894–1937) probably offers the best example of the convergence of the obsession with health, the artist's concern with vital form, and the Australian environment. In an article published in 1931 Hoff wrote of Australia: 'I doubt if the Ancient Greeks produced better examples of physical beauty and grace … The call of the sun and surf, the great open roads and the wonderful bush is all too strong for any to resist. Hence we are active, virile and well …'.[17]

78 Max Dupain

Form at Bondi, 1939

In the 1930s Dupain shot the beach from all angles—from above, at sand level, from the surf, looking up, looking down. Here he achieves monumentality by putting the forms against the open sky with a very low horizon. Although he was used to setting up elaborate studies of form in his studio, his best work of the decade came from simple unforced observations such as this pair of sun-worshippers.

Hoff arrived in Australia from England in 1923 and very quickly attained a position as Sydney's leading monumental sculptor. As his biographer has pointed out, Hoff dominated Australian sculpture until his early death and was responsible for perhaps the only instance of a coherent group production of sculpture in Australia.[18] He gathered in his studio a group of young sculptors, mostly female students at East Sydney Technical College, who assisted in the production of his large-scale commissions. Hoff's greatest commission was the sculpture for the art deco masterpiece Sydney's Anzac Memorial, 1931–4, recognized as the most powerfully realized integration of sculpture and architecture in Australia's history.

The best of the young sculptors of Hoff's circle was Barbara Tribe (born 1913), who, after winning the New South Wales Travelling Art Scholarship in 1935, went on to a distinguished career as a portrait and figure sculptor based in London and then Cornwall. Barbara Tribe shared Hoff's aesthetic of virile figure sculpture, creating groups of passionate lovers and serpentine medusae.[19]

Hoff and his pupils were not alone in their love of ideal and classical form. George Lambert's most devoted pupil, Arthur Murch (1902–89), who also worked briefly with Hoff, carried the beach theme into the subsequent decades in a series of idyllic paintings. Perhaps better known as a painter, Murch saw himself primarily as a sculptor and was responsible for numerous monumental works, including the Wool Pavilion at the 1938 Glasgow Empire Exhibition, in which he was assisted by several young Australians in Britain at the time.[20]

In Melbourne Napier Waller (1894–1972) was perhaps the only artist who was able to match Rayner Hoff's combination of art deco formalism, heroic form, and feeling for the monumental. Waller was an artist in many fields—watercolour, oil painting, stained-glass design, mural painting, and linocut, the last an enthusiasm he shared with his illustrator wife, Christian Waller (1894–1952). As with Hoff, Waller's most complete work of art was a war memorial—the Hall of Memory at the Australian War Memorial in Canberra, for which he created resplendent and suitably heroic mosaic decorations.

'Exhibition 1'

George Lambert and Thea Proctor, Margaret Preston, Roy de Maistre, and Grace Cossington Smith—these were all artists whose application of theory developed in balance with a basic empiricism. The generation that followed, whose presence began to be felt in Sydney in the early 1930s, was far more doctrinaire in its approach— devoutly making the observed world fit into given geometric theories and patterns. Three catalysts of this generation were Dorrit Black (1891–1951), who set up a Modern Art Centre in Sydney in 1930, and Rah Fizelle (1891–1964) and Grace Crowley (1890–1979), who were the

principals of a teaching studio from 1932 until 1937. Ralph Balson (1890–1964) and Frank Hinder (1906–92) also worked in the Crowley–Fizelle studio.

Dorrit Black, whose presence in Sydney was relatively short-lived (she returned to her native Adelaide in 1933), and Grace Crowley were both devotees of the French teachers André Lhote and Albert Gleizes. In 1926 Crowley had followed her friend and fellow student Anne Dangar (1887–1951) to France, where she fell under the spell of the French teachers. In Lhote's Paris studio and at summer schools at Miramande in southern France, he taught a variety of academicized Cubism based on two tenets—that lines and shapes should conform to geometry and that compositions should be unified by the use of *passage*, the passing of one form or plane into another. Albert Gleizes, Crowley's second teacher in France, propounded similar views and was even more convincing as a master and mentor. Anne Dangar was so taken by his teaching that she remained at the artists' colony Gleizes had established at Moly Sabata and turned to making ceramics glazed with geometric motifs.

Frank Hinder was an equally devoted follower of a theoretical position which, although it came from a different source, was consistent with that of Crowley. During a 7-year period of study in the United States (1927–34) Hinder became an adherent to the theory of 'Dynamic Symmetry' originally propounded by Jay Hambidge and taught by his followers at the New York School of Fine and Applied Art. Although the theory was complex and bristled with geometric precepts, it was essentially an idealistic attempt to create pictorial order from an investigation of the geometric order (the grand design) of Nature. Hinder summed up its tenets succinctly: 'Don't copy—draw; don't imitate—design; analyse the anatomy, "analyse the form".'[21]

The culmination of the decade of absorption in such ideas was 'Exhibition 1', held at the David Jones Art Gallery in Sydney in 1939. The exhibition was organized by Frank Hinder and the art-educator and sculptor Eleonore Lange, who contributed an idealistic essay in which she explained the structural and colour principles of the group. Although the artists in the exhibition (Crowley, Balson, Fizelle, Frank Medworth, Margel Hinder, and Gerald Lewers) were broadly linked by a belief in abstraction, their different temperaments were to come to the fore in the direction of their subsequent works; while Hinders and Fizelle remained tied to a kind of benign and diluted modernism, Crowley and Balson continued to explore the potential of the abstract ideas they had developed in the 1920s.

Aboriginal Art and its Reception 1934–49

8

The Hermannsburg painters

In the late 1930s the Australian public first became aware of a group of Aboriginal artists making watercolour paintings in central Australia at the Lutheran mission at Hermannsburg. These landscape watercolours were principally the work of the Arrernte man Albert Namatjira (1902–59). Through his art and its widespread reproduction, Namatjira became the best-known Aboriginal person of his day and one of the few Australian artists who was in his own lifetime—and remains—a household name. Although he became the best-known, he was not the only artist working at Hermannsburg: several others, including his sons Enos and Ewald Namatjira and clansmen Otto, Reuben, and Edwin Pareroultja, developed distinctive landscape motifs and were collected widely in Australia.

The Hermannsburg watercolour movement arose out of a particular confluence of circumstances.[1] The Lutheran Mission of Hermannsburg, some 120 kilometres out of Alice Springs, had been established in 1877. Its existence was precarious and reliant on the help of supporters in urban centres, particularly in Adelaide. By the early 1930s the completion of a railway line to Alice Springs and improved motor transport allowed a greater number of visitors to central Australia and this led to the development of the tourist market that was fundamental to the emergence of the Hermannsburg painters. Initially this market revolved around decorative wooden objects, such as boomerangs and polished wooden plaques decorated with poker-work designs. The decoration of these objects was a field in which Albert Namatjira, who had been born at Hermannsburg at the beginning of the century, showed particular enthusiasm.

Visits to Hermannsburg by a succession of artists from capital cities (among them Violet Teague and Arthur Murch) created the catalyst for the Hermannsburg artists in the early 1930s. But the visitor who was to be most significant to Hermannsburg was the Melbourne landscape watercolourist Rex Battarbee (1893–1973). Battarbee visited Hermannsburg in 1932, in 1934, and again in 1936. He first visited central Australia in search of unique subjects for watercolours, some of

Landscape with ghost gum,
not dated

As with many of Namatjira's depictions of ghost gums, there is an inescapable anthropomorphism in this work. Although such a reading could be taken too far (into realms of symbolism which the artist gives us no clue he intended), there is a disconcerting suggestion of the flesh in this tree trunk. The ghost gum is a distinctive tree of central Australia.

which he showed in the Hermannsburg schoolroom in 1934. Albert Namatjira became interested in watercolour painting and, with Battarbee's work as a model, began to produce watercolours in 1935. In 1937 his paintings started to appear in exhibitions in Melbourne and Adelaide, and by 1938 he had produced sufficient work for a solo exhibition, held at the Fine Art Society in Melbourne, followed up in 1939 by another exhibition at the Royal South Australian Society of Arts in Adelaide. In central Australia the demand for his art grew steadily.

Namatjira's work was immediately successful. The reasons were, first, the effect of travel writers and artists such as Hans Heysen, who had created an interest in the central Australian landscape; and second, the novelty of an Aboriginal artist working (with such individuality) within a European tradition. Much of the early rhetoric about the artist is predictable and follows the same general ideas as those given about Tommy McRae in the 1890s—native genius rapidly grasping the white man's conception of art, and the like. But amidst the chorus of adulation there were detractors: some commentators with modernist leanings criticized Namatjira for forsaking qualities of 'pure expression' and taking on the cloak of what they considered a depleted European landscape vision. But the Australian public at large were not interested in such aesthetic niceties. Namatjira became famous. He was the subject of numerous newspaper and magazine stories and was filmed; his work was sought after by the increasing numbers of tourists visiting central Australia; and in 1954 he achieved the pinnacle of recognition—he was presented to the Queen on her post-Coronation tour of Australia.

Namatjira's best work is characterized by a deep engagement with the natural world and a sensitivity to its subtleties. The dry, light-filled landscape seems particularly well suited to the transparency of watercolour. The glowing trunks of a group of ghost gums placed on the side of a distant vista of purple mountains became Namatjira's stock composition, repeated hundreds of times and susceptible to hundreds of variations. *Landscape with ghost gum* [**79**] embodies that quality of animation which seemed to make Namatjira's art unique in the eyes of his contemporaries—his writhing mountain ranges and intricate rockfaces seem, too, to possess an inner life.

In 1944 Namatjira's work received a significant boost with the publication of the monograph *The Art of Albert Namatjira*. It contains ten colour plates of watercolours, striking for their stark simplicity, and a text in which the anthropologist Charles Mountford discusses the life and work of the artist. In his essay Mountford skilfully introduces all the themes which have subsequently been brought to bear (with varying degrees of sophistication) on the discussion of Namatjira. Mountford acknowledged Namatjira's individuality but was convinced

ALBERT NAMATJIRA

that the artist's work could be understood only against the 'rich cultural background' of his relationship to the Arrernte country. Mountford stressed for his white readers the importance of the bond between Aborigines and their country. In Namatjira's case the fundamental precondition of his art was that 'he has spent most of his time among his fellow-tribesmen, and thus he ... retained contact with the vitalising force of the beliefs that identify him so intimately with his surroundings'.[2] Mountford then described Namatjira's discovery of watercolour painting and ended his text with an account of a meeting with the artist and his surprise to discover the depth of Namatjira's traditional knowledge. Namatjira made an abstracted crayon drawing of his Dreaming for the writer, who described it as a remarkable experience to see Namatjira depicting 'beliefs that stretched back to the dawn of his creation, while lying beside him, the product of the same hand, were beautiful water-colours of the art of today'.[3]

The sense of vitality implicit in Namatjira's work is unmistakable in the watercolours of the Pareroultja brothers, who began painting shortly after Namatjira and whose cause was similarly promoted by Rex Battarbee. Otto Pareroultja (1914–73) took the basic Namatjira composition—distant mountains flanked by ghost gums—and transformed it into a dramatically patterned and vigorous motif [80]. Although Battarbee continued to promote Namatjira, he believed that the younger generation of Hermannsburg watercolourists would be likely to surpass Namatjira in making a more distinctive art, an opinion borne out by an examination of Otto Pareroultja's paintings. The sense of patterning seems to develop as an extension of the patterns in the landscape, rather than being applied to it. Indeed, his style, it has been

80 Otto Pareroultja

James Range Country, 1966
The James Range is a rugged mountainous area 100 km south of Alice Springs in central Australia. Pareroultja's watercolours took their vitality from the forms of the mountains framed by vigorously up-spiralling ghost gums.

suggested, was an extension of the designs used on the highly significant carved sacred objects— the *tjurunga*.[4]

The degree to which Namatjira, the Pareroultja brothers, and the many other watercolourists of Hermannsburg created an art which expressed a distinctively Aboriginal or, more precisely, an Arrernte world-view is a question that has dominated the discussion of the Hermannsburg School in recent years. Some have remained convinced that while Namatjira had an important role in the acceptance of Aborigines' individual rights in the community, his art was fundamentally weak and imitative. Some writers have stressed the innovative quality of Hermannsburg art, which could have taken no other form, coming as it did from a mission settlement. Other writers have pointed out, following Mountford, that the landscapes chosen by the artists have meaning beyond superficial landscape readings through association with a particular artist's Dreaming.[5] This is the inescapable interpretation of the current generation of Aboriginal artists in central Australia, who are less concerned with the form in which the country is depicted than with the meaning of the country itself. In this context the very act of painting is an act of engagement with the Dreaming; 'We're not like whitefellas', explained Wenten Rubuntja, a contemporary Arrernte landscapist, 'who can take a photograph and say what pretty country it is; we've got the song to sing for that country.'[6] Although Namatjira himself never put it this way, the depth of association with specifically meaningful landscapes was an element of his selection and approach.

Changing perceptions of Aboriginal art

The reception and success of Namatjira's art were symptomatic of an increasing interest in Aboriginal art throughout metropolitan Australia and overseas during the 1940s. The various forms which this interest took were demonstrated in the exhibition 'Australian Aboriginal Art and its Application' mounted in the Sydney department store David Jones in 1941. In accord with the practical mood of wartime Australia, the exhibition included not only displays of Aboriginal art and paintings depicting Aboriginal life, but a range of decorative art objects made by Sydney artists, adorned with Aboriginal motifs. The prime motivation of the exhibition was, in effect, to examine the reverse of the Hermannsburg experience—the influence of Aboriginal art on non-Aboriginal art practice in Australia. The organizer of the exhibition, the anthropologist Frederick McCarthy, was closely associated with Margaret Preston, who had written extensively on the subject of the application of Aboriginal motifs in the decorative arts through the 1920s and 1930s.[7]

Margaret Preston's interest in Aboriginal art was a dimension of her design-based modernism. It was also a manifestation of her belief in

the importance of locality—a dimension of her art nationalism (in itself a form of twentieth-century modernism). Yet, despite Preston's notion, expressed in a magazine article in 1941, that 'Aboriginal Art represents not the object alone from which it is drawn, but with the essential truths which may or may not be visible to the human eye', Preston's own work engaged with Aboriginal art largely through formal experimentation.[8] This is demonstrated in paintings such as *Aboriginal landscape* of 1941 and *Flying over the Shoalhaven River* of 1942 [**81**]. In both these paintings Preston adopted a colour scheme of ochres, white, and black, in deliberate imitation of Aboriginal bark-paintings. The surface is broken into areas of pattern around a dominant motif.

Despite the apparent superficiality of its use of an 'Aboriginal'

palette, *Flying over the Shoalhaven River* contains ideas which make it one of the most important paintings of the 1940s in Australia. It demonstrates Preston's idea that an Australian national art would arise from Aboriginal art. In the year the painting was made she was quoted as saying, 'Australia ... has ignored a fine simple art that exists at her own back door. It has to learn what this art could do to help clear up the minds of our people and give them a national culture ...'.[9] Yet *Flying over the Shoalhaven River* owes as much to Chinese art, which Preston enthusiastically embraced after visits to China in 1926 and 1934. Furthermore, this is the first Australian painting which reveals the formal elements of the Australian landscape as seen from the air: the experience of flying has revealed a completely new sense of the structure of the landscape—the obsession of Australian artists since the 1920s.

It has been suggested that Margaret Preston's interest in Aboriginal art became more sophisticated in the 1930s, as a result of her experience living in the bush (between 1932 and 1939 Preston and her husband moved out of the city to live in the bushland setting of Berowra where rock engravings [3] are frequently encountered) and her deeper knowledge of Aboriginal culture. But her interest remained, fundamentally, a formal one. At the height of her enthusiasm for Aboriginal art she experimented with the masonite cut (using the rough side of a prepared builders' hardboard to produce an atmospheric print) and took up the monotype. In the hundred or so monotypes Preston produced in 1946, she introduced (arguably with greater subtlety than in her paintings) ideas of compositional asymmetry, informality, and disregard of Western-style perspective—all derived from looking at Aboriginal art[10] [82].

82 Margaret Preston

Bush track, N.S.W., 1946
One of numerous monotypes Preston made in the 1940s, she described this as an attempt 'to give the rough and tumble of our growth of trees, without design or any other purpose than that of covering space, as the natives do in their well-covered rock paintings'.

Certainly Margaret Preston knew more about Aboriginal art in the 1940s than she did in the 1920s. When the exhibition 'Art of Australia 1788–1941' toured to the United States in 1941 under the auspices of the Carnegie Corporation, Preston wrote the catalogue essay about Aboriginal art. Stressing that 'Aboriginal art represents not only objects but essential truths which may or may not be visible to the human eye', she wrote:

Australia is the only country in the world in which rock painting still flourishes … This painting should not be judged from its technical quality, but from its introspective character. The drawings and rock carvings are a truthful art; they are realism in a wider sense than that recognized by European art … Their symbolism is infinite …[11]

The art of Arnhem Land
The exhibition 'Art of Australia 1788–1941' included several bark-paintings from the group collected at Oenpelli by Baldwin Spencer in 1912 [**57, 58**]. Had the exhibition occurred a decade later, there would have been the opportunity to include many more contemporary bark-paintings from Arnhem Land, for the years immediately following the end of the Second World War saw the beginning of enormous interest in bark-paintings, which led to their production in large numbers. These works were destined to become widely known through inclusion in publications and exhibitions. Indeed, until the advent of the desert-painting movements of the 1970s (discussed in Chapter 11), paintings on bark were the best-known form of Aboriginal art during the 1950s and 1960s (besides the watercolour paintings of Hermannsburg).

The establishment of church missions on the Arnhem Land coast, particularly those at Milingimbi and Yirrkala (established in 1923 and

Aboriginal bark-painting—materials and techniques

Nineteenth-century writers observed Aboriginal people decorating the sheets of bark used to make shelters, but only a handful of such paintings from the nineteenth century now exist. In the twentieth century bark-painting has been most closely identified with the art of Arnhem Land. The process begins with a sheet of bark cut from a stringbark (a type of eucalyptus) tree, specifically for the production of a painting. The sheet of bark is then flattened over a fire. Bark-painters use a range of colours derived from red and yellow ochres, pipeclay, and charcoal, together with a binder (such as orchid-sap or synthetic glues). This is applied using brushes of chewed fibres or hair.

Although they are now hung on walls in houses and galleries, bark-paintings are painted on the flat and generally have no correct orientation, up or down. Both the subject-matter of paintings and the type of cross-hatching with which bark-painters enliven their paintings are closely associated with specific clans. Artists are not permitted to paint any subjects they choose—hereditary laws entitle artists to paint only the subjects to which they have custodial rights.

83 Yilkari Kitani

Wagilag Story, 1937

The story of the Wagilag Sisters is one of the most important Australian creation stories. The elements of the story can be read in the cellular structure of Kitani's painting: the tracks of the Sisters as they pass through the country whose existence they call into being; the spiralling form of Wititj, the python who rises from the waterhole in anger at the presence of the Sisters (and causes the first monsoonal downpour); and the triangular shape made by Wititj as he falls to earth (recreated in the present as ground patterns during the ceremonies associated with Wagilag rituals).

1934, respectively), created convenient localities for visiting collectors and researchers. In 1946–7 the anthropologists Ronald and Catherine Berndt visited Milingimbi and Yirrkala, where they asked Yolngu people to record ancestral narratives on sheets of paper. They also collected 400 bark-paintings, and returned in subsequent years to collect further paintings and sculptures, some of which were exhibited in Sydney in 1949 at the David Jones gallery.

In 1946 and 1947 planning began of a major field study of Aboriginal material culture which was to result in the American–Australian Scientific Expedition to Arnhem Land of 1948.[12] Led by Charles Mountford, the 8-month expedition collected and documented some 500 paintings from three localities—Groote Eylandt (off the eastern coast of Arnhem Land), Yirrkala, and Oenpelli. A large number of the paintings collected were subsequently donated to state art galleries around Australia, the Commonwealth collection, and the Smithsonian Institution. These donations constitute the beginnings of serious collecting of Aboriginal work by art museums. Stimulated by the interest of an art audience, a market for bark-paintings developed in Australia's metropolitan centres during the 1950s, accompanied by increasing activity on the part of collectors and dealers.

The sheer size of the collections of Mountford and the Berndts allowed the complexity, richness, and regional variety of the art of Arnhem Land to be appreciated on a hitherto unprecedented scale. Some of this complexity can be seen if we compare just some examples of the art of those areas visited by the expeditions of the 1940s. The country traversed is rich in traditional lore, and much of the more complex art collected by researchers made reference to the two great creation sagas of the Dhuwa moiety—the stories of the Wagilag Sisters and the ancestral Djan'kawu (the latter discussed in Chapter 10). A work such as Yilkari Kitani's *Wagilag Story*, a bark collected at Milingimbi by the pioneering anthropologist Donald Thomson in 1937, contains a dense iconography of which the artist was custodian[13] [83]. A sense of the reiterative nature of Kitani's depictions of the Wagilag story can be gained from Axel Poignant's 1952 photograph of Kitani, in which the artist is seen at work on another bark of the same subject [84].

Mountford's 1948 expedition cast its geographic net wider than any previous collecting party. At Groote Eylandt, Mountford collected paintings which described the origins of the land and seascapes [2], the stars and planets, and the seasonal winds which govern the cycles of life on the island (both in subsistence and ritual terms) [85].[14] There are certainly links, but there are also numerous stylistic differences between the bark-paintings of Groote Eylandt and those of the mainland. Groote Eylandt paintings are characterized by dense black backgrounds (originating from the manganese found on the island),

84 Axel Poignant

Yilkari, 1952

In 1952 the photographer Axel Poignant spent 5 months in Arnhem Land. For 3 of those months he camped at the Liverpool River, where he carried out his intention to make a photographic record of the life of Aboriginal people. This photograph of Kitani working on a bark-painting of the Wagilag Sisters story reflects Poignant's interest in recording the ongoing traditions of ceremonial life and the teaching of traditional lore.

85 Unknown artist, Groote Eylandt

Mamariga, the south-east wind, 1948

The identity of the artist of this Groote Eylandt bark-painting was not recorded by the members of the 1948 American–Australian Scientific Expedition to Arnhem Land. The work takes its form from the topography of the sacred site created by the ancestral serpent Aitja, the place from which the wind is believed to originate. The wind-form in Groote Eylandt paintings is reminiscent of the sails of the Macassan fishing vessels which visited northern Australian waters over several centuries

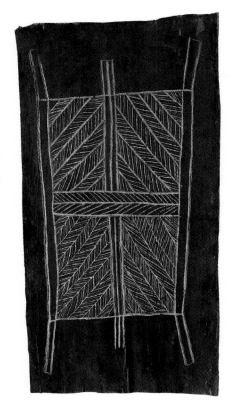

86 Unknown artist, Yirrkala

The moon and yams, 1948

The interpretation of this work was recorded by Charles Mountford in 1948: it depicts the narrative concerning the origin of the moon—the activities of the ancestral brother and sister who entered the sea at Arnhem Bay to become the moon and the dugong. The painting includes a crescent moon as well as a full moon and shapes which represent the yams (or lily and lotus bulbs) taken into the sky by the brother who became the moon.

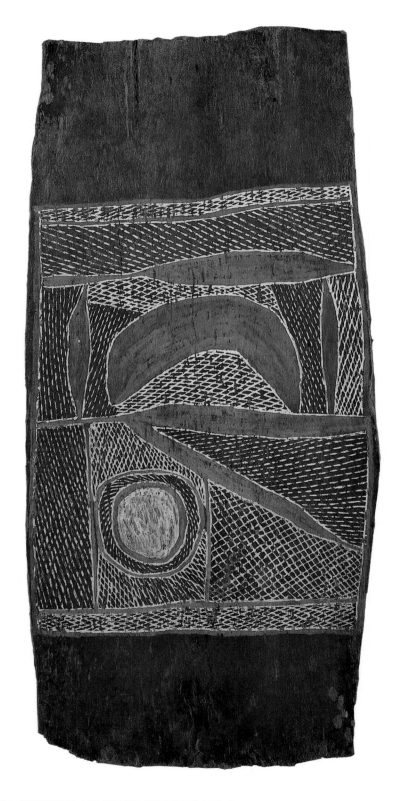

which impart a sparse structural beauty. The characteristic stylistic motif of Yolngu bark painting, on the other hand, is the elaborate cross-hatching which can be seen, for example, throughout Kitani's *Wagilag Story*.

Cross-hatching is an important element of the meaning of bark-paintings; as the chronicler of Yolngu art Howard Morphy explains:

In Eastern and Central Arnhem Land, painting is seen as a process of trans-forming a surface from a state of dullness to that of a shimmering brilliance ... but in [thus] transforming a painting ... Yolngu are not merely producing an aesthetic effect but moving the image towards the ancestral domain. The cross-hatched surface of the painting reflects the power of the ancestral beings it represents, the quality of shininess is the power of the ancestral beings incar-nate in the object.[15]

The complex descriptive and symbolic use of cross-hatching is particu-larly evident in the painting of the phases of the moon in a bark by an unnamed artist collected by Mountford in 1948 at Yirrkala [**86**]. Mountford recorded that the cross-hatched ring around the full moon is the wet-weather camp of the moon—the halo seen during misty weather—and Berndt believed that the background design of criss-crossing lines could be 'either the swamp where the lilies are growing, or the shine of the moon on the water, or ... the light of the evening star shining on the sacred totemic place of the Dugong and the Moon'.[16]

Despite the richness of the collections of painting and sculpture on Groote Eylandt and Yirrkala, Mountford considered Oenpelli to be the most spectacular of the sites visited on the 1948 expedition. This was on account of the hundreds of rock-art sites in the surrounding escarpment, which he described, with justification, as 'the most numerous and beautiful series of cave paintings we know of in Australia'.[17] It excited him (as it does today's visitors to the world heritage areas of Kakadu National Park) to glimpse 'galleries' which housed art of enormous complexity. This expedition stood at the beginning of the systematic study and publication of Australia's rock-art heritage (outlined in Chapter 1), a study which gained enor-mous momentum in the 1960s and which continues to the present day to reveal evidence of a hitherto unimagined antiquity.

Art, Myth, and Society: the Australian Avant-garde 1939–50

9

The publication of Bernard Smith's *Place, Taste and Tradition* in 1945 was a defining event in Australian art history.[1] The book was written during the darkest days of the Second World War (between 1941 and 1943) and expresses the urgency of its era. The compelling climate of its production, Smith's belief in the duty of the historian to make a statement for his own times and his personal determination to pursue a radical left-wing line, led him to the claim that realism was the most valuable quality in contemporary Australian art. Smith treated the art of his own time—beginning with the formation of the Contemporary Art Society in 1938—as a second phase of Australian modernism, within which he identified two broad tendencies, one arising out of Surrealism and another based on Realism. His arguments in defence of Realism were part of his ongoing engagement with modernism and were made against the background of debates within the newly formed Contemporary Art Society.

The Contemporary Art Society was established in Melbourne in 1938 and its first exhibition was mounted in 1939. The formation of the Society was in part a reaction to the formation, in 1937, of an official Australian Academy of Art. The Academy, backed by the conservative Federal Attorney-General Robert Menzies, was a lacklustre affair. The dead hand of officialdom lay heavily upon it and its 10-year life contributed little to Australian art, except to provide a target for disaffection.

From the outset the Contemporary Art Society was riven with internecine disputes about art, politics, and cultural activism: endless polemical writings, strategic resignations, factions, and splits characterized its early years. None the less the value of the Society was seen in its vibrant and wide-ranging exhibitions. A branch was established in Sydney in 1940 and in Adelaide in 1942. As the historian of Australia's avant-garde of the 1940s, Richard Haese, has written, the year 1942 was indeed to be the 'high water mark in the history of the Contemporary

Detail of 90

Art Society. Established in the three largest cities, it could justifiably claim to be a national body representing the most advanced intellectual and artistic elements in the Australian community.'²

Surrealism in Australia

Surrealism was pervasive in the early Contemporary Art Society exhibitions. It was the first international art movement to be apprehended in Australia with any clarity. Whereas Impressionism had been open to hundreds of varieties of interpretation, Cubism had been seen through the filter of a generation of academic teachers, and Futurism sounded to journalists a good catch-all phrase to describe a modern attitude, Surrealism, as a coherent philosophy, was more precisely understood. In 1941 the painter James Gleeson (born 1915) read a paper to the Contemporary Art Society entitled *The necessity for Surrealism*.³ Gleeson argued for Surrealism as a way to broaden the concept of reality by admitting 'the real anarchy of thought'. He postulated the wartime environment as a necessary background to radical rethinking: 'At this moment,' he wrote, 'while we are at war against the totalitarian ideologies, we yet permit the more repressive dictatorship of Reason over our minds.'

Gleeson was Australia's most devoted and outstanding adherent to Surrealism. His earliest paintings show a strong debt to Picasso and to Salvador Dali. There was always a literary element in Gleeson's painting, and some of his most interesting early works were 'poem drawings', in which his imagistic poetry is inscribed across Surrealist forms. The apparent inconsistency of the technique of Gleeson's early work [**87**], with its tendency to literary and visual allusion and the aims as stated in *The necessity for Surrealism*, was pointed out in Smith's perceptive critique in *Place, Taste and Tradition*.⁴ Yet Gleeson continued to paint Surrealist paintings, often with classical or mythological underpinnings, eventually finding a distinctive style in which the accidents of chance-inspired drawings are given a kind of monumental form by the addition of tiny, meticulously painted human figures. Much of Gleeson's time in the decades from the 1950s until the 1970s was occupied with his work as newspaper critic (between 1949 and 1972), writer (authoritatively on fellow artists William Dobell and Robert Klippel), and curator. But after he gave himself again fully to painting in the 1980s and 1990s, he was able to give full rein to his imagination: his 'mindscapes' became immense and Turnerian.

While no Australian artist has had the longstanding commitment to Surrealism that has characterized James Gleeson, a number of Australian artists of the 1930s and 1940s were touched by it.⁵ It must be said, however, that, without the intellectual and political circumstances which made the movement so vital in Europe, a great deal of Australian Surrealism was derivative and unconvincing. Propellers,

87 James Gleeson

The sower, 1944

This wartime painting is a paraphrase of J. F. Millet's 1851 depiction of a French peasant sower, but in Gleeson's Surrealist version the nightmarish figure sows destruction across the world.

flags, flat expanses of primary colour, airless precision, collections of incongruous objects—such were the popular markers of the aesthetic; much painting taken to be Surrealist in the 1930s owed more to the English artist Edward Wadsworth than to radical Surrealism. Furthermore, the joke potential of Surrealism meant that it was easily adaptable in Australia, as elsewhere, to shop-window dressing, advertising imagery, and smart theme-parties.

Among the more interesting Surrealist experimenters was James Cant (1911–82), who lived in London and travelled in France and Spain between 1935 and 1939. He exhibited 'Surrealist Objects' in London in

1936 and the following year was included in a large group exhibition of Surrealist artists at Gloucester's Guildhall.

The Contemporary Art Society exhibitions in Melbourne, Sydney, and particularly Adelaide were replete with Surrealist paintings and for many artists Surrealism held appeal as a reaction to the specific political climate of the war years. Yet there were three identifiable ways in which it made a lasting impact on Australian art. First, through the work of Peter Purves Smith (1912–49) and Russell Drysdale, and to a lesser extent John D. Moore (1886–1958) and Eric Thake (1904–82), Surrealist landscape mood was discovered in the Australian landscape. The twentieth-century equivalent of the previous century's 'weird melancholy' was found in the moonscape of central Australian desert towns. Second, the literary dimension of Surrealism was formative in the vision of such artists as Sidney Nolan, Albert Tucker, and Joy Hester. Third, the liberating effects of chance and accident were valuable strategies to be employed by the emerging generation of non-figurative artists.

European refugee artists in Australia

In *Place, Taste and Tradition* Bernard Smith singled out Social Realism as the most important form of Realism and gave high praise to the three most prominent Social Realists in Melbourne—Noel Counihan (1913–86), Yosl Bergner (born 1920), and Vic O'Connor (born 1918). Of these artists, Bergner was the most powerful and original.[6] He preferred the term 'social humanism' to describe his approach, and certainly his work possessed an intensity which derived from experience, rather than the worthy but unconvincing propagandist quality which was too often the visible sign of political allegiance. He arrived in Melbourne in 1937, a Jewish refugee from Poland, and by 1939 was painting expressive paintings while at the same time improving his skills as a student at the National Gallery School. It is, however, very

Official war artists of the Second World War

As in the First World War, Australian military authorities commissioned artists to record Australia's war effort, mostly for the Australian War Memorial collection. Between 1941 and 1945, some 45 artists served in Australian theatres of war. Several artists, including the South Australian Ivor Hele, worked in the Middle East. Hele's distinctive, muscular style made him the ideal artist of the Australian soldier and he later worked in the Korean War. Noteworthy works were made in South-east Asia and New Guinea by Donald Friend, Eric Thake, Frank Hodgkinson, and Murray Griffin, who recorded the horrors of forced-labour camps. Other artists (several of whom were attached to the camouflage corps) made official records of the home front: William Dobell's paintings and drawings of the Civil Construction Corps include his iconic portrait *The Billy Boy* (1943). Australians serving in England were painted by Stella Bowen and were sculpted powerfully by Barbara Tribe.

88 Yosl Bergner

Aborigines in Fitzroy, c. 1941
Among Bergner's most
intense Australian paintings
are those which depict urban
Aborigines living in poverty in
the inner-city suburb of
Fitzroy. These works address a
subject which is not to be
found in the works of any of his
contemporaries; they seem to
present a clear parallel
between the oppression of
European Jews and the
outcasts of Melbourne.

hard to see any evidence of the type of formal training offered at the
Gallery School in Bergner's highly expressive brooding style.

Not only did Bergner's style mark him out among his contempor-
aries, so too did his subjects. At first he painted the forgotten people of
the nameless city—meths drinkers, barefoot children, jobless men
rummaging in rubbish bins. Then he painted in response to news of
the mass destruction of his people and of Warsaw, the city of his child-
hood. He painted people fleeing from burning cities and trapped in
ghettos. In all of these paintings the city is a crumbly backdrop lit
feebly by light which struggles through the dense clouds. Among
Bergner's most intense paintings are those which depict urban
Aborigines, works which present a clear parallel between the situation
of European Jews and the outcasts of Melbourne [**88**].

Among other artists who came from Europe were a number of
German-born artists who, having escaped Nazism, were deported
from Britain as enemy aliens and imprisoned in internment camps in

Australia. Ludwig Hirschfeld Mack (1893–1984) was the most influential of these artists. Having been a student at the Weimar Bauhaus and later a printmaker there, Hirschfeld Mack was devoted to the graphic arts and to art pedagogy [**89**]. He was released from internment in 1942, and stayed in Australia, accepting a position as art master at Geelong Grammar School, a position he held until his retirement in 1955. Other artists interned in Australia were Erwin Fabian (born 1915) and Klaus Friedeberger (born 1922). They were also released in 1942.

89 Ludwig Hirschfeld Mack

Desolation, internment camp, Orange, NSW, 1941

This woodcut expresses, with simple eloquence, the sense of isolation and dislocation felt by the many German-born artists placed in internment camps in Australia during the early 1940s. For these displaced European artists, the land presented not only a new and unexpectedly desolate landscape, but an unfamiliar cosmology as well.

Both devotees of the monotype, these artists left behind them the Surrealist imagery through which they expressed the anxieties of their displacement and devoted themselves to abstraction. Erwin Fabian began to make sculptural assemblages in the 1960s before graduating to direct metal sculpture.

Albert Tucker, Arthur Boyd

Albert Tucker (1914–99) was another radical Melbourne painter whose work owed a great deal to the example of Bergner (and to another urban painter, the Russian *émigré* Danila Vassilieff). Tucker took Bergner's satanic city as a background for his series of paintings and drawings, *Images of Modern Evil*, made between 1943 and 1947. Tucker's world-view grew out of a combination of experimentation with various modes of European modernism (particularly Surrealism), Social Realism, and, most significantly, his personal experiences in 1942. Tucker was conscripted into the army in April that year and, proving to be unsuited to army life, was discharged in October. He spent part of that miserable year in the Heidelberg Military Hospital, suffering from a range of psychosomatic illnesses. The trauma he witnessed in his fellow patients heightened Tucker's sense of his own time as deranged and claustrophobic.[7] He made a series of vivid pastel drawings of the 'psychos' and 'bomb happies' who drifted through the hospital corridors.

As their collective title suggests, *Images of Modern Evil* are intensely moral paintings. Tucker's shock at the disintegration of the world, symbolized by the blacked-out wartime city of Melbourne, led him to imagine a city of darkness inhabited not by humans but by a horde of biomorphic forms. A painting such as *Victory girls* of 1943 shows the reduction of people and relationships to a cipher of primal elements: animal faces, grinning mouths, sacks of flesh [**90**]. There is no subtlety in Tucker's message—war has irretrievably reduced human values.

Tucker's most comprehensive statement of his early aims is found in his 1943 polemical essay, *Art, Myth and Society*.[8] Although couched in a strident and assertive language which was to soften later in his life, Tucker there stated the ideas which sustained his art over the following half-century. His interest in myth, and in the power of myth to reveal the depths of Australian cultural values, led to a series of paintings entitled 'Antipodean Head', based on a pared-down form which could incorporate references to landscape and to the struggle to survive which he found in the sagas of exploration and pioneering activity of the previous century. Tucker spent the years 1947–60 in Europe and the United States, and it was towards the end of this period that his works, in particular the 'Antipodean Heads', began to enter major Australian and American collections.

Tucker's close contemporary Arthur Boyd (1920–99) was also

compelled in the 1940s to express the derangement of the war experience, but Boyd's armoury of approaches was at first more flexible and, in the end, more sustaining, than Tucker's. Boyd had been painting since his early teens and, following in the footsteps of his father, the potter Merric Boyd, had always been a direct and expressive painter. Whereas Tucker's artistic apprenticeship had been a dour struggle to throw off the Anglophile modernism which pervaded Melbourne's painting in the 1930s, Boyd's bright, direct landscapes, painted while he was in his teens, revealed him to be a readily instinctive painter.

Between 1940 and 1944 Boyd was also in the army, from 1942 serving in the Cartographic Company stationed in South Melbourne. There he abandoned the holiday mood of his pre-war work, and took on a new set of subjects, mostly taken from his surroundings in the beachside suburb of terrace houses: cripples, a woman who took her paralysed dog walking by its hind legs, a mad trumpeter on the beach. The approach to the canvas in these paintings is ferocious: it is not surprising to discover that Boyd took up drawing the same subjects with ink and a home-made reed pen, a medium which gave him an abrupt and powerful line.

In the years towards the end of the Second World War, Boyd's

vision became more broadly apocalyptic. Elements of Old Master painting, derived particularly from Rembrandt and Bruegel, became increasingly prominent in his works—large multi-figured scenes of a brutalized humanity. Yet there was a quieter, more domestic side to Boyd's work, expressed in a series of profound self-portraits [91] and portraits of friends and family members who were associated with the Boyd family pottery at Murrumbeena. The pottery was established in 1944 as a partnership between Arthur Boyd, Peter Herbst (later to become an influential teacher of philosophy in Canberra), and John Perceval (born 1923). Perceval was to continue to create a unique ceramic motif—the sculpted angel—as well as his own vigorous and exuberant landscape painting style.

Boyd's portraits of family and friends of the late 1940s are characteristic of a new mood of domestic contentment which followed the tormented wartime years. Marriage partners and children were subjects for many artists. Yet it was not a lasting mood: the next decade was more apt to treat children as symbols of anxiety about the future.

91 Arthur Boyd

Self-portrait, 1945–6

Arthur Boyd became known as a painter of landscapes and allegorical and religious subjects, but he produced powerful and compelling portraits in the 1940s, mostly of his family and friends. This is one of the greatest of twentieth-century Australian self-portraits, directly painted, yet indebted to the artist who Boyd studied intensively in the 1940s—Rembrandt.

Although they were widely separated in temperament, Boyd and Tucker shared a desire to find a deeper significance for Australian painting. Stories and myths growing out of the Australian landscape became important subjects for them. Following a trip to central Australia in 1951, Boyd had a subject on which to base a series of significant Australian paintings—the conditions and life of Aborigines. The results of his thinking were the 1957 paintings which told stories of the 'half-caste' bride, a symbol of dislocation and often, in Boyd's paintings, a victim of violence and manipulation.

Paradise garden: Heide

The Boyd circle at Murrumbeena was one of a group of centres of intense creative activity in Melbourne in the 1940s. The most important of these other centres was the farm of John and Sunday Reed at Heide, set on a gentle rise above the Yarra at Heidelberg. Appropriate to its setting among the pastures from which sprang the heroic Australian landscapes of the late 1880s, Heide harboured a high vision of a new Australian art. Both Reeds were passionate advocates of modernism (John Reed was one of the foundation members of the Contemporary Art Society) and, because they had more money than the impoverished artists who surrounded them, they could afford to buy the very latest publications from Europe and America for their library—Cyril Connolly's *Horizon*, *The Sewanee Review*, and catalogues of exhibitions at New York's Museum of Modern Art.

As devotees of progressive publications, it was perhaps inevitable that the Reeds would become involved in an antipodean avant-garde publishing enterprise. In 1943 John Reed and the Adelaide poet Max Harris established a publishing firm, Reed & Harris, and became publishers of *Angry Penguins*, a literary and artistic journal which Harris had begun as a student at Adelaide University. *Angry Penguins* is perhaps the most vibrant and contemporary publication to be produced in Australia in the twentieth century. It was very much a product of its time—polemical, devoted to poetry and new ideas—and its folding in 1946 somehow represented the ending of a period of intense cultural endeavour in Melbourne which had existed through the war years.[9]

The Reeds were typical of their generation in finding power and authenticity in the direct and unworked expression. The artist whose work most completely exemplified this spirit at Heide was Joy Hester (1920–60). Like many of the Heide set, Joy Hester was a poet as much as a visual artist. As a painter she abandoned oil painting very early in her career, but continued to make drawings—rapid, contrasty brush-and-ink drawings [92]. Hester's life was not easy: a brief marriage to Albert Tucker, a child whom she formally gave up to the Reeds for adoption, long periods of treatment for lymphatic cancer.

92 Joy Hester

Girl, 1957

The child was a subject endlessly painted in the 1950s—often as a symbol of innocence in a threatening world. Joy Hester's brush-and-ink drawings avoid the rhetorical and the mawkish aspects of the theme through their direct and unsentimental approach. In the best of her drawings Hester achieved a sense of graphic power and vitality, as in this drawing of the comet-like apparition of the young girl.

Her art somehow had to be fitted into this life, and took its subjects from the experiences of it. The spontaneity of her technique, the directness of her expression, and the poetic distillation of her subjects were the qualities which made her work so admired, particularly by Sunday Reed. Her subjects were simple and poetic images—lovers and faces were her persistent themes. There is a pervasive pessimism about Hester's work, relieved by occasional moments of tenderness and passion.

At Heide many artists came and went but the most important artist to work at Heide—Sidney Nolan (1917–92)—was a close and intimate part of the Reeds' circle throughout the early 1940s. Eventually, though, Nolan tired of the 'paradise garden': in 1947, after living mostly at Heide for some years, he left, making a complete break with the Reeds and the house. Yet it was at Heide that Nolan created his most significant series of paintings of the decade, the Ned Kelly series.

Sidney Nolan

Nolan was unquestionably the most original and inventive Australian artist of Australia's post-war decades. His experimentation had begun in the 1930s, when he was employed as a display artist for a Melbourne hat manufacturer. From the beginning of his career—which at first did not look like a career at all, since Nolan appeared to his contemporaries as doing nothing more than dabbling in poetry and longing wistfully for Paris—Nolan was experimenting with a range of mediums. Indeed,

his first solo exhibition, mounted in his studio in 1940, showed some of the range of his unorthodox uses of any material that came to hand. It consisted of a series of rapidly executed calligraphic drawings, abstract monotypes in simple primary colours, and collages made from cut-up nineteenth-century steel engravings.[10] If nothing else, the exhibition demonstrated Nolan's powerful determination to produce a completely non-figurative and avant-garde art.

Nolan's abstract work was distinct from the faintly utopian geometry which characterized the non-figurative stance of his Sydney contemporaries such as the 'Exhibition 1' artists. In addition to making drawings, Nolan wrote poetry and eventually his non-figurative works developed into simple poetic images—faces, ladders, stars, the structure of Melbourne's beachside Luna Park, the horizon of Port Phillip Bay. *Boy and the moon*, painted in 1939–40, a quite remarkable painting for its date which proved too extreme even for the Contemporary Art Society, demonstrates the extent of Nolan's originality [**93**].

Nolan's engagement with the European avant-garde took an entirely new direction after he was drafted into the army in April 1942. By May of that year he began what was to be a period of a little over 2 years as an army storeman and railway guard in western Victoria, in the Wimmera [**94**].[11] In this remote and flat landscape, Nolan began to apply his formal experimentation to what he saw and experienced. In late 1942 he reflected on his previous work: 'This is a very bright country, glittering in fact and we might have lived in a studio in Paris or Berlin, for the amount of good it has done us. We all took the policy of

Paris on, there was nothing else to do, but always [there] was the thought we would learn to tell our own story.'[12] The Australian landscape now became Nolan's preoccupation, and over the ensuing decade he experimented in an attempt to find a simple and lucid formal language through painting it.

The scope of Nolan's thinking was profound and far-reaching. In 1944 he began to paint stories in the landscape. The following year he discovered the subject which had sufficient scope to combine his interest in the nature of the Australian landscape, poetry, myth, and autobiography—the Ned Kelly story.[13] Between 1945 and 1947 Nolan was preoccupied with the late nineteenth-century bushranger whose mixture of daring, folly, and anti-authoritarianism had already ensured his status as one of the defining Australian folk figures. Many years after they were painted, Nolan said that the Kelly paintings were a post-war meditation on violence. They were also about action: Kelly as a poetic rebel reformer who 'did something about the world'. Ned Kelly's story was, Nolan wrote, 'a story arising out of the bush and ending in the bush'.[14] A deeper appreciation of Australia's landscape through myth was a significant motivation for the Kelly paintings.

One feature of the Kelly story—the fact that the gang had fashioned home-made suits of armour to protect them in the event of a

police siege—gave Nolan a superb vehicle for formal experimentation. The way in which he took the Kelly armour and transformed it into a square and put the black shape up against the landscape can be seen in *Ned Kelly*, one of the most distilled images in the series [**95**]. While the iconic shape of Kelly is simple—almost child-like—the series is enormously complex, its meanings multi-layered. Yet each painting retains a sense of directness and spontaneity. After Nolan left Melbourne in 1947, first to live in Sydney, then to move permanently to England in 1950, he continued to paint Kelly subjects (and to include the figure in paintings such as his masterpiece, the multi-panelled landscape *Riverbend*, 1965). He also explored some of the other stories of almost mythical dimension arising from the Australian bush—Burke and Wills, the shipwreck of Mrs Fraser, and the failed republican rebellion on the Eureka gold-fields in the 1850s.

Sydney painters of the 1940s

Nolan was not the only artist to be interested in vernacular survivals in the landscape in the post-war years. In 1947 Russell Drysdale and Donald Friend, both of whom were living in Sydney, came upon a rich source of landscape imagery in the gold-towns of Hill End and Sofala to the west of the Blue Mountains. Apart from a picturesque decay, these out-of-the-way villages had barely changed for decades, and the surrounding landscape of turned-up earth from nineteenth-century mining gave a distinctive worn landscape and historical resonance to these places.[15]

The discovery of Hill End as a subject came at a crucial moment in the development of both artists. Drysdale had studied at George Bell's school in the 1930s, and during the war years had developed a unique vision of the Australian landscape—coppery in colour, pervaded by a gloomy light (derived from the Surrealist experiments of Peter Purves Smith), and stark in form. This vision began in Drysdale's work of the early 1940s, when he and Donald Friend worked together in the New

The George Bell School

The George Bell School was Melbourne's most significant private art school of the mid-twentieth century. George Bell set it up in 1932, in partnership with Arnold Shore. After Shore's departure in 1936, Bell carried on alone and his teaching attracted a score of brilliant students, many of whom were already well-trained artists before they joined him. Bell's teaching was modestly modernist in outlook— he stressed the importance of three-dimensional (heavily modelled) form and fundamental design, principles he had absorbed when he studied as a mature artist at the Grosvenor School in 1934. Ian Fairweather was briefly in the Bell circle, but the students through whom Bell had the most lasting influence on Australian art were Russell Drysdale, Peter Purves Smith, Sali Herman, Fred Williams, and interior designer Frances Burke. The school operated until Bell's death in 1966.

South Wales town of Albury. Drysdale, who had sight in only one eye, was managing one of his family's pastoral interests; Friend was in the army and stationed nearby. In 1944 the depressing element in the landscape was intensified for Drysdale when he travelled through inland New South Wales recording the catastrophic drought of that year in the company of Keith Newman, a *Sydney Morning Herald* journalist. Drysdale's earlier paintings were reminiscent of the English artists Graham Sutherland and John Piper, with scooped-out forms, skeletal trees, and dark skies. In the outback such Surrealist motifs were transformed into a kind of eerie realism as the air filled with huge dust storms which further eroded the bare land [**96**].

Drysdale recognized, as did Margaret Preston, that to portray the Australian environment and distinctly Australian themes, he must engage with Aboriginal Australia. His earliest paintings of Aboriginal subjects were made in the early 1950s, following a trip to northern Queensland, and they continued the themes established in the 1940s paintings—pockets of human melancholy set against a featureless horizon. By the latter part of the decade Drysdale had

96 Russell Drysdale

The drover's wife, 1945
Painted in 1945, this was a direct result of Drysdale's 1944 trip into outback New South Wales. The germ of the idea was contained in a small drawing of a drover and his wife setting up camp. When he came to paint the subject, Drysdale exaggerated distances between the parts of the composition to extremes of attenuation: he stripped the trees to twigs, reduced the horizon to a line, and erased any discernible expression from the face of the woman.

developed a more complex pictorial space which allowed him to express, symbolically, his notion of the close relationship between indigenous people and the landscape. In an interview with Geoffrey Dutton, Drysdale described his fascination with 'the way in which a man comports himself in an environment which is his and has been his and his alone, he's at ease with it'.[16] To express this idea, Drysdale created a language in which the landscape of vertical abstracted rocks and trees intersects with the naked and decorated bodies of Aboriginal men and women to create a unified compositional field. It was an approach indebted to contemporary European painting, particularly in its opal-fire palette of hot reds and burnt oranges and the deployment of planes and lozenge shapes which slide across the surface of figures and landscape.

Donald Friend's approach to the historical dimension of the landscape was less weighty than Drysdale's. His drawings delight in what he described as the Hogarthian dimension of country life. Before he moved to Hill End, where he bought a cottage in 1947, Friend had been closely associated with a group of painters and designers who congregated at Merioola, a tumbledown mansion in Edgecliff, an eastern suburb of Sydney. This group included Justin O'Brien (see Chapter 10) and the theatre designer Loudon Sainthill, who shared with Friend a love of the theatrical, an enjoyment of the decorative (particularly a kind of music-hall Victorianism), and a devotion to cultures with a deeper sense of civilization than white Australia—Greece and Rome and South-east Asia. Inevitably these artists became expatriates—or at the very least inveterate travellers—living away from Australia for long periods. Friend lived for many years in Bali, and Justin O'Brien left Australia for Italy in 1967.

The Merioola group of painters and designers created a taste in post-war Sydney which was to prove enduring. It was a taste for art-as-lifestyle. To a great degree its antecedent was the world created by Thea Proctor (who, incidentally, ran a design class at Merioola) and Sydney Ure Smith in *Home*; its inheritor was Brett Whiteley. What all these artists shared was a fascination with Sydney as a place to live—the Harbour and the remnants of picturesque history.

There was another side to Sydney art in the 1940s—a serious engagement with modernism which carried through from the 1930s and which flourished in the 1950s. Although he did not live to see out that decade, Eric Wilson (1911–46) was an influential teacher who had left Australia in 1937 as a committed realist and returned from study in London in 1939 a devoted abstractionist. He experimented briefly with Cubism, but Wilson's last landscapes, painted for the art patron Sir Keith Murdoch, were attempts to come to grips with Australian subject-matter, to explore the deeper meaning of a rural landscape of bush-fires, bald hills, and ring-barked trees.

William Dobell

William Dobell (1899–1970) was the most visible Sydney artist of the 1940s and in many ways the artistic heir of George Lambert, particularly as his major field of activity was portraiture. Like Lambert, Dobell left Australia as a brilliant student. He spent almost a decade in London, from 1929 until 1938. During these years he studied at the Slade School and developed his unique style of figure and portrait construction from the drawing method taught there. The Slade School emphasized drawing as the basis of art and the favoured tool was the pencil, used to create form through directional hatching. Dobell simply extended this method to painting, laying down skeins of paint to create volume. The method was capable of great expressiveness and Dobell subtly adapted it to a range of subjects—*Mrs South Kensington*, *The Cypriot*, and a variety of lanky youths who posed in the poky bed-sitters in which Dobell lived during his London years.

Dobell's greatest portraits were the works painted in the years immediately after his return to Australia. A trio of his best paintings includes his portrait of the journalist Brian Penton, painted in 1942, his depiction of a labourer, *The Billy Boy* of 1943, and his most celebrated work, the portrait of Joshua Smith. It is impossible to discuss Dobell's work without reference to the Archibald Prize controversy of 1944, in which two disgruntled mediocrities took the trustees of the Art Gallery of New South Wales to court. They claimed that Dobell's painting of Joshua Smith [**97**], which won the 1943 Archibald Prize, had been admitted to the Prize in contravention of Archibald's bequest, because it was a caricature, not a portrait. The case, which opened late in 1944, is usually regarded as a face-off between modernists and traditionalists, yet Dobell himself regarded his practice as firmly grounded in European portrait traditions.

The arguments brought to bear on either side of the Dobell case do none the less highlight some of the divisions in Australia's art-world in the 1940s. The trustees won the day, the judge eventually finding that '[T]he Dobell picture of Joshua Smith … characterised by startling exaggeration and distortion … bears, nevertheless, a strong degree of likeness to the subject … It is a portrait … and consequently the trustees did not err in admitting it to the competition.'

Dobell's work of the late 1940s partakes of the decorative mood among Sydney artists of the period. Portraits of two artists, the painter Margaret Olley (born 1923) and the designer Elaine Haxton (1909–99)—both members of the Merioola gang—are all bows and summer hats and frills. Such portraits looked lively and had a refreshing lightness of touch amid the usually sombre portraiture of the period: they introduced some of the admired qualities in fashion and Bohemianism into a high-art context. The Olley portrait won the Archibald Prize in 1948.

97 William Dobell

Joshua Smith, 1943

Dobell painted this portrait of his fellow artist Joshua Smith as an entry for the Archibald Prize of 1943. Through a sequence of drawings Dobell had arrived at a heightened characterization and a rigorous composition based on the geometric shape made by the sitter's arms. This illustration is based on an early photograph of the work, which was irreparably damaged in a fire in 1958.

Like most artists of his generation, Dobell looked for ways in which to invigorate his art with new subjects and landscapes. In 1949 he visited New Guinea for the first time, flying into the central highlands, where he stayed for two months. Dobell was captivated by the mood of the place and early the following year he visited again, making numerous sketches in which he attempted to capture the distinctive qualities of this new landscape. He worked on New Guinea paintings almost exclusively until 1954, yet the qualities which attracted him in the landscape seemed to elude him. While he occasionally returned to the New Guinea theme, his engagement with it ceased in 1954, leaving him with a lot of provisional and small-scale works in which he had tried to bring the relationship between the villagers and their landscape into a pictorial equivalence. Overall, the New Guinea experience did not profoundly change Dobell's approach: until his death he remained rooted in the character portraiture that had brought him recognition in the 1940s as Australia's most accomplished portrait artist.

Icon and
Abstraction 1951–68

Non-figurative artists

In 1951 a group of Sydney painters exhibited together at Macquarie Galleries in an exhibition devoted to non-figurative art.[1] Three of the artists, Grace Crowley, Ralph Balson, and Frank Hinder, had exhibited in 'Exhibition 1' in 1939 and by the beginning of the 1950s were mature artists; each of them had been working with abstract art for decades. So the works shown in 1951 could be considered the mature product of the ideologies of the inter-war years, late fruits of reflection and experimentation.

Grace Crowley and Ralph Balson were both born in 1890 and by the mid-1940s had come to share an aesthetic sensibility which makes their works of the period virtually indistinguishable. Having worked with Crowley to create the geometric style typified by Crowley's *Abstract Painting* [**98**], Balson began to work in a looser and more painterly fashion in the early 1950s. He became increasingly interested in American Abstract Expressionism and at the beginning of the 1960s created a series of free-flowing works in enamel paint described as 'matter paintings', a title which was intended to draw attention to their non-objectivity. 'My painting', wrote Balson, 'is not associative either of England or Australia, or going for a walk or coming back from one. I try to find out what the substance of paint will give me, to make a Painting a Matter Painting.'[2]

Along with fellow abstractionist Godfrey Miller (1893–1964), Balson argued that his work was deeply indebted to the discoveries of modern science.[3] The fascination which Balson and Miller felt with scientific theory—and with transcendental philosophy—was characteristic of their generation's search for logic. It is important to distinguish them from the younger generation of Abstract Expressionist artists in Australia, for their art was rooted in the preoccupations of the 1920s and 1930s. It must be remembered that in 1950, Balson and Crowley were 60 years old and Miller was in his late 50s.

Whereas Balson's art strove for greater painterly freedom in the 1950s (he wanted to express the 'ineffable'), Godfrey Miller's painting was beset by a painfully microscopic approach.[4] His canvases were covered with a dense thicket of pen-and-ink lines, a matrix to which he

98 Grace Crowley

Abstract Painting, 1950

The blocks of colour that drift across the flat surfaces of the paintings of Grace Crowley and Ralph Balson sometimes suggest musical sequences of colours and tones, but in the most successful works appear to overlap, evoking space and transparency. This example is characteristic of an art which has developed considerably in freedom and subtlety when compared with the doctrinaire paintings she executed under the tutelage of André Lhote in France in the 1920s.

added a mosaic of dabs of finely modulated paint. The result is an impenetrably arcane and laborious style of painting. His life drawings, on the other hand, succeed where the paintings fail: they are fluent, open, and exploratory [**99**].

Most artists working in abstract modes in the 1950s produced derivative and superficial works. Australia had its share of such artists, whose work served to fill out the annual exhibitions of the Contemporary Art Society. Among the artists who could be singled out as exceptions to this overall blandness were the fine abstractionist Carl Plate (1909–77), the Polish-born painter and ceramic artist Stacha Halpern (1919–69), and the Lithuanian-born Henry Salkauskas (1925–79), one of the pioneers of the modern print in Australia. In 1963 Salkauskas surprised Sydney audiences when his untitled abstract screenprint became the first work of graphic art to win a major Australian art prize in preference to painting.[5]

Sculpture: Robert Klippel

The sculptor Robert Klippel (b. 1920) was an exhibitor in the 1951 exhibition of Sydney abstractionists. His work included a small sculpture which sounded a new note in Australian art, entitled *Entities*

Seated figure, c. 1950s

Godfrey Miller's life drawings, produced in many hundreds from the 1940s until his death, are constructed with a searching and superbly practised hand. Among the greatest of all Australian drawings, they demonstrate a grasp of relationships and exude a sense of space, vitality, and flux.

suspended from a detector, a carved and painted wooden construction, formal, yet playful. In 1952 Klippel mounted a joint exhibition with Ralph Balson, and while the work of the two artists shared some similarities, Klippel's sculpture (if not his drawings) had fundamentally different sources. Despite its formal concerns, Klippel's sculpture was rooted in Surrealism, which he explored during the years he spent in London and Paris between 1947 and 1950. Surrealism led to the construction of some joint works (painted sculptures) made with James Gleeson, but more profoundly influenced his subsequent practice in encouraging him to exploit chance as a strategy of artistic creation.

Klippel's career in sculpture began immediately after the Second World War. He had been an expert ship model-builder but with his developing interest in serious sculpture came the study of the figure,

100 Robert Klippel

Opus 182 Metal construction,
1965

In his comprehensive study of
Klippel's art, James Gleeson
described this as a key piece
in an important year of the
sculptor's work. Gleeson
described it as 'airy in its
thread-like weavings through
space, yet in its combination
of several distinct units rising
from a common base picking
up suggestions first made in
the sculpture-landscape
drawings of the 1950s'.

which he decided to pursue further at the Slade School in London. But Klippel's interests were not well served by orthodox training and with the zeal of an encyclopaedist he began a methodical study of the vocabulary of forms—the forms used by modern sculptors, the forms of the natural world, the forms of iron girders and intricate machinery. A London diary entry of 1947 made after a period of struggle with drawing is revealing:

I drew all sorts of things and was very excited … and I went home to draw out, in imaginative ideas, what I had seen at the museum. I felt the relationship between my present attitude and all those wonderful forms—constructions based on antennae, trees—in fact, all nature.[6]

The all-encompassing aspiration in this statement has been the driving force of Klippel's art, which has continued to combine the natural and the artificial into an organic whole. Originally working in wood, Klippel began to make metal sculpture in 1955. In 1963, at the end of a 6-year period spent working and teaching in the United States, he started to construct sculpture from discarded machine parts welded together in forms of great delicacy and inventiveness [**100**]. Yet Klippel's sculpture remained fundamentally organic, despite the use of pre-existing industrial components.

No Australian sculptor has approached Klippel's mastery of form and grasp of the inherent sculptural potential of new forms thrown up by twentieth-century industrialism. In an environment which remained largely devoted to English models—Henry Moore, Barbara Hepworth, and, later, Anthony Caro and Phillip King—Robert Klippel has been foremost of the Australian sculptors who have demonstrated sustained originality. Other sculptors of originality who emerged in these years include Inge King (born 1918) and Clement Meadmore (born 1929), whose Australian work was limited in possibility but who was able to create perfectly constructed yet monumental public pieces in rusted steel after he left Australia to live in the United States in 1963.

Ian Fairweather

The art of Balson and Crowley, Godfrey Miller, and the slightly younger artists Frank Hinder and John Passmore (1904–84) was assured in the decade of the 1960s. Through their teaching activities and exhibitions these painters were influential in forming the ideas of a much younger generation of abstract painters who looked to France and the United States for new models for painting. Yet the most significant abstract painter in Australia during this decade, Ian Fairweather (1891–1974), was, so to speak, out of circulation—living on Bribie Island off the coast of Queensland. Fairweather did not teach;

he was isolated and hermit-like, but he was not obscure. His work was regularly exhibited in Sydney and he exercised a powerful influence on Australian art.

In 1953, when he was 62, Fairweather settled on Bribie Island after a lifetime spent travelling and living in many places—Canada, China, Bali, Sri Lanka, India, the Philippines. He had been born in Scotland and lived most of his early life in England, where he trained in the 1920s. But the greatest influence on the shaping of his visual imagination was China (where he lived from 1929 to 1932 and from 1935 to 1936). Fairweather's first visit to Australia was in 1934, when he painted for several months with George Bell's circle in Melbourne. After the Second World War Fairweather returned to Australia. When he finally settled on Bribie Island, he spent the rest of his life there, living in a succession of chaotic huts he built near the beach.

Fairweather's art is rooted in English painting and his early training at the Slade School, but his early and persistent fascination with Asian culture and language transformed his art. The fluid line and abstract compression of calligraphy is an important characteristic of the works painted after his years in China. A mature work such as *Monsoon* (1961–2) [**101**], one of his greatest paintings, clearly evokes calligraphy, yet the calligraphy of monsoonal lightning only explains a part of the immensely complex formal structure of the painting. The painting is a rich accretion of layers, each one modifying the preceding layer, a play of transparency and opacity. The forms of figures and tropical buildings are merely suggested; the calligraphy oscillates between descriptiveness and a presence as paint, complete with drips and a literal display of fluidity which seems appropriate to the painting's subject.

101 Ian Fairweather

Monsoon, 1961–2

Like so much of Fairweather's art, *Monsoon* is an evocation of a remembered event. It has been convincingly suggested by Fairweather's biographer, Murray Bail, that the event which triggered the painting was a violent tropical storm which struck Bribie Island (where the artist lived) in November 1961.

The landscape as a source

Fairweather was not alone in his preoccupation with bringing together the formal concerns of the construction of paintings and description, or reflection, of the Australian environment and the landscape. These were ideas with which Sidney Nolan had grappled in the 1940s—before his departure to pursue his career in England—and they were taken up by the Melbourne artist Fred Williams (1927–82) in the latter part of the 1950s after he himself returned from a long period of study in England.

Fred Williams had begun primarily as a painter of the figure. Occasionally, in the company of fellow students Harry Rosengrave and Ian Armstrong, he would make free gouache sketches in the bush near Melbourne, but the figure was his main interest. After study at the National Gallery School in Melbourne and under George Bell in the late 1940s, Williams had mastered aspects of figure drawing and in 1951 left Australia to continue his studies in London. He based his work

102 Fred Williams

Sherbrooke, 1966

In the gum-tree forests of Sherbrooke in the Dandenong Ranges, the verticality of the tree-trunks provided Fred Williams with a motif of formal simplicity and descriptive nuance in equal measure. *Sherbrooke* is subtly coloured with the pinks and greys of the forest and its sense of space is created by an ambiguous interplay of lines and planes. By 1966 Williams had hit his stride as a major landscape artist.

around the street life and the music hall and began to make grimy etchings of acrobats, clowns, and washerwomen. These were the first forays in Williams's career as a major Australian printmaker.

When he returned to Australia, Williams immediately began to paint the landscape. Initially his motif was the dense wall of foliage and tree trunks presented by a close-up view of the bush [**102**]. Nowhere is the intensity of Williams's investigation of the bush more evident than in his monumental cycle of works based on landscapes in the You Yangs, a range of hills to the west of Melbourne. The You Yangs, covered with open scrub and rocks, with vantage points over the plain towards Port Phillip Bay, provided Williams with endless landscape possibilities and pictorial problems [**103**].

Williams traditionally made gouache drawings, oil paintings, and prints of each of his most successful compositions. In his art, ideas often emerged first in etchings. The finely tuned horizonless prints of the mid-1960s prefigure an increasing minimalism in his landscapes which reached its most extreme point at the end of the decade. Landscape remained the source of his ideas, but now, clearly influenced by colour-field painting, he attempted to make large-scale works with dense, opaque backgrounds. The 1969 paintings to which he gave the generalizing title *Australian Landscapes* are monumental fields of a single colour arranged in blocks and modulated by tiny flecks of paint. Through their size and intensity these spots evoke contour and space; James Mollison has described these severe and reductive paintings as Williams's attempt to convey the vast scale of much of the Australian landscape. After 1969, however, having reached an extreme of minimalism, Williams's painting became more densely coloured and textured; it was increasingly able to describe a variety of Australian

103 Fred Williams

Knoll in the You Yangs, 1965
The knoll in the You Yangs was the subject of a gouache, two oils, and an etching which Williams worked through 35 variant states. In each treatment he brought out new aspects of the motif— sometimes the geometry of the knoll's pyramidal shape, at other times the rhythm of the trees or the weight of the rocks. The upper half of the composition with its upward drift of the spots of paint suggests the distant plain below the outcrop.

landscape types, from the lush rainforests of Queensland to the hard iron-ore ranges of Western Australia's Pilbara region.

Fred Williams was the most dogged and persistent explorer of the idea that Australia's landscape could be the source of pure paintings, but there have been many others. Janet Dawson (born 1935) began her career exploring the shapes and forms which loosely fitted together to make up the Italian landscape at Anticoli Corrado, where she studied in 1960–1. After her return to Australia she was considered to be an abstract painter, a status confirmed by her inclusion in the exhibition 'The Field', Australia's most determined statement of belief in colour-field abstraction (discussed in Chapter 11). Dawson was a very fine and subtle abstract painter—never doctrinaire, always concerned with nuance and the possibilities of paint. After her move to live in the bush in 1973, Dawson's work became engaged with the qualities of the natural world: not only the landscape [**104**], but the sheen of birds' feathers, the shapes of growing things, the endless pictorial possibilities of vegetables tended in the garden.

John Olsen (born 1928) has been less interested in the formal qualities of the landscape and more inclined to express a personal vision of landscape experience. His persona is passionate and expansive—the antithesis of the dour and misanthropic John Passmore, Olsen's

105 John Olsen

Goyder Channel, 1975

Goyder Channel is a creek which drains into the Lake Eyre Basin. Olsen's watercolour is restrained and minimal, yet the surface of the Torinoko paper (like a salt pan) and the materials (watercolour, drying to a stain of pigment) combine to profound effect. Chinese and Japanese philosophy play a part in the conception: what is important in the work is not the form, but the central void—the space between.

teacher in the 1950s. Whereas Passmore sought throughout his painting life to get beyond the dead end of a feeble Cézannism, Olsen's first mature paintings were exuberant and expressive, and his art has continued in this vein. He has deliberately made it difficult to find the compositional focus of his almost rococo paintings, compelling the viewer to find tracks through them. The artist himself has been divided between his devotion to crude Australia and his love affair—which began in the early 1960s—with Spain, a country similar to Australia in its light but dissimilar in its consciousness of tradition, deep religiosity, and mixture of patrician values and peasant culture.

Olsen's painting of the 1960s was infused with a sense of fun, a rare quality in Australian art. His art shared some of the larrikin humour prevalent among a generation of Sydney writers, cartoonists, and journalists. The series of landscapes painted after his return from Spain, in which he dubbed Australia the 'you-beaut country' after a popular vernacular expression, were intended to suggest the experience

of making a journey through the landscape. Olsen subsequently painted many works recalling travels in and over outback Australia.

Among Olsen's best paintings of the landscape are those which resulted from his visits to Lake Eyre in the desert of South Australia. Lake Eyre is a salt lake—the sort of landscape which led nineteenth-century explorers to despair [27]. Very occasionally, however, the Lake is the site of massive inundations of rainwater. Olsen first visited it in late 1974 with the naturalist Vincent Serventy in the wake of one such flooding. The miraculous transformation of the landscape from a barren salt pan to a lake teeming with living things gave Olsen a subject which combined his feeling for a 'life-force' and his sense of the monumental scale of the Australian interior. Captivated by the interior landscape, Olsen visited on several subsequent occasions in the 1970s [105].

David Moore, photographer

The distinctive landscape, light, and textures of Australia have been irresistible subjects of exploration for photographers. The twin demands of empiricism and the creation of a formally satisfying visual language have been accepted as basic to modern photography as art: they have driven the investigations of many Australian photographers of the twentieth century.

Foremost among the landscape photographers of post-war Australia is David Moore (born 1927), who shares with the painters of his generation a deep concern for the formal coherence of the image. *The Impossible Tree 11* is a fine example of the photographer's capacity to find motifs in the landscape [106]. His photographic practice is rooted in modernism and abstraction. His father, John D. Moore (1886–1958), was a leading modernist architect and a painter of landscapes. Furthermore, he spent a formative period at the property of the sensitive painter

106 David Moore

The Impossible Tree II, 1972
Although Moore is a superb photographer of the man-made world (ships, bridges, and buildings), he has a great empathy for the bush and in 1972 built a bush retreat at Lobster Bay, to the north of Sydney. This photograph was taken there—in the 'environment of twisted angophora trees, lichen-covered rocks as big as houses, and beaches'.

of landscape rhythm, Kenneth Macqueen, in Queensland. Yet from the outset, Moore's practice has combined this formal concern with photo-journalism—a field which produced some of the most memorable images. His photograph of a group of European migrants arriving on board ship in Sydney in 1966 is justly recognized as an iconic image—a frieze of monumental structural power within which is discovered a range of gesture and expression such as one might find in an eighteenth-century French narrative painting.

John Brack

In 1968 the Melbourne painter John Brack (1920–99) made the simple but significant observation that the image of Australia presented by Fred Williams, Sidney Nolan, and Russell Drysdale did not embody the landscape as most Australians experienced it. Drawing attention to these artists' evocations of an imaginary antipodean desert, Brack

107 John Brack

The car, 1955

Brack had originally intended to set this in an urban setting, but in making the decision to pare back the background and concentrate the composition, he was able to illustrate 'a phenomenon important in our time'—the Sunday drive. This sets the suburban visitors in a landscape which remains 'remote, ancient, not interested in the lives of little people and their cars'.

wrote, 'the experience of the vast majority of Australia is not like that at all, and what [Australians] see apart from the cities is a land criss-crossed by roads, dotted with telegraph poles, hoardings, milk bars and loud with the sound of trucks and cars'.[7]

In his own art Brack deliberately set out to confront the visual experience of city and suburban living. This subject-matter was taken on almost as an act of defiance in the face of what Brack perceived to be an Australian art lacking intellectual rigour and over-reliant on emotional excess. From the moment of his first solo exhibition in 1953, Brack embraced subjects which were patently unheroic—a barber shop, a fishmonger's window, a butcher's block. Yet he treated these seemingly banal subjects with an unblinking scrutiny and precision of depiction. He carefully constructed his paintings to create formal coherence. Not only in his subject-matter, but in his avoidance of flamboyance, accident, or anything in which the whiff of personality

The Antipodeans, 1959

In August 1959 a group of Melbourne artists mounted an exhibition accompanied by a polemical essay composed by Bernard Smith with the title 'The Antipodean Manifesto'. The artists included were loosely linked by some stylistic affinities, and the Manifesto itself, while it had little appreciable effect on the direction of art in Australia, highlights a distinction, strongly felt in Melbourne, between figuration and pure abstraction. The artists who exhibited in the single exhibition of the Antipodeans were Arthur Boyd, his brother David, John Brack, Robert Dickerson, Charles Blackman, and Clifton Pugh. In the ensuing years these artists sought to distance themselves from the definite programme which the grouping and the Manifesto implied. The Manifesto itself was intended as a 'defence of the image'— 'image' being defined as 'the recognisable shape, the meaningful symbol'. The Manifesto read, in part, 'Today *tachistes,* action painters, geometric abstractionists, abstract expressionists and their innumerable band of camp followers threaten to benumb the intellect and wit of art with their bland and pretentious mysteries. The art which they champion is not an art sufficient for our time …'.

cult could be detected, Brack created paintings which were for many decades treated as somehow 'outside' the mainstream of Australian art. This role as 'outsider' seemed to fit Brack's strategy of standing aside from the world and observing it with detachment and irony.

Brack liked to draw attention to the artifice of his works by introducing framing devices. In *The car*, a work of 1955, the cabin provides a framing device which draws attention to the painting's inside and outside dimension, a feature of all of Brack's subsequent work [107]. Brack's interest in artifice became more heightened as his painting developed through the 1950s. He based series of works around highly stylized motifs—shop-windows, horse-racing, ballroom-dancing (which preoccupied him in the late 1960s and which produced some of his most memorable works). The formal language which he developed eventually saw him pare down his subjects to variations on two ideas— the endless possibilities of the nude in the bare studio and the dramatic and formal possibilities of simple objects such as pens, pencils, walking-sticks, and postcards. From the outset Brack's nudes were deliberately presented as artist's models, detached from the world through boredom or languor and posed in a studio setting the sterility of which is relieved by the inclusion of a Persian rug.

Expatriate painters

Brack has come to be regarded as a painter of suburbia, yet suburbia was, to be precise, his subject only for patches in the 1950s and 1960s. The Adelaide-born painter Jeffrey Smart (born 1921) has been seen in a similar light, largely as a result of a single, often-reproduced, and undeniably fine painting, *Cahill Expressway* (1962) [108]. Like Brack, Smart is a painter of formal inventiveness and his subjects have been as much about man in nature—the way there is a man-made nature as

compelling as the natural world—as about the sterility of the city. Like
Brack, Smart found his subject and his formal language as a young
painter and retained its essential coherence through subsequent decades
and changes of environment. Smart's 1946 painting of the black-and-
white striped obelisk at Cape Dombey near Robe on the southern coast
of South Australia prefigures all his later painting: it is a piece of incon-
gruous man-made pattern set against the chaos of nature.

Smart went to live in rural Italy in 1963 and later explained his deci-
sion to leave Australia as exasperation with its dullness and isolation.
Italy, by contrast, was modern, and he 'adored the modernity as well as
the antiquity'.[8] A more deliberately archaizing painter than Smart, and
an artist who had a great admiration for Smart's work, Justin O'Brien

The 'Annandale Imitation Realists'

In 1961, three Sydney artists—Mike Brown, Ross Crothall, and Colin Lanceley—
formed a trio and dubbed themselves the Annandale Imitation Realists. Under that
name they mounted exhibitions in Sydney's Rudy Komon Gallery and Melbourne's
Museum of Modern Art and Design. Their art was chaotic, exuberant, and profuse—
collaborative collages consisting of junk and plastic objects, doodle-like drawings,
and paintings celebrating a bizarre cast of invented characters. In an introduction to
their Sydney exhibition, Mike Brown summed up the group's position in the art-
world of the early 1960s: 'At different times the work has been called Fine Art, and
Anti-Art, and irresponsible Nihilism, and Junk Culture, and mere Junk, and Modern
Totemism, and modern reliquary, and satirical goonery, and inspired or uninspired
doodling, and Sheer Corn, and Dada, and neo-Dada and Lah-de-dah and what-
you-will. It has also been said to comprise a new Art Movement. God Forbid.' With
the departure of Colin Lanceley for a long sojourn in Europe in 1964, the group
dissolved and the artists pursued separate careers.

(1917–96), left Australia to live in Rome in 1967 and remained there until his death. O'Brien's preoccupation with European religious imagery developed in Australia very early in his career, with large imitations of early Italian painters. His best paintings of the 1950s and early 1960s, however, are not the self-conscious attempts to create an Australian religious idiom, but the portraits, particularly the sensitive portraits of boys who attended his art classes at Cranbrook School. Like Smart, O'Brien was not cut off by his expatriate existence because he, too, continued to exhibit in Australia throughout his painting life.

The degree to which Jeffrey Smart and Justin O'Brien might have felt themselves seriously out of step with their fellow painters can perhaps be gauged from the contrast between their work, as included in the Tate Gallery's 1963 exhibition of Australian painting and the work of their almost universally more abstract-leaning or deliberately 'Australianist' contemporaries.

The Tate Gallery exhibition (which followed an exhibition of two years previously at London's Whitechapel Gallery) cemented the early careers of a number of Australian artists, such as the Brisbane artist Jon Molvig (1923–70) and Leonard French (born 1928). The most precocious artist to be included was the 24-year-old Brett Whiteley (1939–92), who had also been in the Whitechapel survey. Whiteley's paintings were virtuoso exercises in a kind of sexualized landscape-based abstraction. Whiteley was living in London by the early 1960s and his bravura drawing style and pop-culture status ensured that his work was widely admired. He continued living in London until 1969, when he returned to Australia. His unashamedly hedonistic paintings of the mid-1970s are the most relaxed and honest work in an *œuvre* too

often characterized by the overblown and rhetorical. His best works celebrate the relaxed linear rhythms of the rural landscape and the dream of living in Sydney, surrounded by the Harbour and sensuous women, with frangipanis and palms rustling outside the open windows [109]. In many ways Whiteley's paintings of the artist's life in the harbour city represent the ultimate in lifestyle aspiration paintings.

'Australian Aboriginal Art'

In 1960–1 a major exhibition which toured the state galleries of Australia, was, in terms of increasing understanding of an aspect of contemporary Australian art, probably more important than those that toured to England in the same years. 'Australian Aboriginal Art' included 115 objects, mostly bark-paintings and sculptures from Arnhem Land, and led to the publication in 1964 of an ambitious book of the same title, with contributions by six significant authors. The exhibition was organized by Tony Tuckson (1921–73) and he was responsible for a chapter in the subsequent volume. Tuckson was himself a fine abstract painter [110], but his more public face was in his role

110 Tony Tuckson

Five white lines (vertical) on black ground, 1970–3
Simple in conception, deliberately limited in palette but vigorously gestural, this is a typical work of Tuckson's mature abstraction. As he was an art-gallery administrator, Tuckson's painting activity was barely visible during his lifetime, but since his death in 1973 the full extent of his commitment to abstraction has emerged.

as deputy director of the Art Gallery of New South Wales. For more than a decade he was responsible for developing that Gallery's collections of Aboriginal and Melanesian art.

Tuckson's interest in Aboriginal art was not primarily ethnographic; as an artist he had a deep appreciation of its aesthetic impact. He sensed that the inherent qualities of the materials of Aboriginal art were important. He wrote that 'the texture of cleaned bark, the lustre of pearlshell, and the softness of down or the colour of feathers or paint, have a direct impact on our senses. And this directness is an important characteristic of Aboriginal art'.[9] Tuckson's own aesthetic, represented in his bold, gestural paintings, led him to appreciate the simple harmony of the bark-painter's palette and to an observation that 'line permeates all Aboriginal art ... In all its forms their linear art reflects the image, the spirit of Aboriginal society as a whole'.[10]

Tuckson's major collecting was undertaken during two field trips to northern Australia in 1958 and 1959. He was taken on these trips by the orthopaedic surgeon, patron, and enthusiast Stuart Scougall, and they were accompanied by Margaret Tuckson and Dorothy Bennett. On the 1958 trip they commissioned the 17 graveposts from Melville Island [111], which made a great impact when they were acquired and displayed in the following year by the Art Gallery of New South Wales. Individual examples of such graveposts and associated objects had been collected earlier by Baldwin Spencer [55] and other museum curators, but the particularly large and spectacular group demonstrated perfectly those aesthetic qualities that Tuckson so admired in Australian indigenous art. Traditionally made as part of the *pukamani* ceremonies, the posts are, in effect, abstract representations—the personal attributes, gender, clan designs, and totems of the deceased person are all encoded in the shape of the posts and the designs painted on them.

On their 1959 field trip Tuckson and Scougall visited Yirrkala, where, following the example set by Mountford a decade earlier, they commissioned a series of bark-paintings. These works formed the nucleus of the Aboriginal art collections of the Art Gallery of New South Wales and were central to the 1960–1 touring exhibition. Several of these works depict the major Yolngu creation stories. One of the more spectacular and rich examples was painted by Mawalan Marika, one of a family of artists with responsibility for painting the Djang'kawu story [112]. Tuckson took pains to record the public meanings embedded in the paintings.

The painting illustrated here was not the only Djang'kawu bark painted by Mawalan and his family for the 1959 party. As recorded in Tuckson's notes, the painting of these 'encyclopaedic' works was attended by a great seriousness, appropriate to the recording of these creation myths. Descriptions of the iconography can simply point to

certain elements of the painting but cannot indicate the depth of connectedness between this narrative and the other narratives which surround it. Neither can such descriptions adequately explain how the form of the work and decisions about composition and structure are intimately connected with its meaning. This is equally true of Mawalan's sculptural figures which were collected by Tuckson and Scougall in 1959, which also represent the ancestral beings of the Dreaming. In 1960–1, however, what was important about showing these works with their attendant stories was to make known the richness, the variety, and the ritual seriousness of Yolngu visual culture.

112 Mawalan Marika

Djang'kawu Creation Story,
1959

The birth of the people of the clans of the Dhuwa moiety: in the top part of the composition the Djang'kawu sisters stand on either side of a sacred waterhole. Their brother, who accompanied them on their westward journey of creation, is in the top right. In the central and lower panel the Djang'kawu sisters give birth to the people. The middle band depicts the digging sticks that the sisters thrust into the ground on their journey, which created waterholes and grew into trees. On the right of this panel the sisters and brother look at the two star shapes always associated with the Djang'kawu story. This shape refers to the Morning Star and to the rays of the setting sun which guided the trio from the east.

113 Unknown artist, Aurukun

Fish on poles, 1962

This remarkable sculpture was one of several collected by the anthropologist Fred McCarthy at Aurukun in 1962. Such sculptures were the focus of ceremonial dances—this one representing night fishing and the suspension of fish on a rack. The distinctive red and white decoration and bold carving of forms are characteristic of these sculptures.

In addition to the sculptural traditions of the Tiwi and Yolngu, which became more widely known in the 1960s, the unique sculptural traditions of the people of Aurukun on Queensland's Cape York Peninsula were made manifest in a collection by the anthropologist Frederick McCarthy in 1962. By the 1950s the people at the mission at Aurukun had developed a set of ceremonies which incorporated large wooden painted objects. McCarthy visited Aurukun to record these ceremonies and brought the sculptural objects into the collection of the Museum of Australia. *Fish on poles* [**113**], for example, formed the focus of a dance which enacted night fishing. The sculpture demonstrates the characteristic plastic quality and boldness of three-colour decoration of the Aurukun sculptors' work. Always alert to the aesthetic dimensions of indigenous art, the Czech-born painter Karel Kupka (who was himself responsible for the creation of a major collection of Aboriginal art) described the Aurukun pieces in his 1965 book *The Dawn of Art* as 'true sculpture'.[11]

nunloommi
kribbig

ma! Hill

New Harbour Range

Cox Bluff

Saying and Seeing: Contemporary Art 1968–99

11

A question has beset Australian art in the last 30 years: what is the relationship between art and life? Despite occasional optimistic pronouncements, the question remains unanswered and is, perhaps, fundamentally unanswerable. The question has been posed with urgency since the late 1960s. The reasons for this urgency are complex, yet clearly the question is a political one—it concerns the power of art in society and the limits of that power. We might pose the question another way: does art matter? If not, does its perceived lack of efficacy result from its having become a marginalized and self-referential activity, an activity with little relevance except for its initiates?

Artists have employed various strategies to address this question. Some have emphasized the conceptual elements of art-making, treating *living itself* as the subject of art; others have pushed art practice into an apparently more public domain of architectural decoration, poster-making and political activism; others, following the lead of feminism, have rescued the forms of arts and crafts which have been traditional to the daily lives of people in marginalized groups; others have asserted the crucial role of art as an expression of identity; others have become increasingly drawn to photography as a deliberately de-aesthetized tool of visual recording. While many of these strategies have been superficial, there is a deeper level at which artists have sought to explore the relationships between the visual arts, language, and politics. This investigation is the constant theoretical background for much Australian art in the last three decades of the twentieth century.

Object and post-object

In 1968 the National Gallery of Victoria opened its new building with an exhibition entitled 'The Field'. The exhibition stands as a landmark exhibition for several reasons: it declared an unequivocal allegiance to the contemporary art of the United States (a relatively new note in the predominantly Anglophile Australian art-world, first sounded in 1967 with the success of the touring exhibition 'Two Decades of American Art'); it demonstrated a renewed commitment to contemporary art on the part of Australian public art museums; and it launched the careers

of a generation of significant artists. 'The Field' comprised the works of 40 Australian painters all working in abstract styles variously described as 'hard edge' or 'colour-field'

While 'The Field' was a bold declaration of Australia's place in contemporary painting, it was clear, by 1968, that there were many other ways in which artists could engage with the nature of the art object, and a significant number of artists developed a mistrust of the orthodoxy which the exhibition represented. In 1971, the Sydney theorist Terry Smith included the following statement as one of the 'Ten Propositions' which he wrote to introduce the Contemporary Art Society exhibition 'The Situation Now: Object and Post-object Art':

In all the arts, the notion of the self-referring art object (and its associated notions of 'physicality', the 'real', 'objecthood') has become dogma. The object (in colour-painting, or coloured metal sculpture, for example) is seen as the culmination of mainstream aesthetics, as an art-for-art's-sake pursuit, as a thing which embodies no more than the ritual of making it. It is claimed that this sort of art offers only closed information, is devoid of idea-content, and is merely sensuous. This is a false generalisation about the physical object as such in art, but it does reflect the way the notion of physicality has recently dominated the way we see the potentialities of the object in art.[1]

There was an inevitable political dimension to this 'proposition'. For Smith the prevailing obsessions with the qualities of the object were, ultimately, limiting. He offered post-object art as an escape from the commodification of art characterized by what he described as the 'ludicrously exaggerated and irrational microcosm'—the art market. In retrospect it seems that such aspirations proved illusory.

114 Nigel Lendon
Structure for a specific site,
1971
At the Mildura Sculpture Triennial of 1970 Lendon had exhibited sculpture made up of modular units with no predetermined arrangement and in his 1971 work he continued to use modular units. In this site-specific piece he employed everyday materials—steel scaffolding—to create a work which was transitory, existing for only 3 weeks in February–March 1971. The work transformed the entire interior space of Watters Gallery in Sydney into a sculptural experience.

One of the distinct phenomena of the latter part of the twentieth century was the proliferation of large survey exhibitions of contemporary art—Biennales and Triennales—in which works were brought together under a curatorial theme. One of the most rewarding of these events was the Sculpture Triennial mounted in the country town of Mildura. Begun in 1961 as a sculpture prize, its heyday was the early 1970s when it was a significant focus of avant-garde sculpture in Australia. The first 'Biennale of Sydney' was mounted in 1973 and was most imaginative and stimulating in the late 1970s and early 1980s. 'Australian Perspecta', an exhibition focused on new Australian work (rather than international art), was instigated by the Art Gallery of New South Wales in 1981 to be held annually, alternating with the Biennale year. The first Adelaide Biennial of Australian Art was held in conjunction with the Adelaide Festival of the Arts in 1990. In addition to these events, Australia supports selected artist exhibitions in its purpose-built pavilion at the Venice Biennale.

Of the artists whose work was included in the 1971 exhibition, Nigel Lendon (born 1944) could be taken as an exemplar of the polarity 'object'–'post-object'. In 'The Field', Lendon was represented with two coloured sculptures, one of which set ultraviolet lights against shapes painted in a strident primary yellow. Three years later, Lendon's *Structure for a Specific Site* [**114**]—a work of extreme provisionality— was taken to be an exemplary work of post-object art.

The Melbourne painter Peter Booth (born 1940) was represented in 'The Field' with purely abstract painting, but in the following decade his work exemplified a shift towards another kind of engagement with objecthood—figuration. In the 1960s and early 1970s Booth's large black panels with gritty, lustrous surfaces suggested the realm of night. But by the middle of the decade he was making paintings and drawings

115 Ken Whisson

Disembarkation at Cythera (Idiot Wind), 1976

Whisson's paintings have always possessed a sense of enigma. This work, painted in Melbourne during a break from the artist's long domicile in Italy, takes its title from Watteau's celebrated fantasy. Yet the setting of this work— the industrial water-lanes of Port Phillip Bay—could hardly be further from Watteau's dream of romantic love.

in which this realm was given form—lumpen people trudging down roads under black skies, distant furnaces, figures without heads, Kafka-esque insect-men. These imaginings developed into a series of monumental paintings which began in 1977 and were recognized as heralding a new and powerfully figurative element in Australian painting of the 1980s.

Of course there were many artist working in the 1970s who had never abandoned figuration at all. A fine painter such as Ken Whisson (born 1927), whose roots are in the radical Melbourne avant-garde discussed in Chapter 9, continued to explore, throughout the 1970s, the possibilities of a style of painting which oscillates between abstraction and figuration [115]; Arthur Boyd demonstrated in an even more direct way the continued preoccupation with the themes of the earlier generation in a masterly series of major paintings in 1972–3 which fed into his passionate engagement with the landscape of the Shoalhaven River in the 1980s [116]. Keith Looby (born 1940), who has always painted figurative pictures, the best of which explore autobiographical themes, proved to be a major Australian portraitist. Jan Senbergs (born 1939), only briefly an abstract painter, has continued to be a forceful and imaginative presence in Australian figurative painting. And William Robinson (born 1936), who proved to be a figurative artist of enduring quality in exhibitions throughout the 1970s and 1980s, emerged in the 1990s with a series of mature landscape paintings which explored, with great sensitivity to nuance

116 Arthur Boyd

Bathers with Skate and Halley's Comet, 1985

In 1973 Boyd bought a property on the Shoalhaven River, on the south coast of New South Wales. The epic landscapes he painted there explored the relationship of mankind to the landscape. This work is, on one level, an indictment of Australian hedonism: lobster-red bathers lie in the sun, blind to all around them and unaware that their hedonism is, in the artist's words, 'a dying business, an ending'.

and light, the complex experience of the Australian bush. There is a quality of nineteenth-century sublimity and abundance in Robinson's work.

Contemporary Aboriginal Art

While artists in Australia's metropolitan centres argued over the efficacy of art in society and the most effective approach to the object, the movement of Aboriginal art from a peripheral practice to a central position in Australian art was making dramatic beginnings. This shift had everything to do with the issues of contemporary moment—abstraction, commodification, the nature of closed or open systems of meaning, and, most importantly, political empowerment. It was a shift

117 Clifford Possum Tjapaltjarri

Bushfire II, 1972

The motif of this small, early Papunya painting—the effect of fire on a landscape, with the ashes and charcoal covering animal tracks—is apparently simple. Bushfires are, however, part of larger multi-layered Dreaming stories explored in the artist's subsequent paintings. Those associated with Warlugulong, a site north of Alice Springs, describe the actions of the ancestral figure Lungkata who created an immense bushfire which led to a complex of creation events associated with a vast tract of country.

enabled principally by the adoption of non-traditional mediums by people in central and western Australia for the expression of traditional motifs and bodies of knowledge.

The 1970s saw the beginning of artistic enterprises in a number of remote desert communities, most spectacularly the acrylic painting movement centred on Papunya. The catalyst for this movement was the work of the art teacher Geoffrey Bardon who, some months after his arrival in the depressed desert settlement of Papunya in 1971, encouraged the production first of murals, then of paintings. Bardon's account of the development of Papunya painting describes how he encouraged the dispossessed and dispirited Papunya men (who originated from a range of backgrounds and language groups, but who had come into the settlement after its establishment in 1960) to paint their traditional lore on to boards.[2] These works were based on designs traditionally made on the ground or painted on to the body during ceremonies, and embodied the Dreamings of the sites from which the men originated. The paintings were iconographically dense and were susceptible to complex narrative interpretations, which Bardon faithfully recorded.

The distinctive style which developed at Papunya resulted in part from Bardon's injunction against non-Aboriginal modes of representation: the artists were to use 'no whitefella colour, no whitefella perspective, no whitefella images'.[3] Despite the apparently arcane nature of their depictions, Bardon found that there was a ready market

118 Clifford Possum Tjapaltjarri and Tim Leura Tjapaltjarri

Napperby Death Spirit Dreaming, 1980

Three Dreamings are arranged around a story track: Old Man's Dreaming is depicted in the rectangular shape in the upper half of the left-hand side of the composition; the Yam Dreaming occupies the lozenge shape in the upper right-hand side; and the Sun and Moon Dreaming is depicted in the lower right-hand corner. The concentric circles around the track are resting places and immersed in the country are campsites, windbreaks (the semi-circular forms), and running water.

for the paintings, and production during 1971 and 1972 was prolific. As the curator Judith Ryan has written, 'What nobody could have predicted then is that the seemingly abstract designs painted on anything that came to hand would speak so directly to a white audience accustomed to the visual language of Abstract Expressionism, Conceptualism, Minimalism and Op Art.'[4] In 1972 the artists formed the company Papunya Tula Artists Pty Ltd, and began relationships with a series of art advisers who have continued to develop the market for their works.

Bushfire II [117], painted by Clifford Possum Tjapaltjarri (born *c.* 1943), is a small work, one of the early paintings of an artist who has continued to paint and exhibit throughout the world. While the first works produced at Papunya were painted 'on anything that came to hand', artists such as Clifford Possum eventually worked on canvases, occasionally of enormous scale. The immense 7-metre-long canvas *Napperby Death Spirit Dreaming* [118], painted in 1980 by Tim Leura Tjapaltjarri assisted by his brother Clifford Possum, shows dramatically the increase in scale, complexity, and ambition of the Papunya painters' work within the first decade of the painting movement. The work was commissioned by Geoffrey Bardon, who described it as 'a savagely brooding, terse journey, with the black human death emblem watching over the enormous, sinuous story track'.[5] The painting is really several paintings in one, and the incorporation of these several

elements allows the viewer to understand how the iconography of much Papunya painting operates. Unlike Clifford Possum's *Bushfire II*, which focuses on one Dreaming, this canvas incorporates the three Dreamings which defined the artist's life, each disposed around the story track.

Straightening spears at Ilyingaungau by Turkey Tolson Tjupurrula (born *c.* 1942) [**119**] demonstrates a close connectedness between the form of the work, the landscape, and the Dreaming associated with a specific place. The success of the Papunya painting movement consisted precisely in this—giving forceful expression to the connectedness of Aboriginal people to land, and in providing cultural expression to otherwise impoverished groups of people. Papunya created a pattern which was replicated throughout many central and western desert communities in the ensuing decades. From the early 1980s the communities at Yuendemu, Mount Allan, Lajamanu, Balgo Hills, and Utopia developed art practices of enormous vitality and visual variety.

Several features of the art movement in Utopia made it utterly distinctive. While the Papunya painting movement developed among a group of senior men, the art movement at Utopia has been largely the preserve of women. Furthermore, its roots were not in sand-painting

119 Turkey Tolson Tjupurrula

Straightening spears at Ilyingaungau, 1990

In its severe minimalism this painting seems to evoke the very desert landscape from which its subject derived. The painting tells the story of a confrontation between one group of ancestral men travelling from Tjukula in central Australia to Ilyingaungau (a rocky outcrop far to the west of Alice Springs) and another group coming from the north. The lines in the painting are spears being prepared for a fight and their flight.

120 Emily Kngwarreye

Wild Potatoes Dreaming, 1991
Essentially the structure of
Kngwarreye's work is a strong
net of interconnected lines
over a ground, a structure
derived from patterns of body
painting and ultimately from a
description of the artist's
connectedness to place
through her Dreaming.

but in body-painting and, surprisingly perhaps, Indonesian batik. Following the successful adoption of batik techniques among the women of Ernabella in the early 1970s, batik was introduced to the people of the Utopia communities in 1977 and was enthusiastically embraced. As with the painters of Papunya, the women of Utopia had a rich vein of traditional designs from which to draw, particularly the body-painting designs which are applied to women's arms, breasts, and legs as a part of the traditional *awelye* ceremonies.

The delicacy and beauty of the Utopia silk batiks found an immediately positive response in metropolitan centres and public art museum collections. In the late 1980s painting on canvas and paper developed as another significant element of Utopia's artists' activities. The most senior artist at this time was Emily Kngwarreye (*c.* 1910–96), who, in a painting career which lasted no longer than a decade, developed an extraordinary range of expressive techniques and an approach to subject-matter of great formal complexity. Kngwarreye was central to the group of batik-making women at Utopia (although her style as a batik designer was regarded as eccentric in its wild informality) and in 1989 she exhibited the first paintings which were to presage her concerns in future works [120].

Unlike the artists of Papunya, Kngwarreye presented neither precise symbolic iconography in her work, nor recordable narratives. Something of the difference can be seen by comparing Clifford Possum and Tim Leura Tjapaltjarri's 1980 painting [118] with Kngwarreye's 1991 untitled painting. In Kngwarreye's work a sea of dots washes over the structure below; in subsequent works (too large to be satisfactorily reproduced on a small scale) these dots become a

dense, semi-transparent mat through which a linear structure is only just visible. These paintings do not depict, but suggest vast tracts of infinitely subtle landscape seen from above. In yet later works the dots disappear and the paintings reveal the 'armature' networks of lines.

Much of the discussion about Kngwarreye's work in her lifetime, and more especially since her death, has been concerned less with an understanding of the way in which the paintings relate to the artist's Dreaming (which is accepted as being largely inaccessible to outsiders) and more with the way in which they have been seen in a context of their reception as modernist paintings.[6] This latter context has raised fascinating questions for art historians, because while it is clear that Abstract Expressionism explains the existence of an aesthetic which allows for the appreciation of Kngwarreye's painting in a principally non-indigenous market, it fails to account for the way in which her particular form of abstract painting emerged from the hand and mind of an elderly woman in a desert community in Australia.

There can be little doubt that the same post-Abstract Expressionist and Minimalist aesthetic which led to the wide marketability of the works of the women of Utopia was also responsible for the enthusiastic reception of the painters of the Kimberley in the northern part of Western Australia. The Kimberley is an area of Australia with rich traditions of rock art, in particular related to the ancestor figures, the Wandjina (see Chapter 1). The Wandjina were a significant subject for a group of artists who, in the mid-1970s, began to paint traditional subjects on sheets of bark. Notable among these artists are Charlie Numbulmoore (c. 1907–71), who painted on bark, and Alec Mingelmanganu (died 1981), whose last works constituted a series of important Wandjina paintings on canvas. The iconography of both Numbulmoore and Mingelmanganu was drawn from particular Wandjina in rock shelters; the iconic power of their paintings derived from the monumental force of their ancient sources.

The appearance and exhibition of the painters of the Wandjina was part of a widespread cultural revival in the Kimberley which took distinctive forms across this culturally and linguistically diverse region. Among the most remarkable expressions of this revival emerged from the Warmun community at Turkey Creek, where rectangular sheets of board, painted and carried in ceremonies, became the matrix for an art of severe simplicity and power. Among the protagonists of the distinctive art of the Warmun were Paddy Jaminji (1912–86) and his nephew Rover Thomas (1926–98). In 1975 Rover Thomas created a dance-drama (called *Gurirr Gurirr*, or *Krill Krill*, the substance having been revealed to the artist in a dream), which in the 1980s became a significant focus for ceremonial activity in the Warmun community; it also served as a declaration of the continuing importance of culture.

Whereas Jaminji was the main painter of the boards used in the *Gurirr Gurirr* dances, Rover Thomas's work was not limited to the iconography of the dance-drama and became both larger in size and broader in subject-matter [**121**].

The events which precipitated the *Gurirr Gurirr* cycle occurred in 1974, and they are linked not only to the advent of Cyclone Tracy, but to the ongoing significance of a number of ancestral sites around the Kimberley and off the Kimberley coast. In another series of paintings made in the early 1990s, Thomas recorded more distant, but none the less potent events—three violent massacres of Aboriginal people which took place on cattle stations in the early decades of the century and had been recounted to him during his early life as a stockman.

Rover Thomas was one of several Warmun artists to adopt a distinctive view on the landscape. His art shares many features with artists such as Queenie McKenzie (born *c.* 1930), whose subject is the limestone range in her country near Texas Downs Station. Making a distinction between the treatment of landscape by Warmun painters and Western Desert artists, curator Wally Caruana has written that while there are some shared elements of iconography (most importantly the planar view of the landscape), the emphasis in Warmun art is 'on the depiction of the features of the environment created by the ancestors, rather than on the narration of ancestral events'.[7]

Whilst paintings on canvas and board have, in effect, created

122 John Mawurndjurl

*Ngalyod, the Rainbow
Serpent*, 1988

Ngalyod is the principal
ancestral being of the
Kunwindjku, believed to have
created the land and the
seasons and to govern all of
the cycles of human
existence. Ngalyod takes
many forms—a snake, a
crocodile, a woman, a
kangaroo—and is a very
powerful figure. The
embodiment of this ancestral
power is present in the
complex and dazzling cross-
hatching in the bark-painting
of Kunwindjku artists.

completely new forms of Aboriginal art, innovative artists have continued to enliven traditional forms. The bark-paintings of John Mawurndjurl (born 1952) [122] are an example of the traditions of the Kunwindjku carried into the present. Mawurndjurl was taught to paint by his father-in-law, Peter Marralwanga (*c.* 1916–87), and has created an extraordinary style in which fine cross-hatching creates compositions of great vitality and almost inexplicable compositional complexity.

'The Provincialism Problem'

Since the beginning of the nineteenth century the world of Australia's visual arts has been preoccupied with the relationship of Australia to the rest of the world. For the most part this preoccupation has been with 'the tyranny of distance' (physical and intellectual) from European and American centres of culture. But the 1970s saw a profound critical engagement with this long-standing notion of Australia's culture. The classic statement of this renewed engagement was Terry Smith's essay 'The Provincialism Problem', published in the American journal *Artforum* in 1974. In that essay Smith examined the hegemony of the New York art-world, particularly as it related to Australia, and claimed that the actions of most Australian artists and influential critics constantly reinforced a relationship of dependence. Yet, as Smith reminded his readers, the whole notion of provincialism was more complex than one of simple dependence—New York itself could be viewed as having a provincial climate. He therefore encouraged artists to begin to address the provincialism question by recognizing, as a first step, that art-making is a 'thoroughly context-dependent activity'.

The artists whose work engages most meaningfully with the questions raised by Smith are Imants Tillers (born 1950) and Ian Burn (1939–93). Writing 10 years after Terry Smith had defined 'The Provincialism Problem', Tillers proposed that, rather than seeing Australian artists' isolation from original 'canonical' works of art as a problem, one should see it as creating a unique situation which should be embraced. In his essay entitled 'In Perpetual Mourning', Tillers wrote: 'The dot-screen of mechanical reproduction renders all images equivalent, interchangeable, scale-less and surface-less; but above all it makes them far more susceptible to local readings.'[8] His own art had for several years taken this as a central tenet, and his entire enterprise as a painter has been at least in part a 'local' engagement with pre-existing images. Tiller's own position, as the son of Latvian 'displaced persons' who had come to Australia after the Second World War, heightened his sense of the importance of an art that is centred on an exploration of marginalization, alienation, and loss. *Untitled* (1978) [123] declares Tillers's interest in the gaps of understanding and the symbolic possibilities inherent in reproduction.

123 Imants Tillers

Untitled, 1978

Untitled consists of two large canvases on which two different reproductions of Hans Heysen's 1909 watercolour *Summer* have again been reproduced, using a computerized photomechanical spray process. The struggle of the original against the doubling, the distortion of scale, the haze of reproductive technologies (and indeed *Summer*'s own history as a well-known print) give this work a moving, almost melancholy quality.

In 1981 Tillers began to use grids of small pre-prepared canvas-boards as his principal medium. He has continued to work in this way and has exploited the possibilities which this method has offered to create a vast (yet portable) interconnected system of images; it is encyclopaedic in scope and incorporates many thousands of images as diverse as the paintings of de Chirico and Baselitz, the word-paintings of Colin McCahon and von Guérard landscapes, Arakawa and Beuys, Clifford Possum Tjapaltjarri, book illustrations, and images from Latvian texts. Wystan Curnow has summed up the overwhelming impression of Tillers's canvas-board project as one of 'relentless plurality, of proliferating differences and partial, improvised, conjectural identities and hybridised, multicultural identities'.[9]

Ian Burn shared many of Tillers's concerns with Australia and its relationship to modernist art history, though his visual strategies were somewhat different. Burn was as significant a writer as a visual artist—indeed most of his art must be 'read' as parts of visualized arguments. Trained at the National Gallery School in Melbourne in the 1960s, Burn lived and worked in New York between 1966 and 1977. He was a member of the Art & Language group of conceptual artists, and after his return to Australia brought many of ideas of the group to bear on the trade union movement. At the same time he sought to uncover traditions in twentieth-century Australian art which had been obscured by art historians' focus on a particular type of modernist painting. His last works were a series entitled 'value added landscapes', in which texts concerned with seeing and painting have been super-imposed on the surfaces of small amateur landscape paintings picked up in junk shops.[10] Bringing complex conceptual arguments into a

relationship with the work of the 'Sunday painter' was typical of Burn's strategy to explore the verbal and visual order of Australian art.

A great many works by Tillers and Burn made extensive use of pre-existing imagery and engaged with the history of images made and consumed in Australia. Gordon Bennett (born 1955) is another artist whose work has consistently dwelt on the ways in which Australian ideologies have been established and perpetuated through imported and Australian images. He has written: 'My approach to "quotation" within the "mainstream" European tradition is to select images from Euro-Australian art history, that have accumulated certain meanings over time, placing them in new relationships to other images.'[11] Bennett shared this strategy with many artists at the end of the twentieth century, although the particular urgency of Bennett's project derived from his own personal history as the child of an Aboriginal mother. The force of his imagery came from his determination to address the hurt of racism and injustice: his work has confronted the often suppressed yet painful history of oppression of indigenous Australians. He has often employed in his paintings a kind of incommensurate layering through which he exposes the tensions and strains of Australian history.

Awareness of Australian art history

A distinct feature of Australian art of the years from the late 1970s to the 1990s was the heightened sense of Australia's art history and the un-precedented incorporation of historical references into contemporary works of art. This was symptomatic of a continuing concern with Australia's relationship to American and European art-worlds, but was also a result of increased opportunities to see and understand Australian art history through publications and public art museum exhibitions.

In this increased awareness, art museum displays were important. From the early 1970s the Art Gallery of New South Wales began to pay close and serious attention to colonial art, largely as a result of the enthusiasm of the curator Daniel Thomas. The opening of the Australian National Gallery in 1982 (renamed the National Gallery of Australia in 1993) was significant in increasing awareness about the history and shape of Australian art. The Australian art displays of the Gallery, also conceived by Daniel Thomas, incorporated not only paintings and sculpture, but also examples of Aboriginal art, decorative arts, photographs, prints, and drawings. Many other public galleries, both in metropolitan centres (particularly Adelaide and Hobart) and in regional cities and towns (such as Ballarat and Newcastle), began to present coherent and well-documented displays of Australian historical paintings.

These rich and well-researched displays were important in allow-ing artists to engage with hitherto unnoticed aspects of Australia's landscape painting. The way in which this operated can be seen by

examining the case of a single colonial image. In 1967 Eugene von Guérard's 1862 painting, *Waterfall, Strath Creek*, was bought by the Art Gallery of New South Wales (this was the start of a process of rehabilitation of the reputation of the nineteenth-century painter). In 1970 Fred Williams made a 'free copy' gouache after the von Guérard painting and in 1980 William Delafield Cook (born 1936) was inspired to retrace von Guérard's steps to Strath Creek and paint his own much larger version of the composition [**124**].

Delafield Cook's interest in von Guérard was part of his wider interest in nineteenth-century imagery (in particular early photographs) evident in his work from the late 1960s.[12] While living in London in the 1970s, Delafield Cook developed an interest in the artifice of art-making: he made paintings and drawings of museum interiors which incorporated precisely rendered copies of the paintings of such (highly constructive) painters as Ingres, Vermeer, and de

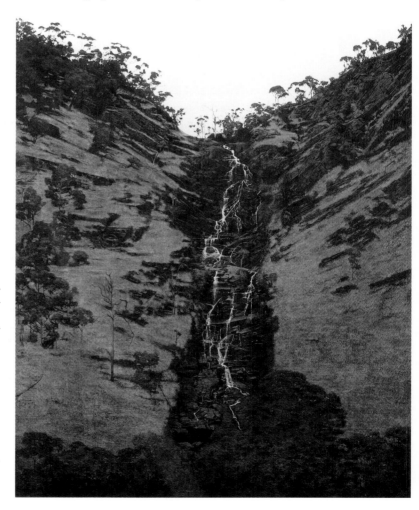

124 William Delafield Cook

A waterfall (Strath Creek), 1980

'The waterfall was almost exactly as it was in von Guérard's picture. He was at Strath Creek on 14 January 1862; I was there on 23 January, 1980.' So wrote William Delafield Cook about his arrival at the spot from which this composition was made. A little over a year after the artist's visit to Strath Creek, the painting was awarded the Wynne Prize for landscape painting for 1980.

Hooch. It is therefore not surprising that when Delafield Cook wanted to immerse himself in the Australian landscape as a subject, he should do so with a full consciousness of the work of all the artists who had worked through it before him, not only von Guérard but also John Glover, the painters of Heidelberg (a circle in which his own painter grandfather was a peripheral figure), and Fred Williams.

Delafield Cook is a highly accomplished painter, fastidious about the creation of a seamless surface. Earlier art informs his vision. His art is allusive, but one could not say his work is appropriative. In this it contrasts with a great deal of the work of the 1980s and 1990s, which incorporated obvious references to earlier Australian art and which was often rather simplistically appropriative.

Visual art as a language

Many Australian artists of recent decades have been deeply interested in language—written and spoken rather than visual language—and the order it creates. Never did words have such an important role in the visual arts in Australia as in the last decades of the twentieth century. Words and images have collided often, yet the artists who are able to bring these two modes of knowing together effectively are few. Mike Parr (born 1945) is a powerful exception; indeed his richly layered work has successfully combined many of the themes examined in this chapter.

Mike Parr started out as a poet and his first exhibited works of the early 1970s were typewritten word-pieces. These works were viewed more as 'conceptual art' than 'concrete poetry', but such distinctions were of little interest to the artist, for whom these works were but the opening sally in a campaign to show the complex relationships between language, authority, and the self.[13] The arena in which Parr freely experimented with such ideas was the Inhibodress artists' collective, a gallery space established in 1970 by a group of artists, among whom Parr and Peter Kennedy (born 1945) were the central figures. At Inhibodress, Parr created the first of his performance pieces in which he carried through a set of violently painful acts on himself in an attempt to evoke a deep audience response and to force a critical examination of their own collective and individual positions. The culmination of these performances was *Cathartic Action/Social Gestus 5 (The Armchop)* (1977) during which Parr (who was born without one arm) chopped off a life-like prosthetic arm with a tomahawk and then proceeded to explain to an audience, reeling in shock, the theoretical and ideological roots of his cathartic art.

Mike Parr's *œuvre* is enormously dense, theoretical, and self-referential; and, with the possible exception of those works conceived in collaboration with John Nixon, it could be described as a vast self-portrait. This was made manifest in a series of drawings he began in 1982. Drawing allowed Parr to engage in a different way with the

concerns explored in his performances—in particular the direct correlation between the definition of the world through language and the definition of the world through the authoritative visual orders of perspective and photography [**125**].

Whilst Parr's art and position are unique, there have been other artists whose sustained interest in language and perception has led to important investigations of the nature of symbolic order. Of these, Peter Tyndall (born 1951) has been the most interesting—creating work which embodies wit and a lightness of touch seamlessly married with a determined and sustained intellectual rigour.

The position of photography

One dimension of the work of Mike Parr is an engagement with another form of authoritative representation—the photograph. Photography was a crucial concern of many artists during the 1970s; indeed,

125 Mike Parr

O O Otohp (The Death of Ekim Rrap) In the Wings of the Oedipal Theatre, Part 2, 1985

In the series of 'drawing installations' Parr made in the mid-1980s, the artist set anamorphically distorted self-portrait drawings in precisely constructed rooms (with angled walls and ceilings). The visual disruptions allowed the viewer to speculate on the relationship between representation and authority, the underlying theme of Parr's œuvre.

126 Fiona Hall

Salix babylonica: urn, 1991

In 1991 Fiona Hall made a series of ceramic vessels in response to the Gulf War. Although Hall was at the time best known as a photographer, she deliberately fashioned these ceramics as objects, in contrast to the distanced and disembodied photo imagery which dominated the media coverage of the conflict. The title of the work and its form (an earthenware vessel) are reminders of the depth of human culture and experience in the Gulf region.

there was no time in the history of Australian art in which photography had such importance as it enjoyed in the 1970s, a decade of theoretical engagement with the nature of photography's visual language. It was also a time of optimism for photography in Australia—optimism which culminated in the establishment of a number of display spaces for photography in Melbourne and Sydney. The Australian Centre for Photography was established in Sydney in 1974 with the declared aim to 'promote photography as a visual art'.

Whilst 'photography as art' is a completely valid concept, many of the best contemporary artists using the photographic medium have been fundamentally unconcerned about the status of the medium *per se* and have used it because it best suits their aesthetic ends. The versatile Fiona Hall (born 1953), for example, began her career as a photographer, yet she has also made sculptures, designed gardens (a form of organic sculpture), created installations, painted and drawn, and in 1992 produced a series of ceramic pieces relating to the Gulf War [**126**].

Bill Henson (born 1955) and Tracey Moffatt (born 1960) are two artists for whom photography has been the medium for powerful and often enigmatic narratives. Both photographers have an extraordinary understanding of the qualities of the medium—their works are impossible to conceive in any other form, an impression strengthened by the attention to process, scale, surface, and objecthood which characterizes their work. Bill Henson's earliest photographs were pictures of crowds, arranged in sequences which seemed to suggest a narrative, but the meaning of which remained eerily intangible [**127**]. In later sequences and triptychs, Henson would bring together opulent European interiors with elegiac portraits or densely romantic landscape. The mood and ambition were operatic. A similar interest in the loosely conceived

127 Bill Henson

Untitled, 1980–2

Bill Henson's photographs suggest narratives—they seem to be suspended moments in the unfolding of people's lives. In the early 1980s the photographer created sequences of arrested movement—anonymous crowd scenes captured in slightly blurred black and white—yet he was able to make images of fleeting and transcendent beauty from this otherwise everyday urban subject.

narrative informs Tracey Moffatt's photographic sequences. Moffatt's haunting short film, *Night Cries: A rural tragedy* (1990), was made at a time when her serial presentation of photographs seemed to suggest the stills from unmade films. As curator Michael Snelling has written:

Moffat has a love of … an eclectic collection of styles that she combines with a desire to experiment by mixing and matching language and convention. There is an invigorating casual challenge in her interweaving of film, photography and stage that brings much energy to the overexploited and sometimes slightly exhausted media of film and photography.[14]

The landscape and responsibility

As pointed out in the introduction to this book, the story of Australian art is diminished if it is treated wholly as a story of artists' engagement with the natural world. None the less the natural world is a source and a background even for artists (Mike Parr or Imants Tillers, for example) whose work appears at first sight remote from it. But the landscape—or, more precisely, the land—has continued to be a significant subject. Increasingly throughout recent decades there has been a recognition of the highly culturated ways in which the natural world is seen and presented: there has also been a realization, brought about by an increased understanding of indigenous art, that the certainties of earlier generations of Australian landscape artists were strongly ideological. Perhaps the strongest motivation for continued investigation of the landscape in Australia has been ecological concern.

128 John Wolseley

The great tectonic arc …,
1995 (detail)

In 1997 the artist wrote: 'I do feel that the great modern myths … are the great paradigm shifts in how we see the structures of the earth, of space and time. Plate tectonics or quantum physics do not sound like titles of myth and may be thought of as primarily scientific, but to me they are deeply spiritual. I hope that [this work] may have something in common with those wonderful Eastern paintings, in its attempt to unite microcosmic with the cosmos, the phenomenal with the absolute.'

129 Rosalie Gascoigne

Set Up, 1984 (detail)

The simple weather-worn materials—old enamel vessels and pieces of painted wood— are brought together to suggest a landscape with floating clouds, such as are experienced through the long summers in the artist's city of Canberra. The work brings to mind again A. G. Stephens's 1901 description of Australia as a 'Land of Faded Things'.

130 Paddy Dhatangu, David Malangi, George Milpurruru, Jimmy Wululu, and other Ramingining artists, Arnhem Land

The Aboriginal Memorial, 1988

The Aboriginal Memorial was created by 43 artists from around Ramingining in 1988. The work consists of 200 painted hollow logs, of a type used in traditional re-burial ceremonies in Arnhem Land. The logs are disposed around a central space and suggest a map of the clan lands around the Blyth River. The work was conceived as a memorial for the Bicentennial year of European settlement (1988), to symbolize and commemorate the Aboriginal people whose lives were lost in the two centuries of colonization.

There have been many artists (too many to recount here) for whom Australia's environment has been a central theme: the example of one artist—English-born draughtsman and printmaker John Wolseley—will suffice to bring into focus many of the preoccupations of Australians at the end of the twentieth century. Wolseley has explored the relation-

ship of people to the landscape through a body of work in which he has documented—in fastidious detail—his own journeys and sojourns in the wilderness areas of Australia. The first of these journeys was undertaken in 1976, when, recently arrived from England, he travelled widely in search of an 'undescribed' landscape. Wolseley's work has always

possessed a delicacy akin to the watercolours and collections of dried specimens of amateurs in the nineteenth century; it has been an ideal vehicle to express ideas about the fragility of the environment. In all of his Australian work the idea of investigation of minutiae is important. *The great tectonic arc* ... of 1995 [**128**] is the result of a typical Wolseley investigation—in this case built around the idea of the primeval connectedness of the continents of Australia and South America which can be inferred from such tiny details as the seed pods of trees.

Something of Wolseley's aspiration to combine the phenomenal with the absolute can also be discovered in the work of Rosalie Gascoigne (1917–99), an artist who, like Wolseley, has searched for the fragile and evanescent in the Australian bush. Using pieces of abandoned and weathered material—packing crates, discarded road signs, birds' feathers—Gascoigne creates constructions which possess some of the qualities of the landscape, bringing into her work the colours, surfaces, and textures of the bush and visible signs of the inexorable workings of the quiet forces of nature [**129**]. Rosalie Gascoigne's work was the fruit of a lifetime spent observing the Australian bush. In that feature alone her work resembles her close contemporary in Western Australia Howard Taylor (born 1918). Taylor's most sublime abstract works appeared in the 1980s, only after a lifetime of engagement with Western Australian light and landscape.

Two centuries

Many of the themes in Australian art in the late twentieth century come together in probably the most extraordinary and symbolically rich work of public sculpture to be produced in Australia. *The Aboriginal Memorial* of 1988 [**130**] was conceived by a group of major artists around Ramingining as both a celebration of the continued coherence of the Aboriginal culture of Arnhem Land, but also as a gesture of commemoration of the thousands of Aboriginal lives lost in the course of Australia's 200 year history of European occupation. The Memorial takes its forms from the hollow-log coffins (*dupun*) traditionally used in re-burial ceremonies; there are 200 of these, each painted with motifs belonging to the 43 artists who painted them. They are arranged around a central space which the viewer can walk through and which symbolically represents the Blyth River in central Arnhem Land. Thus the work stands as a representation of a deep relationship to a specific topography, as a political work and a dazzling demonstration of the richness of the visual languages of Aboriginal Australia.

After its initial display in the Biennale of Sydney, the Memorial's ultimate destination was the National Gallery of Australia in Canberra, where it is now permanently displayed. The location—in the national capital, in a city much inhabited by public memorials and symbolic of nationhood—is highly significant. So, too, is the fact that the Memorial

is housed in a public art museum. In the latter part of the twentieth century such places became the most significant institutions of art in Australia, largely supplanting the artists' societies, art schools, and prize exhibitions of earlier generations as the focus of serious art discourse.

Another work impossible to imagine without the context of the public art museum space is likewise a profound attempt to bring together the experience of the indigenous and the non-indigenous inhabitants of Australia. *TERRA SPIRITUS ... with a darker shade of pale* [131] is a construction of an imaginative circumnavigation of the island of Tasmania by Bea Maddock (born 1934), made between 1993 and 1998. When fully displayed, the work is enormous, comprising 51 sheets of paper mounted end to end. Its effect is powerful; as a meditation on the history of the island and of the continent it is one of the most important and perfectly conceived works of Australian art of the 1990s.

This book was introduced with an investigation of a work by William Westall, the artist who accompanied Matthew Flinders on his circumnavigation of the Australian continent. *TERRA SPIRITUS*, completed in the lead-up to the bicentenary of Flinders's journey, forms the end point. Westall described the coastline of Terra Australis from the deck of a ship which was charting a littoral beyond which it was impossible to imagine. In Bea Maddock's work the viewer is conscious of the inscribed landscape—through a complete description of the edge of the island, a different horizon is being described and imagined beyond. It is impossible to experience *TERRA SPIRITUS* except as a sequence or a journey; like *The Aboriginal Memorial* it is a journey in which an immensely long history is brought into the present through different orders of naming, of seeing, and of knowing the land.

Notes

Introduction

1. William Westall to Joseph Banks, 31 January 1804. *Banks Correspondence*, vol. 4, Mitchell Library, State Library of New South Wales.
2. C. P. Mountford, *Records of the American–Australian Scientific Expedition to Arnhem Land: 1 Art, myth and symbolism* (Melbourne, 1956), 62.

Chapter 1. Art and the Dreaming

1. Governor Phillip's second despatch, 15 May 1788 in G. Barton (ed.), *Historical Records of New South Wales* (Sydney, 1889) 291.
2. Frederick McCarthy, *Australian Aboriginal Rock Art* (Sydney, 1958), 19.
3. Flinders's journal, 16 Jan. 1803 (Public Record Office, London), quoted in T. M. Perry and D. H. Simpson (eds), *Drawings by William Westall* (London, 1962), 52.
4. A. Sayers, *Aboriginal Artists of the Nineteenth Century* (Melbourne, 1994), 73–5.
5. Sir George Grey, *Journals of Two Expeditions of Discovery in North-West and Western Australia* (London, 1841), quoted in H. Morphy, *Aboriginal Art* (London, 1998), 21.
6. J. Flood, *Rock Art of the Dreamtime: Images of ancient Australia* (Sydney, 1997), 178–222.
7. L. Maynard, 'The archaeology of Australian Aboriginal art', in S. M. Mead, *Exploring the visual art of Oceania* (Honolulu, 1979), 83–110; and L. Maynard, 'Classification and terminology in Australian rock art', in P. Ucko (ed.), *Form in indigenous art* (Canberra, 1977), 387–402.
8. G. Chaloupka, *Journey in Time: The world's longest continuing art tradition* (Sydney, 1993).
9. G. L. Walsh, *Bradshaws: Ancient rock paintings of Australia* (Geneva, 1994) illustrates many of these figures.
10. The best account of the Macassans in Australia is C. C. MacKnight, *The voyage to Marege: Macassan trepangers in northern Australia* (Melbourne, 1976).
11. Morphy, *Aboriginal Art*, 100.
12. Watkin Tench, 1791, quoted in P. Emmett,

Fleeting encounters: Pictures and chronicles of the First Fleet (Museum of Sydney, Sydney, 1995).
13. D. Collins, 1798, quoted in C. Cooper, 'Traditional visual culture in south-eastern Australia', in Sayers, *Aboriginal Artists*, 108.
14. L. Taylor, *Seeing the inside: Bark painting in Western Arnhem Land* (Oxford, 1996).
15. A point explicitly made in D. Mundine, *Tyerabarrbowaryaou 2: I shall never become a white man* (Museum of Contemporary Art, Sydney, 1994).

Chapter 2. The Lines of Empire

1. B. Smith and A. Wheeler, *The Art of the First Fleet* (Melbourne, 1988).
2. P. Watts, J. Pomfrett, and D. Mabberley, *An Exquisite Eye: The Australian Flora and Fauna Drawings 1801–1820 of Ferdinand Bauer* (Historic Houses Trust, Sydney, 1997).
3. W. T. Stearn and W. Blunt, *The Australian Flower Paintings of Ferdinand Bauer* (London, 1976).
4. For a large number of illustrations of these drawings and biographical notes, see J. Bonnemains, E. Forsyth, and B. Smith, *Baudin in Australian Waters* (Melbourne, 1988).
5. In the collection of the Art Gallery of South Australia, Adelaide.
6. Quoted in Smith and Wheeler, *Art of the First Fleet*, 64–5.
7. T. Bonyhady, Introduction to *The Skottowe Manuscript* (Sydney, 1988).
8. J. Wallis, *An Historical Account of the Colony of New South Wales* (London, 1821), 40.
9. J. Glover, *A Catalogue of Sixtyeight Pictures, Descriptive of the Scenery and Customs of the Inhabitants of Van Dieman's* [sic] *Land … painted by John Glover Esq.* (exhibition catalogue, London, 1835).
10. Augustus Earle, *Views in New South Wales and Van Diemen's Land* (London 1830).
11. *Ibid.*
12. *Ibid.*
13. *Sydney Gazette*, 9 May 1829.

14. Earle, *Views in New South Wales*.

15. T. Bonyhady, *Images in Opposition: Australian Landscape Painting 1801–1890* (Melbourne, 1985), 42.

16. E. Ellis, *Conrad Martens: Life and Art* (Sydney, 1994), 26.

17. L. Lindsay, *Conrad Martens: the Man and his Art* (Sydney, 1920).

18. D. Dunbar et al., *Thomas Bock: Convict engraver, Society portraitist* (Launceston, 1991).

19. A. Sayers, *Drawing in Australia* (Canberra and Melbourne, 1989), 44.

20. Glover to Sir Thomas Phillipps, 15 January 1830. Phillipps Papers, Bodleian Library, Oxford.

21. Glover's handwritten note was on the back of this work when it was in the collection of Sir Thomas Phillipps at Thirlestaine House, Cheltenham, England. Recorded in an undated catalogue, Phillipps Papers, Bodleian Library, Oxford.

22. Glover to G. A. Robinson, Robinson Papers, vol. 37, 430, Mitchell Library, State Library of New South Wales, Sydney.

23. J. McPhee, in *The Art of John Glover* (Melbourne,1980), 42, indicates that Glover had one pupil for three months, but that no work is known by this artist. Glover's son was also a watercolourist, but did not reach the extent of his father's reputation.

Chapter 3. The Pursuit of Knowledge

1. J. Lhotsky, *Art Union* (London), July 1839, 99–100.

2. M. Ord, *Historical Drawings of Moths and Butterflies* and *Historical Drawings of Native Flowers* (Sydney, 1988).

3. I. Auhl and D. Marfleet (eds), *Journey to Lake Frome 1843: Paintings and Sketches by Edward Charles Frome and James Henderson* (Blackwood, South Australia, 1977).

4. R. Appleyard, B. Fargher, and R. Radford, *S. T. Gill, the South Australian years* (Art Gallery of South Australia, Adelaide, 1989), 86–94.

5. G. F. Angas, *Savage Life and Scenes in Australia and New Zealand* (London, 1847), vol. 1, vii–viii.

6. G. F. Angas, 'Note 1: Aboriginal carvings, or outline tracings, upon rocks and headlands in the vicinity of Port Jackson', Appendix to vol. 2 of his *Savage Life and Scenes*, 271–6.

7. In the collection of the Australian Museum, Sydney.

8. See T. Bonyhady, 'German Melbourne: Artists, scientists, explorers' in H. Gerke (ed.), *Australische Impressionen: Landschaftsmalerei aus hundert Jahren* (Heidelberg and Melbourne, 1987), 18–33.

9. T. Bonyhady, *Burke and Wills: From Melbourne to Myth* (Sydney, 1991).

10. Quoted in M. Tipping, *Ludwig Becker: Artist and naturalist with the Burke and Wills Expedition* (Melbourne, 1979), 10.

11. L. Becker, letter of 22 January 1861, quoted *ibid.*, 192.

12. Reprinted in Tipping, *Ludwig Becker*, 190.

13. Von Guérard has been the subject of two major studies: C. Bruce, *Eugen von Guérard*, (Australian National Gallery, Canberra, 1980); and C. Bruce, *Eugène von Guérard: A German Romantic in the Antipodes* (Martinborough, New Zealand, 1982).

14. 'Art in Victoria', *The Illustrated Journal of Australasia*, 4 Jan. 1858, 35.

15. Von Guérard's collecting activities are discussed in C. Bruce, 'The nostalgic landscape', *Australian Journal of Art*, 14.2.99, 111–27.

16. For a full discussion of the journey, see T. Bonyhady, *Colonial Paintings in the Australian National Gallery* (Australian National Gallery, Canberra 1986), 189–94.

17. Von Guérard, unpublished letter 1870, reproduced in B. Smith, *Documents on Art and Taste in Australia 1770–1914* (Melbourne, 1975), 169.

18. *Ibid.*

19. *Argus* (Melbourne), 25 October 1866.

20. In the collection of the National Gallery of Victoria, Melbourne.

21. M. Clarke, *Photographs of Pictures in the National Gallery of Victoria, Melbourne* (Melbourne, 1874), quoted in Smith, *Documents*, 136.

Chapter 4. Colonial Art-worlds

1. J. S. Prout, *The Art Union* (London), 1 November 1848, 332.

2. M. Nixon to her father, 12 February 1845, in N. Nixon (ed.), *The Pioneer Bishop in Van Diemen's Land 1843–1863: Letters and Memories of Francis Russell Nixon D.D. First Bishop of Tasmania* (Hobart, 1953), 45.

3. See H. Curnow, 'William Strutt: Some problems of a colonial history painter in the nineteenth century', in A. Bradley and T. Smith (eds.), *Australian Art and Architecture: Essays presented to Bernard Smith* (Melbourne, 1980), 33–44.

4. C. Downer, 'Bushfire Panic: William Strutt *Black Thursday, February 6, 1851 1864*', in D. Thomas (ed.), *Creating Australia: 200 Years of Art 1788–1988* (Art Gallery of South Australia, Adelaide, 1988), 44–5.

5. T. Bonyhady, *Images in Opposition:*

Australian landscape painting 1801–1890 (Melbourne, 1985), 53.

6. John Jones, *The Ware Family of Koort-Koort-Nong, Minjah and Yalla-y-Poora in the Western District of Victoria and their patronage of the artists Robert Dowling and Eugene von Guérard* (National Gallery of Australia, Canberra, 1997).

7. See K. Scarlett, *Australian Sculptors* (Melbourne, 1980), 708–17.

8. Much of Theresa Walker's *œuvre* is illustrated in J. Hylton, *Colonial Sisters* (Art Gallery of South Australia, Adelaide, 1994).

9. A transformation charted by A.-M. Willis in her *Picturing Australia: A history of photography* (Sydney, 1988), 20–1.

10. *Argus* (Melbourne), 13 August 1858. Quoted in A. Davies and P. Stanbury, *The Mechanical Eye in Australia: Photography 1841–1900* (Melbourne, 1985), 48.

11. D. Reilly and J. Carew, *Sun Pictures of Victoria: The Fauchery-Daintree Collection* (Melbourne, 1983) illustrates all the plates in the *Australia* album and discusses the attribution of the individual plates.

12. Willis, *Picturing Australia*, 53.

13. Barak's life and work and the lives and work of Tommy McRae and Mickey of Ulladulla are catalogued and treated in detail in A. Sayers *Aboriginal Artists of the Nineteenth Century* (Melbourne, 1994).

14. This subject has been treated by C. P. Cooper in 'Traditional visual culture in Southeast Australia' in Sayers, *Aboriginal Artists*, 90–109 and in Cooper's 'Art of temperate southeast Australia', in C. P. Cooper et al., *Aboriginal Australia* (Australian Gallery Directors' Council, Sydney, 1981), 29–40.

15. K. Langloh Parker, letter to A. G. Stephens, 30 Jan. 1897, ML364, Mitchell Library, State Library of New South Wales, Sydney.

16. A. Sayers, 'Jump up whitefellow: The iconography of William Buckley', *Voices* (Canberra, 1996–7) 6, 4, 14–21.

17. The two prize-winning works are illustrated in Sayers, *Aboriginal Artists*, colour plates 24 and 25.

18. P. Sutton, *Dreamings: The art of Aboriginal Australia* (New York, 1988), 29.

Chapter 5. What should Australian Artists Paint?

1. V. Hammond and J. Peers, *Completing the Picture: Women artists and the Heidelberg Era* (Melbourne, 1992).

2. Most brilliantly in I. Burn, 'Beating about the bush: The Landscapes of the Heidelberg School', in A. Bradley and T. Smith (eds), *Australian Art and Architecture: Essays presented to Bernard Smith* (Melbourne, 1980), 83–98.

3. *Herald* (Melbourne), 19 March 1872, 2.

4. R. H. Croll, *Tom Roberts: Father of Australian Landscape Painting* (Melbourne, 1935), 5.

5. The exchanges in the pages of the *Argus* (Melbourne) between James Smith and the artists in August–September 1889 are reproduced in B. Smith (ed.), *Documents on Art and Taste in Australia 1770–1914* (Melbourne, 1975), 202–11.

6. R. Radford, 'Celebration: Charles Conder *A holiday at Mentone*, 1888', in D. Thomas (ed.), *Creating Australia: 200 Years of Art 1788–1988* (Art Gallery of South Australia, Adelaide, 1988) 116–17.

7. *Impression for Golden Summer* is in the Benalla Art Gallery, Victoria.

8. Streeton's letters written during the execution of the work are collected in A. Galbally and A. Gray (eds), *Letters from Smike: The letters of Arthur Streeton 1890–1943* (Melbourne, 1989), with the exception of a long letter describing the work to Frederick McCubbin which is reproduced in Smith, *Documents*.

9. Arthur Streeton to Tom Roberts, 1891, in Galbally and Gray, *Letters from Smike*.

10. Sidney Dickinson 'What should Australian artists paint?', *The Australasian Critic*, I, I, October 1890, 21–2. Reprinted in Smith, *Documents*.

11. Tom Roberts, 1919, quoted in Croll, *Tom Roberts*, 114.

12. Barry Pearce, 'Bailed up' 1895/1927' in R. Radford (ed.), *Tom Roberts* (Art Gallery of South Australia, Adelaide, 1996), 116–23.

13. For further details on this work see M. Eagle, *Oil Paintings by Tom Roberts in the National Gallery of Australia* (National Gallery of Australia, Canberra, 1997), 68–75.

14. *Sydney Morning Herald*, 2 September 1892, quoted in Radford, *Tom Roberts*.

15. R. Zubans, *E. Phillips Fox: His Life and Art* (Melbourne, 1995), 67.

16. Quoted in Hammond and Peers, *Completing the Picture*, 22.

17. J. Burke, *Australian Women Artists* (Melbourne, 1980), 32.

18. Described in G. Newton, *Shades of Light: Photography and Australia 1839–1988* (Australian National Gallery, Canberra, 1988), 54–7.

19. For the careers of these photographers see A. and D. Pitkethly, *N. J. Caire: Landscape*

Photographer (Melbourne, 1988), and S. Jones, *J. W. Lindt: Master Photographer* (Melbourne, 1985).

Chapter 6. 'Beautifying the objects of our daily life'

1. D. H. Souter, 'Miss Florence Rodway. Comments on her work', *Art and Architecture*, 6, 1 (January–February 1909), 2.
2. 'The Royal Academy through Australian spectacles', *Art and Architecture* (June–July 1910).
3. W. Baldwin Spencer, letter to G. V. F. Mann, 4 September 1916. Art Gallery of New South Wales Archives, Sydney.
4. D. J. Mulvaney and J. H. Calaby, *'So much that is new': Baldwin Spencer 1860–1929. A biography* (Melbourne, 1985), 359.
5. W. Baldwin Spencer, *Wanderings in Wild Australia* (London, 1928), 794.
6. W. Baldwin Spencer, *Native Tribes of the Northern Territory of Australia* (London, 1914), 421.
7. W. Baldwin Spencer, diary, 9 July 1912. Mitchell Library, State Library of New South Wales, Sydney (ML MSS29/4).
8. A. C. Haddon, *Reports of the Cambridge Anthropological Expedition to the Torres Strait: Vol. 4, Arts and Crafts* (Cambridge, 1912), 342.
9. Norman Lindsay, letter to Lionel Lindsay quoted in U. Prunster, *The Legendary Lindsays* (Art Gallery of New South Wales, Sydney, 1995), 99.
10. *Ibid.*
11. Orpen's views as reported in Australian newspapers in October 1923, quoted in N. Lindsay, 'Lindsay's reply to Orpen', *Art in Australia* 3rd series, 6 (December, 1923), np.
12. A. G. Stephens, 'The Black-and-Whiters 1—Preliminary', *The Bookfellow*, 3rd series, 1, 11 (October 1912), 262.
13. Catalogue of the Society of Artists' Annual Exhibition, Sydney, October 1897.
14. See E. Fink *The Art of Blamire Young* (Sydney, 1983).
15. Catalogue of the First Australian Exhibition of Women's Work, October–November 1907.
16. B. Spencer, 'Hugh Ramsay: An Australian Artist', *Herald*, Melbourne, 1 October 1918. Quoted in P. Fullerton, *Hugh Ramsay: His Life and Work* (Melbourne, 1988), 133.

Chapter 7. Order and Transcendence

1. A. Lambert, *Thirty Years of an Artist's Life* (Society of Artists, Sydney, 1938), 112.
2. Arthur Streeton to Baldwin Spencer, 11 October 1918, in A. Galbally and A. Gray

(eds), *Letters from Smike: The letters of Arthur Streeton 1890–1943* (Melbourne, 1989), 152.
3. A.-M. Condé, 'A marriage of sculpture and art: dioramas at the Memorial', *Journal of the Australian War Memorial*, 19 (November 1991), 56–9.
4. Julian Ashton to Baldwin Spencer, 14 January 1919, Mitchell Library, State Library of New South Wales, Sydney, ML MSS 875 f.295.
5. Quoted in H. Johnson, *Roy de Maistre: The Australian years, 1894–1930* (Sydney, 1988), 30.
6. *Art in Australia*, June 1926.
7. Quoted in Johnson, *Roy de Maistre*.
8. M. Eagle, *Australian Modern Painting: Between the Wars 1914–1939* (Sydney, 1990), 51.
9. See B. James, *Grace Cossington Smith* (Sydney, 1990).
10. B. Pearce, *Elioth Gruner* (Art Gallery of New South Wales, Sydney, 1983), note to cat. 58.
11. I. Burn, *National Life and Landscapes: Australian Painting 1900–1940* (Sydney, 1990), 190–1.
12. Hans Heysen to S. Ure Smith, quoted in *Hans Heysen Centenary Retrospective Exhibition* (Art Gallery of South Australia, Adelaide, 1977), 101.
13. L. Lindsay, 'Heysen's Recent Water-colours', *Art in Australia*, 3rd series, 24 (June 1928), np.
14. L. Klepac, *Nora Heysen* (Sydney, 1989).
15. Cazneaux has been the subject of two books published by the National Library of Australia, Canberra: M. Dupain, *Cazneaux* (1978), and H. Ennis and P. Adams, *Cazneaux: The quiet observer* (1994).
16. M. Dupain, '*Caz*—An appreciation' in *Cazneaux*, xi.
17. Hoff, 1931, quoted in D. Edwards '*This Vital Flesh': The Sculpture of Rayner Hoff and his School* (Art Gallery of New South Wales, Sydney, 1999), 31.
18. *Ibid.* 11.
19. P. MacDonald, *Barbara Tribe: Sculptor* (Sydney, 1999).
20. R. Murch, *Arthur Murch: An artist's life 1902–1989* (Sydney, 1999), 9.
21. Frank Hinder's note on Dynamic Symmetry quoted in R. Free, *Frank and Margel Hinder 1930–1980* (Art Gallery of New South Wales, Sydney, 1980), 10.

Chapter 8. Aboriginal Art and its Reception

1. These are discussed extensively in a series of essays: J. Hardy, J. V. S. Megaw, and M. R.

Megaw (eds), *The Heritage of Namatjira* (Melbourne, 1992).

2. C. P. Mountford, *The Art of Albert Namatjira* (Melbourne, 1944), 44.

3. *Ibid.*, 74.

4. By Jane Hardy in Hardy et al., *Heritage*, 167.

5. The best summary of various approaches to the meaning of Namatjira's art is D. Thomas, 'Albert Namatjira and the Worlds of Art: A re-evaluation' in N. Amadio (ed.), *Albert Namatjira: The life and work of an Australian painter* (Melbourne, 1986), 21–6.

6. Quoted in Hardy et al., *Heritage*, 288–9.

7. See the introductory chapters of R. Butler, *The Prints of Margaret Preston* (Canberra, 1987).

8. *Australia: National Journal*, 2, 6 (May 1941), 12.

9. *Studio* (London), 124 (1942), 122.

10. Artist's commentary in S. Ure Smith (ed.), *Margaret Preston's Monotypes* (Sydney, 1949), plate 8.

11. M. Preston, 'Aboriginal Art of Australia', in *Art of Australia 1788–1941* (exhibition catalogue, Sydney 1941), 16–17.

12. The results of the art collecting of the expedition were published in C. P. Mountford, *Records of the American-Australian Scientific Expedition to Arnhem Land: 1 Art, myth and symbolism* (Melbourne, 1956).

13. W. Caruana and N. Lendon (eds), *The Painters of the Wagilag Sisters Story 1937–1997* (Canberra, 1997).

14. See Mountford, *Records*, 94–7, and Margo Neale's discussion of the 1948 expedition in L. Seear and J. Ewington (eds), *Brought to Light: Australian Art 1850–1965* (Brisbane, 1998), 210–17.

15. H. Morphy, *Aboriginal Art* (London, 1998), 188–9.

16. Commentary in R. M. Berndt (ed.), *Australian Aboriginal Art* (Sydney, 1964), 85.

17. Mountford, *Records*, 109.

Chapter 9. Art, Myth, and Society

1. B. Smith, *Place, Taste and Tradition: A study of Australian art since 1788* (Sydney, 1945).

2. R. Haese, *Rebels and Precursors: The revolutionary years of Australian art* (Melbourne, 1981), 75.

3. Published in *A Comment*, 5 (May 1941), np.

4. Smith, *Place, Taste and Tradition*, 211.

5. Many of these artists are surveyed in C. Chapman, 'Surrealism in Australia', in *Surrealism: Revolution by Night* (National Gallery of Australia, Canberra, 1993), 216–317.

6. J. Helmer, *Yosl Bergner* (National Gallery of Victoria, Melbourne, 1985).

7. See J. Mollison and N. Bonham, *Albert Tucker* (Melbourne, 1982).

8. *Angry Penguins* (Melbourne), 4 (1943), 49–54.

9. The Melbourne painters of the 1940s are often described as the 'Angry Penguins' group, but it is misleading to bracket every radical or modernist artist with Reed and Harris's quite specific enterprise.

10. A. Sayers, *Sidney Nolan Drawings* (National Gallery of Australia, Canberra, 1989).

11. See R. Haese, *Nolan, the City and the Plain* (National Gallery of Victoria, 1983) and I. Burn's thought-provoking analysis of Nolan's Wimmera paintings, 'Sidney Nolan: Landscape and Modern Life', in his *Dialogue: Writings in Art History* (Sydney, 1991), 67–85.

12. Nolan letter to Sunday Reed, October 1942, Dimboola. Reed Papers, La Trobe Library, State Library of Victoria, Melbourne.

13. A. Sayers, *Sidney Nolan: The Ned Kelly Story* (Metropolitan Museum of Art, New York, 1994).

14. Nolan, quoted in *The Australian Artist*, 1–4 July 1948, 20.

15. G. Wilson, *The Artists of Hill End* (Art Gallery of New South Wales, Sydney, 1995).

16. Quoted in G. Dutton, *Russell Drysdale* (London, 1964), 101.

Chapter 10. Icon and Abstraction

1. *Abstract Compositions: Painting—Sculpture*, Macquarie Galleries, Sydney, 8–21 May 1951.

2. Ralph Balson, artist's statement in J. Reed, *New Painting 1952–1962* (Melbourne, 1963), 30.

3. See B. Adams, *Ralph Balson: A Retrospective* (Heide Park and Art Gallery, Melbourne, 1989).

4. D. Edwards, *Godfrey Miller* (Art Gallery of New South Wales, 1996).

5. The Mirror-Waratah Art Prize, 1963.

6. Robert Klippel, diary of 11 November 1947, quoted in J. Gleeson, *Robert Klippel* (Sydney, 1983), 39.

7. J. Brack, *Four Contemporary Landscape Painters* (National Gallery of Victoria, Melbourne, 1968), 20.

8. Jeffrey Smart, quoted in G. De Groen, *Some other dream: The artist, the artworld & the expatriate* (Sydney, 1984), 50.

9. T. Tuckson in R. Berndt (ed.), *Australian Aboriginal Art* (Sydney, 1964), 66.

10. *Ibid.*, 67.

11. K. Kupka, *The Dawn of Art: Paintings and Sculptures of the Australian Aborigines* (Sydney, 1965), 154.

Chapter 11. Saying and Seeing

1. T. Smith, 'Ten Propositions' in *The Situation Now* (exhibition catalogue, Contemporary Art Society, Sydney, 1971), reprinted in P. Taylor (ed.), *Anything Goes: Art in Australia 1970–1980* (Melbourne, 1984), 26–9.

2. G. Bardon, *Papunya Tula: Art of the Western Desert* (Melbourne, 1991).

3. Ulli Beier, 'Foreword', in Bardon, *Papunya Tula*, xv.

4. Judith Ryan, 'Foreword', in Bardon, *Papunya Tula*, xi.

5. Bardon, *Papunya Tula*, 118.

6. See, for example, R. Benjamin, 'A new modernist hero', in M. Neale (ed.), *Emily Kame Kngwarreye: Alhalkere, Paintings from Utopia* (Queensland Art Gallery, Brisbane, 1998), 47–54.

7. W. Caruana, *Aboriginal Art* (London 1993), 168.

8. This quotation from Tillers's 1984 essay is cited in W. Curnow, *Imants Tillers and the Book of Power* (Sydney, 1998), 24.

9. *Ibid.*, 126.

10. Stephen (ed.), *Artists Think: The late works of Ian Burn* (Sydney, 1996).

11. G. Bennett, 'The Manifest Toe', in G. Bennett and I. McLean, *The Art of Gordon Bennett* (Sydney, 1996), 42–3.

12. D. Hart, *William Delafield Cook* (Sydney, 1998).

13. Mike Parr's work is treated in detail in D. Bromfield, *Identities: A critical study of the work of Mike Parr 1970–1990* (Perth, Western Australia, 1991).

14. M. Snelling, *Tracey Moffatt* (Institute of Modern Art, Brisbane, 1999), 8.

15. *TERRA SPIRITUS … with a darker shade of pale* (exhibition catalogue, Queen Victoria Museum and Art Gallery, Launceston, Tasmania, 1998).

Timeline
Further Reading
Websites
List of Illustrations
Index

	Art	**Events**
Prehistoric period		
c. 60,000 years before present		Humans are thought to have first arrived in the Australian continent
c. 20,000 years before present	Wall-markings on limestone walls of caves in the Nullabor Plain. Considered by many archaelogists to be the earliest Australian art. Earliest engraved rock art sites.	
c.14,000 years before present	Hand stencils in ochre on walls of Tasmanian caves.	
c. 15–10,000 years before present	Painted rock art widely practised in Arnhem Land and Cape York Peninsula.	
c. 4–3,000 years before present	The flowering of the 'X-ray style' of rock art in Arnhem Land.	
c. 1,500 years before present	Minimum age for rock engravings at Mount Cameron West, north-west Tasmania.	

	Art	**Events**
1600s		**1600s** Macassan trepang fishermen from Celebes begin annual fishing expeditions to northern Australia. **1606** Dutch navigator Willem Janszoon explores parts of the coast of the Cape York Peninsula. **1616** Dutch navigator Dirk Hartog makes a landfall on the west coast of Australia. **1642** Exploring party from the Dutch East Indies, led by Abel Tasman, makes landfall and names Van Diemen's Land. **1690s** Willem de Vlamingh and William Dampier explore and chart areas of the coast of Western Australia.
1700	**1770** The artist accompanying Cook's first Pacific voyage, Sydney Parkinson, makes drawings of Australian fauna and flora.	**1770** James Cook charts the east coast of Australia on his first Pacific voyage and claims possession. The eastern part is named New South Wales.
1788	**1788** Naval officers and the convict Thomas Watling make drawings of the European colony, Aborigines, and flora and fauna.	**1788** Capt. Arthur Phillip, with the 'First Fleet', takes possession of New South Wales and establishes the penal colony at Sydney Cove, Port Jackson. Phillip is declared governor and British laws and legal system are established in Australia. **1793** Arrival of first free settlers in Australia.
1800	**1800** J. W. Lewin, natural history artist and first free-settler professional artist, arrives in Australia. **1801–3** Surveying voyage of Matthew Flinders in Australian waters, accompanied by landscape artist William Westall and botanical artist Ferdinand Bauer. French exploration voyage under the command of Nicolas Baudin in Australian waters, accompanied by artists Nicolas-Martin Petit and Charles-Alexandre Lesueur.	

	Art		**Events**	
1803			1803	Establishment of European settlement in Van Diemen's Land under Lieut.-Col. David Collins. The site named Hobart after Lord Hobart, Secretary of State.
			1808–9	'The Rum Rebellion', in which rebel officers of the NSW Corps arrest the governor, William Bligh. This coup follows a long period of widespread dissatisfaction with Bligh's governorship, his interference with the rum trade, and his conflict with the leading pastoralist and sheep-farmer, John Macarthur.
1810			1810	The beginning of the governorship of Lachlan Macquarie. The administration of Macquarie (1810–21), in which Mrs Macquarie plays a significant part, sees the consolidation of the legal and civic structure in New South Wales, the establishment of many institutions, and the expansion of the reach of European occupation.
	1813	J. W. Lewin's *Birds of New Holland*, the first illustrated book published in Australia.	1813	The first crossing of the Blue Mountains by Europeans. This crossing leads to the opening up of the country to the west of the coastal settlements in New South Wales.
	1817	Lewin begins painting in oils.		
			1819	The first book of poetry published in Australia: Judge Barron Field's *First Fruits of Australian Verse.*
			1823	Laws passed in Britain establish a legislative council, courts, and trial by jury in New South Wales and Van Diemen's Land.
	1824–5	Publication of Joseph Lycett's *Views in Australia* in London.		
	1825	Arrival of Augustus Earle. Sets up exhibition gallery in George Street, Sydney in 1826.		
			1829	The first official census of New South Wales totals the settler population at 36,598, made up of 20,870 free settlers and 15,728 convicts. The establishment of a European settlement at the Swan River (later Perth) in Western Australia.
1830			1830	The Van Diemen's Land governor George Arthur attempts to round up all remaining Aborigines in the island. The attempt fails. The first novel published in Australia: Henry Savery's *Quintus Servinton.*
	1831	Arrival of John Glover in Tasmania. Arrival of Mary Morton Allport in Tasmania.		
			1832	George Augustus Robinson, 'The Conciliator', sets out on the first of several journeys to contact and to bring out of the bush the remaining Aborigines of Tasmania. They are then sent to a settlement on Flinders Island in Bass Strait.
1834	1834	Thomas Bock and Benjamin Duterrau paint portraits of Tasmanian Aborigines.		

	Art	Events
1835	**1835** Arrival of Conrad Martens in Sydney. Exhibition of 68 paintings of Tasmanian subjects by John Glover mounted in London.	**1835** The settlement at Port Phillip established, later to become Melbourne.
		1836 Establishment of a new colony in South Australia. The following year colonists decide to establish Adelaide on the Torrens River.
	1837 First documented group art exhibition in Australia, held in Hobart.	**1837** Arrival of Sir John and Lady Franklin in Van Diemen's Land. Under Franklin's governorship (1837– 43) the colony thrives as a scientific and intellectual centre.
	1838–40 John and Elizabeth Gould, bird artists, in Australia.	
	1839 John Lhotsky's summary of Australian art published in *The Art Union*, London. Arrival of Louisa Anne Meredith.	**1838** The Myall Creek massacre, in which 28 Aborigines are killed on the Liverpool Plains (NSW).
1840		**1840** Transportation of convicts to New South Wales ends.
	1841 Earliest Australian photograph announced in the press, a view of Bridge Street, Sydney.	
		1842 The Moreton Bay district (later to become Queensland) officially opened for settlement.
		1844-5 Explorer Ludwig Leichhardt travels from Jimbour in present-day Queensland to the Northern Territory coast. In 1848 he and his party disappear while attempting an east–west crossing of the continent.
	1845 Group exhibition organized by John Skinner Prout in Hobart. Another is held in 1846.	
	1846 S.T Gill accompanies J.A Horrocks's inland exploring expedition in South Australia.	
	1847 Group exhibition held in Adelaide. First exhibition of the Society for the Promotion of the Fine Arts in Australia, Sydney. The second and final exhibition is held in 1849.	
1850	**1850** Arrival of William Strutt in Melbourne.	
	1851 Arrival in Australia of Ludwig Becker.	**1851** Significant quantities of gold discovered in New South Wales mark the beginning of the Australian gold-rushes. Gold is discovered soon after at Ballarat in Victoria. The Port Phillip district proclaimed as the separate colony of Victoria.
	1852 Arrival of Eugene von Guérard.	
	1853 Exhibition of the Victorian Fine Arts Society, Melbourne.	**1853** Last convicts arrive in Van Diemen's Land.
	1854 Melbourne Exhibition held in connection with the Paris Exhibition (1855).	**1854** The Eureka uprising, in which gold-miners at Ballarat make a stand against what they regard as unjust government policies, particularly in relation to the licensing of miners.
		1856 Van Diemen's Land officially renamed Tasmania. The first parliaments of NSW, Victoria, and Tasmania opened. South Australia's parliament opened the following year.
1858	**1858** The Art Treasures Exhibition, Hobart. Richard Daintree and Antoine Fauchery's album of photographs, *Australia*.	

Art

1860

1860–1 Ludwig Becker accompanies Burke and Wills Expedition.

1862 Von Guérard accompanies Georg von Neumayer on expedition to Mount Kosciuszko.
William Strutt leaves Australia for England, where he paints his monumental *Black Thursday,* 1864.

1865 Arrival of Louis Buvelot.
Charles Summer's monument to Burke and Wills.

1866 Melbourne Intercolonial Exhibition.

1869 Exhibition at the Melbourne Public Library and Museum.
First acquisition of an Australian painting for a public collection (National Gallery of Victoria).

1870 **1870** Sydney Intercolonial Exhibition.
Establishment of the National Gallery School, Melbourne.

1874 Establishment of collection of the Art Gallery of New South Wales.

1876 William Barak leads land-rights deputation from Coranderrk to Melbourne.

1879 Sydney International Exhibition.

1880 **1880** Melbourne International Exhibition.

1881 Foundation of the Art Gallery of South Australia, Adelaide.

1885 Return of Tom Roberts to Australia.

1886 Artists' camps around Melbourne.

1888 Centennial International Exhibition, Melbourne.

1889 The '9 by 5 Impression Exhibition', Melbourne.

1890 **1890** American-born critic Sidney Dickinson's essay 'What should Australian artists paint?'

Events

1860–1 The Victorian Exploring Expedition led by Burke and Wills attempts to cross the continent from Melbourne to the northern coast. The expedition ends in disaster at Cooper Creek.

1861 Riots on the gold-fields at Lambing Flat (NSW), in which Chinese and police are attacked, prompting calls for an end to persecution of Chinese in Australia. The NSW government legislates to restrict Chinese immigration.

1863 Establishment of the Coranderrk Aboriginal Station, near Melbourne.

1868 The Aboriginal cricket team tours England, the first Australian touring side.
Prince Alfred, Duke of Edinburgh, tours Australia, where he is shot and wounded by the Irish nationalist Henry O'Farrell.

1869 Discovery of the 80kg 'Welcome Stranger', the largest nugget of gold discovered in Australia.

1874 Publication of Marcus Clarke's Australian historical novel *His Natural Life.*

1880 The arrest, trial, and execution of the bushranger Ned Kelly.
First publication of *The Bulletin* illustrated magazine in Sydney.

1886 Soprano Nellie Melba leaves Australia to pursue an illustrious international career.

1889 The NSW Premier, Sir Henry Parkes, speaking at Tenterfield (NSW) calls for a federated Australian parliament. In the ensuing decade Parkes is the leading advocate for federation at a series of intercolonial conventions.

Art

1891	Arthur Streeton's *Golden Summer, Eaglemont*, 1889, becomes the first painting by an Australian-born artist to be hung in the Royal Academy, London.
1893	E.Phillips Fox and Tudor St George Tucker establish the Melbourne Art School.
1895	New South Wales Society of Artists formed.
1899	Lionel Lindsay's *A Consideration of the Art of Ernest Moffitt*, the first monograph on an Australian artist.
1901	Tom Roberts commences large painting of the opening of the first federal parliament.
1907	The First Australian Exhibition of Women's Work, Melbourne.
1910	Merric Boyd establishes studio pottery.
1911	Baldwin Spencer begins collecting bark-paintings in Arnhem Land, Northern Territory.
1916	Journal *Art in Australia* commences publication.
1917	Commencement of official war-art scheme.
1919	Roy de Maistre and Roland Wakelin's 'Colour in Art' exhibition, Sydney.

Events

1891	The first Queensland shearers' strike. The first Labor members elected to Australian parliaments in South Australia and NSW. In 1899 the world's first labor government is formed briefly in Queensland.
1893	Discovery of gold at Kalgoorlie in Western Australia.
1894	South Australia becomes the first colony to extend the vote to women and to allow women to stand for parliament.
1898	The Haddon Expedition to the Torres Strait Islands.
1901	The Commonwealth of Australia comes into being. The first federal ministry formed under the prime ministership of Edmund Barton.
1902	A uniform federal franchise established, including votes for women.
1907	First issue of *The Lone Hand*.
1910	Publication of Henry Handel Richardson's *The Getting of Wisdom*. Her trilogy *The Fortunes of Richard Mahony* completed in 1929.
1913	Establishment of the national capital at Canberra. Chicago architect Walter Burley Griffin wins the competition to design the city.
1914	Outbreak of the First World War. Australian navy and army involved in capture of German New Guinea. Expeditionary forces leave for the northern hemisphere.
1915	Australian troops take part in the Allied landings at Gallipoli, where they meet determined resistance from the Turkish army. Fierce fighting over the ensuing months makes this a defining moment in Australia's sense of nationhood.
1916	Australian troops in France. Over the next two and a half years Australian casualties on the Western Front are enormous. In all, Australia loses nearly 60,000 men and over 166,000 are wounded. Following a referendum, conscription is rejected. Conscription is the dominant political issue in Australia.
1918	End of the First World War.
1919	Australia plays a role in the Paris Peace Conference. Spanish influenza epidemic. The beginning of 'soldier settlement' schemes across rural Australia. After a decade many of these have collapsed.

Art

1921 Return to Australia of George Lambert.
Return to Australia of Thea Proctor.
First award of the annual Archibald Prize
for portraiture.

1926 'A Group of Modern Painters' exhibition,
Sydney.
Hans Heysen paints in the Flinders
Ranges, South Australia.

1930 The Modern Art Centre established in
Sydney.

1932 George Bell School established in
Melbourne.
1934 William Moore's *The Story of Australian
Art* published.
1937 Formation of the Australian Academy of
Art.
1938 First solo exhibition of watercolours by
Albert Namatjira.
Formation of the Contemporary Art
Society in Melbourne.
1939 'Exhibition 1', David Jones Art Gallery,
Sydney.
1941 'Australian Aboriginal Art and its
Application' exhibition, David Jones Art
Gallery, Sydney.
1942 The 'Anti-Fascist Exhibition',
Contemporary Art Society, Melbourne.
1943 Avant-garde magazine *Angry Penguins*
published by Reed and Harris.
1944 The Dobell case over the awarding of the
1943 Archibald Prize to his portrait of
Joshua Smith.
1945 Publication of Bernard Smith's *Place,
Taste and Tradition*.

1948 The American–Australian Scientific
Expedition to Arnhem Land.

Events

1922 D. H. Lawrence lives in Australia.
His novel *Kangaroo* appears in 1923.

1928 Kingsford Smith and Ulm make the first
flight across the Pacific, from California
to Queensland.
The Coniston massacre, in which a
Northern Territory police constable,
Murray, indiscriminately kills 31
Aborigines.
Don Bradman's international cricketing
career begins.
Great Depression hits Australia.
1930 Amy Johnson flies solo from England to
Australia.
1931 Sir Isaac Isaacs appointed as the first
Australian-born Governor-General.
Arnhem Land declared an Aboriginal
Reserve.
1932 Opening of the Sydney Harbour Bridge.
Establishment of the Australian
Broadcasting Commission.

1938 Formation of the Jindyworobak writers
group, established to pursue Australian
themes in writing.

1939 Outbreak of the Second World War.

1941 Japan begins Pacific offensive.

1945 End of the Second World War
Death of Australia's wartime leader John
Curtin.
Howard Florey, Adelaide-born pioneer in
antibiotics, awarded the Nobel Prize.
1948 Australian politician H.V. Evatt elected
president of the UN General Assembly.
Retirement of Don Bradman from test
cricket.
1949 Commencement of major civil
engineering project the Snowy
Mountains Scheme. The scheme
employs large numbers of new migrants
from Europe.
Federal legislation to allow Aborigines to
vote in NSW, Tasmania, and South
Australia.
1950 Australians involved in the Korean War.

Timeline dates column: 1921 · 1930 · 1950

Art		Events	
1955		1955	Publication of Patrick White's novel *The Tree of Man*.
		1956	Commencement of television broadcasts in Australia.
			Melbourne Olympic Games.
1958	The first of Tony Tuckson and Stuart Scougall's field trips to Arnhem Land.	1958	Commencement of Qantas round-the-world service.
1959	The 'Antipodeans' exhibition, Melbourne.		
1960 1960–1	Major touring exhibition 'Australian Aboriginal Art'.	1960	The first Adelaide Festival.
	Bernard Smith's *Australian Painting* published.		
		1962	Legislation gives Aborigines the right to vote in federal elections in Western Australia, Queensland, and the Northern Territory.
			Beginning of Australia's military involvement in the Vietnam War.
1963	Journal *Art and Australia* commences publication.		
		1966	Retirement of Sir Robert Menzies, ending his 16-year term as Prime Minister.
			The birth of the Aboriginal land rights movement with the Wave Hill walk-off in the Northern Territory.
			Publication of Geoffrey Blainey's *The Tyranny of Distance*.
		1967	Referendum gives Federal government power in Aboriginal affairs and allows for inclusion of Australia's indigenous people in the census.
1968	'The Field' exhibition, National Gallery of Victoria, Melbourne.		
1970		1970	Publication of Germaine Greer's *The Female Eunuch*.
1971	Beginning of the Papunya painting movement.		
		1972	Election of the Whitlam Labor government.
1973	The first Bienniale of Sydney.	1973	Opening of Sydney Opera House.
			Patrick White awarded the Nobel Prize for Literature.
1974	Establishment of the Australian Centre for Photography, Sydney.	1974	Cyclone Tracy devastates Darwin.
		1975	Dismissal of Labor government by Governor-General, Sir John Kerr.
			Picnic at Hanging Rock, film directed by Peter Weir.
		1976	Northern Territory Land Rights Act.
1981	Touring exhibition 'Aboriginal Australia'.		
1982	Opening of the Australian National Gallery, Canberra (now the National Gallery of Australia).		
1988	'The Great Australian Art Exhibition' tours Australia.	1988	Bicentenary of European settlement in Australia.
	Exhibition 'Dreamings: The Art of Aboriginal Australia'.	1992	The 'Mabo judgement' in the High Court ends the doctrine of 'Terra nullius' and declares existence of Native Title to land.
1990 1990	Rover Thomas and Trevor Nickolls are the first Aboriginal artists to represent Australia at the Venice Biennale.		
1993	First Asia-Pacific Triennial of Contemporary Art, Queensland Art Gallery.		

1995

Art

1995	Bill Henson represents Australia at Venice Biennale.
1997	Emily Kngwarreye, Yvonne Koolmatrie, and Judy Watson represent Australia at the Venice Biennale.
1999	Howard Arkley represents Australia at the Venice Biennale.

Events

1999	Republic referendum fails.
2000	Sydney Olympic Games.

Further Reading

Australian art: general

The earliest book to attempt a **comprehensive coverage** of Australian art was W. Moore, *The Story of Australian Art* (Sydney, 1934, reissued in facsimile Sydney, 1980), a two-volume work valuable for the range of mediums covered and for information the author obtained directly from his sources. B. Smith's *Place, Taste and Tradition* (Sydney, 1945, reissued Melbourne, 1979), a robust and vigorous account on Marxist principles, can justly be considered the first attempt to write a history from a historical position, rather than as a straight narrative. Smith's status as the foremost historian of Australian art was strengthened by the publication of his *Australian Painting* (Melbourne, 1960, revised editions with additional chapters to 1989). Smith's *Documents on Art and Taste in Australia 1770–1914* (Melbourne, 1975) forms a useful companion to his histories, reprinting several key documents. A lively survey concentrating mainly on painting and largely following the structure of Smith's book is R. Hughes, *The Art of Australia* (Harmondsworth, 1970). The most useful survey published to accompany an exhibition is *Creating Australia: 200 years of art 1788–1988* (Adelaide, 1988), which accompanied the Bicentennial touring exhibition, 'The Great Australian Art Exhibition', and includes essays on individual works by a range of experts.

Three accessible surveys based on **individual collections** are D. Thomas, *Outlines of Australian Art: The Joseph Brown Collection* (Melbourne, 1974 and subsequent editions), M. Eagle and J. Jones, *A Story of Australian Painting* (Sydney, 1994), and L. Seear and J. Ewington (eds), *Brought to Light: Australian Art 1850–1965 from the Queensland Art Gallery Collection* (Brisbane, 1998).

The most useful and reliable **dictionaries and encyclopaedias** on Australian artists are J. Kerr (ed.), *The Dictionary of Australian Artists: Painters, Sketchers, Photographers and Engravers to 1870* (Oxford University Press, Melbourne, 1992) and A. McCulloch, *The Encyclopaedia of Australian Art* (Sydney, 1964 and subsequent revised and updated editions). J. Kerr (ed.), *Heritage: the national women's art book* (Sydney, 1995) combines a biographical dictionary and entries about art works covering the period up to 1955. See also V. Johnson, *Aboriginal artists of the Western Desert: a biographical dictionary* (Sydney, 1994) and S. Kleinert and M. Neale (eds), *The Oxford Companion to Aboriginal Art and Culture* (Oxford, 2000).

Medium-specific surveys of Australian art have not been abundant in fields other than painting. Sculpture is surveyed in G. Sturgeon, *The Development of Australian Sculpture 1788–1975* (London, 1978) and in the biographically arranged K. Scarlett, *Australian Sculptors* (Melbourne, 1980); drawing in A. Sayers, *Drawing in Australia: Drawings, water-colours and pastels from the 1770s to the 1980s* (Canberra and Melbourne, 1989); watercolour in J. Campbell, *Australian Watercolour Painters 1780 – 1980* (Adelaide, 1983) and H. Kolenberg, *Australian Watercolours* (Art Gallery of New South Wales, Sydney, 1996); photography in J. Cato, *The Story of the Camera in Australia* (Melbourne, 1955), G. Newton, *Shades of Light: Photography in Australia 1839–1988* (Canberra and Sydney, 1988), and A.-M. Willis, *Picturing Australia: A history of photography* (Sydney, 1988). The literature on the decorative arts is specialized: aspects of the field are surveyed in J. McPhee, *Australian decorative arts in the Australian National Gallery* (Canberra, 1982), Peter Timms, *Australian studio pottery and china painting* (Melbourne, 1986), and K. Fahy et al., *Nineteenth-century Australian furniture* (Sydney, 1985).

Aboriginal art: general

There is now an increasing body of literature on Aboriginal art, the best **general surveys** being H. Morphy, *Aboriginal Art* (London, 1998) and W. Caruana, *Aboriginal Art* (London, 1993). P. Sutton et al., *Dreamings: The art of Aboriginal Australia* (New York, 1988) is an excellent introduction to the concepts in Aboriginal art. C. P. Cooper et al., *Aboriginal Australia* (Australian Gallery Directors' Council, Sydney, 1981) is the catalogue of a major touring exhibition which illustrates and contextualizes a wide range of work from several regions. The catalogue of the touring exhibition 'Aratjara' also provides excellent introductory essays. M. Neale, *Yiribana* (Art Gallery of New South Wales, Sydney, 1994) is a broad survey based on the Gallery's collection. The literature on the Torres Strait art remains meagre: T. Mosby (ed.), *Ilan Pasin (this is our way)* (Cairns Regional Gallery, 1998) presents a range of contemporary viewpoints.

The most accessible discussions of the often technical and arcane study of **Aboriginal rock art** are J. Flood, *Rock Art of the Dreamtime: Images of ancient Australia* (Sydney, 1997), R. Layton, *Australian Rock Art: A new synthesis* (Melbourne, 1992), and the excellently illustrated G. Chaloupka, *Journey in Time: The world's longest continuing art tradition* (Sydney, 1993).

1788–1900: general

As an introduction to the **early art of Europeans in Australia** and the Pacific, B. Smith, *European Vision in the South Pacific 1768–1850* (Oxford, 1960, second edition Sydney, 1985) is unsurpassed. T. and R. Rienits, *Early artists of Australia* (Sydney, 1963) is now old-fashioned, but remains useful. B. Smith and A. Wheeler, *The Art of the First Fleet* (Melbourne, 1988) illustrates and gives context for many early drawings, as do J. Bonnemains, E. Forsyth, and B. Smith, *Baudin in Australian Waters* (Melbourne, 1988), and T. McCormick et al., *First views of Australia 1788–1825* (Sydney, 1987). R. Dixon's *The Course of Empire: Neo-classical culture in New South Wales 1788–1860* (Melbourne, 1986) sets the cultural context of early colonial Australia, largely from literary sources, and includes a discussion of images.

On **specific areas of early colonial art** the following general surveys are invaluable: T. Bonyhady, *Images in Opposition: Australian landscape painting 1801–1890* (Melbourne, 1985); E. Buscombe, *Artists in early Australia and their portraits* (Sydney, 1978); D. Thomas, *Australian Art of the 1870s* (Art Gallery of New South Wales, Sydney, 1976). B. Chapman, *The Colonial Eye* (Art Gallery of Western Australia, 1979) surveys Western Australian colonial art; R. Radford and J. Hylton, *Australian Colonial Art 1800–1900* (Art Gallery of South Australia, 1995) is best on South Australian material and H. Kolenberg, *Tasmanian Vision* (Tasmanian Museum and Art Gallery, Hobart, 1987) for Tasmaniana.

A. Davies and P. Stanbury, *The Mechanical Eye in Australia: Photography 1841–1900* (Melbourne, 1985) remains the only broad-ranging work on **colonial photography**.

A. Sayers, *Aboriginal Artists of the Nineteenth Century* (Melbourne, 1994) is biographical in approach and contains a catalogue of known works.

On **nineteenth-century collecting** see P. McDonald and B. Pearce, *The artist and the patron: aspects of colonial art in New South Wales* (Art Gallery of New South Wales, Sydney, 1988) and, for Victoria, A. Galbally (ed.), *The first collections* (University Art Museum, Melbourne, 1992).

The art of the **Heidelberg School** and its era is studied in H. Topliss, *The artists' camps: plein air painting in Melbourne 1885–1898* (Monash University Gallery, Melbourne, 1984), J. Clark, *Golden Summers: Heidelberg and beyond* (National Gallery of Victoria, Melbourne, 1985), L. Astbury, *Sunlight and Shadow: Australian impressionist painting 1880–1900* (Sydney, 1989), and V. Hammond and J. Peers, *Completing the Picture: Women Artists and the Heidelberg Era* (Melbourne, 1992). The essays by I. Burn and T. Smith included in A. Bradley and T. Smith (eds), *Australian Art and Architecture: Essays presented to Bernard Smith* (Melbourne, 1980) have been influential in the study of the era.

1788 – 1900: monographs

Most of the major references to the artists treated in this work are to be found in the notes. Studies of the lives and works of nineteenth-century artists are not as extensive as for the twentieth century and those which exist can be relatively easily found in catalogues. The thinness of the earlier part of the century is made up for in the literature on the artists of the Heidelberg School—the literature on Tom Roberts, in particular, is extensive.

Catalogues raisonnés of Australian artists are rare.

The twentieth century: general

Works which encompass **broad periods or movements** include C. Merewether, *Art and Social Commitment: an end to the city of dreams 1931–48* (Art Gallery of New South Wales, 1984), I. Burn, *National Life and Landscapes; Australian Painting 1900–1940* (Sydney, 1990), M. Eagle, *Australian Modern Painting: between the Wars 1914–1939* (Sydney, 1990), C. Chapman, 'Surrealism in Australia', in *Surrealism: Revolution by Night* (National Gallery of Australia, Canberra, 1993), 216–317, R. Haese, *Rebels and Precursors: The revolutionary years of Australian art* (Melbourne, 1981), and C. Heathcote, *A Quiet Revolution: the rise of Australian art 1946–1968* (Melbourne, 1995). P. Taylor (ed.), *Anything Goes: Art in Australia 1970–1980* (Melbourne, 1984) is a collection of seminal art writing of the decade.

Aboriginal art and art styles in the twentieth century are studied in J. Ryan, *Mythscapes: Aboriginal art of the desert* (National Gallery of Victoria, Melbourne, 1989), W. Caruana (ed.), *Windows on the Dreaming* (Australian National Gallery, Canberra, 1989), H. Morphy, *Ancestral Connections: art and an Aboriginal system of knowledge* (Chicago, 1991), G. Bardon, *Papunya Tula: Art of the Western Desert* (Melbourne, 1991), J. Hardy, J. V. S. Megaw, and M. R. Megaw (eds), *The Heritage of Namatjira* (Melbourne, 1992), J. Ryan and K. Akerman, *Images of Power: Aboriginal art from the Kimberley* (National Gallery of Victoria, Melbourne, 1993), L. Taylor, *Seeing the inside: Bark painting in Western Arnhem Land* (Oxford, 1996), W. Caruana and N. Lendon (eds), *The Painters of the Wagilag Sisters Story 1937–1997* (Canberra, 1997), and D. Mundine et al, *Saltwater: Yirrkala Paintings of Sea Country* (Buku Larrgnugay Mulka, 1999).

Twentieth century: monographs

There are now many hundreds of excellent monographs on both Aboriginal and non-Aboriginal artists which are readily accessible through catalogue searching. Many of the major references to the artists treated in this work are to be found in the notes.

Contemporary art: catalogues and essays

Among the most accessible compilations of contemporary art are the catalogues of *Australian Perspecta* (Art Gallery of New South Wales) from 1981, *The Adelaide Biennial of Australian Art* (Art Gallery of South Australia) from 1990, and included in the international surveys *The Biennale of Sydney* from 1973 and *The Asia-Pacific Triennial* (Queensland Art Gallery) from 1993.

Catalogues of overseas exhibitions of Australian art with good essays include *Antipodean Currents: 10 contemporary artists from Australia* (Guggenheim Museum, New York, 1995) and *In Place (Out of Time): Contemporary Art in Australia* (Museum of Modern Art, Oxford, 1997).

Collections of essays on contemporary Australian art are comparatively scarce. I. Burn, *Dialogue: Writings in Art History* (Sydney, 1991), E. Colless, *The Error of my Ways: Selected writing 1981–1994* (Brisbane, 1995), and R. Butler, *What is Appropriation?: An anthology of critical writing on Australian art* (Sydney, 1996) are all rewarding, as are the reflections of the late English critic P. Fuller, *The Australian Scapegoat: Towards an Antipodean Aesthetic* (Perth, 1986).

Journals

Since 1888 there have been many ephemeral and small-scale art journals in Australia. The first journal of substance devoted solely to art was *Art in Australia*, published between 1916 and 1942. The principal journals are now *Art and Australia* (1963–), *Art & Text* (1981–), *Artlink* (1981–), *Art Monthly Australia* (1987–), *Australian Art Collector* (1997–). The Australian Art Association (the association of art historians) publishes *The Australian Journal of Art* (1978). Most public galleries publish newsletters or magazines; the Contemporary Art Society of South Australia produces a broadsheet.

Websites are one of the fastest-growing areas of publishing. The sites listed below are currently the most comprehensive and good starting points.

	Website
National art collections	
Australian Museums On Line (AMOL) Entry-point to over 400,000 collection records and 1,000 Australian museum listings	*www.amol.org.au*
National Gallery of Australia Particularly strong on Australian prints	*www.nga.gov.au*
National Library of Australia IMAGES 1 database	*www.nla.gov.au*
State Library of New South Wales PICMAN database	*www.slnsw.gov.au/picman/*
State Library of Victoria Multimedia Catalogue	*www.slv.vic.gov.au/slv/mmcatalogue/*
National Portrait Gallery	*www.portrait.gov.au*
Australian War Memorial	*www.awm.gov.au*
Library of the Institute of the Arts at Australian National University Australian Visual Resources site	*www.anu.edu.au/clusters/ita/subjects/austvisres.html*
State art galleries	
Art Gallery of New South Wales, Sydney	*www.artgallerynsw.gov.au*
Art Gallery of South Australia, Adelaide	*www.artgallery.sa.gov.au*
Art Gallery of Western Australia, Perth	www.artgallery.wa.gov.au
National Gallery of Victoria, Melbourne	*www.ngv.vic.gov.au*
Tasmanian Museum and Art Gallery, Hobart	*www.tmag.tas.gov.au*
Queensland Art Gallery, Brisbane	*www.qag.qld.gov.au*
State Library of Tasmania Good pictorial resources, particularly in the area of the nineteenth century	*www.tased.edu.au/library/library.htm*
Contemporary art	
Museum of Contemporary Art	*www.mca.com.au*
The Experimental Art Foundation	*www.eaf.asn.au*
Australian Centre for Contemporary Art	*www.artnow.org.au/*
Sydney Contemporary Art Network Includes the **Australian Centre for Photography**	*www.sydneyarts.net/*
Powerhouse Museum See especially for design and technology	*www.phm.gov.au.*
Australian Commercial Galleries Association	*www.acga.com.au*

List of Illustrations

The publishers would like to thank the following individuals and institutions who have kindly given permission to reproduce the illustrations listed below.

1. William Westall, *Groote Eylandt*, 1803. Pencil. 18.5 x 27.2 cm. Courtesy of National Library of Australia, Canberra. (PICR4352)
2. Gulpidja, Groote Eylandt, *Jundurrana creation story*, 1948. Natural pigments on bark. Courtesy of Australian Museum, Sydney/Nature Focus. (ANT-33145)
3. *Spirit figure*, Basin track. Ku-ring-gai Chase. Courtesy of National Parks and Wildlife Service. ©NPWS Photo: N. Paton.
4. William Westall, *Chasm Island, native cave painting*, 1803. Watercolour. 26.7 x 37.2 cm. Courtesy of National Library of Australia. (R4356)
5. Rock engravings at Thomas Reservoir, Northern Territory. Photo: Robert Edwards.
6. Rock engravings, Mount Cameron West, Tasmania. Photo: Robert Edwards.
7. Rock art, Ubirr, Kakadu, Arnhem Land. Photo: Robert Edwards.
8. Rock art sequences, Kakadu. Photo: Robert Edwards.
9. Rock shelter, Victoria River region, Northern Territory. Photo: Robert Edwards.
10. Unknown artist, Port Jackson, *Balloderree*, c. 1790. Watercolour. 28.7 x 21.8 cm. Courtesy of The Natural History Museum, London. T12508/D.
11. Tommy McRae, *Victorian Blacks. Melbourne Tribe Holding corroboree after seeing ships for the first time*, c. 1890. Pen and ink on sketchbook page. 24 x 36 cm. Courtesy of National Gallery of Australia, Canberra.
12. Unknown artist, Port Jackson Painter Collection, *Diamond python*, No. 40 from Banks Manuscript 34, c. 1790. Ink, Watercolour. 31 x 20 cm. (T12640/A)
13. Ferdinand Bauer, *Banksia speciosa*, c. 1805–14. Watercolour. 52.5 x 35.6 cm. Courtesy of Natural History Museum, London.

(T/21740/R)
14. Charles-Alexandre Lesueur, *Macropus fuliginosus*, c. 1805. Watercolour. 25 x 40 cm. Muséum d'Histoire Naturelle, Lesueur Collection, Le Havre. (80 057).
15. Augustus Earle, *Portrait of Bungaree, a Native of New South Wales*, c. 1827. Oil on canvas. 68.5 x 50.5 cm. Rex Nan Kivell Collection. Courtesy of National Library of Australia. (NK118 T305)
16. Benjamin Duterrau, *The conciliation*, 1840. Oil on canvas. 119.5 x 167.5 cm. Courtesy of Tasmanian Museum and Art Gallery, Hobart.
17. George Raper, *View of the East Side of Sydney Cove, Port Jackson from the Anchorage. The Governour's House … c.* 1790. Watercolour. 31.7 x 47.4 cm. Courtesy of Natural History Museum, London. (T15116/A)
18. Augustus Earle, *Government House and part of the town of Sydney New South Wales*, 1828. Watercolour. 18.1 x 31.1 cm. Rex Nan Kivell Collection. Courtesy of National Library of Australia, Canberra. (NK 12/31T69)
19. Conrad Martens, *View from Rose Bank*, 1840. Oil on canvas. 47 x 66 cm. From the James Fairfax collection, gift of Bridgestar Prt Ltd, 1993. Courtesy of National Gallery of Australia, Canberra.
20. Thomas Bock, *Alexander Pearce executed for the murder of a Man named Cox of Macquarie Harbour*, 1824. In his *Sketches of Tasmanian bushrangers*, f.25. Pencil. 23.2 x 41.7 cm. Courtesy of The Dixson Library, State Library of New South Wales, Sydney. (ZP. x 5)
21. Thomas Griffiths Wainewright, *The Cutmear twins, Jane and Lucy*, c. 1842. Watercolour and pencil. 32.0 x 30 cm. Courtesy of National Gallery of Australia, Canberra.
22. Emily Stuart Bowring, *A view from the cottage window, Burlington*, 1855. Pencil on sketchbook page. 29.6 x 22.6 cm. Courtesy of Queen Victoria Museum and Art Gallery, Launceston.
23. John Glover, *View of Mills Plains, Van Diemen's Land*, 1833. Oil on canvas. 76.2 x 114.6

cm. Courtesy of Art Gallery of South Australia, Adelaide. South Australian Morgan Thomas Bequest Fund 1951.

24. John Glover, *Cawood on the Ouse River*, 1835. Oil on canvas. 76 x 114.4 cm. Gift of Mrs G. C. Nicholas, 1936. Courtesy of Tasmanian Museum and Art Gallery.

25. John Glover, *Aborigines dancing at Brighton, Tasmania*, 1835. Oil on canvas. 73.5 x 112.5 cm. Courtesy of Mitchell Library, State Library of New South Wales, Sydney. (ZML154)

26. Mary Morton Allport, *Opossum Mouse* from the *Tasmanian Journal of Natural Science*, 1843. Lithograph. Courtesy of Allport Library and Museum of Fine Arts, State Library of Tasmania.

27. E. C. Frome, *First view of the Salt Desert – called Lake Torrens*, 1843. Watercolour on paper. 18 x 27.8 cm. Courtesy of Art Gallery of South Australia, Adelaide. South Australian Government Grant City Council and Public Donations 1970.

28. S. T. Gill, *Country north-west of the Tableland, Aug 22, c. 1846*. Watercolour. 19.1 x 30.5 cm. Courtesy of National Library of Australia, Canberra. Gift of Her Majesty Queen Elizabeth II 1956. (R347)

29. Ludwig Becker, *Portrait of Dick, the brave and gallant native guide*, 1860. Watercolour. 14 x 22.3 cm. Ludwig Becker sketchbook, MS 13071, La Trobe Collection, State Library of Victoria, Melbourne.

30. Eugene von Guérard, *Basin Banks about twenty miles south of Mount Elephant*, 1857. Oil on canvas. 50.8 x 85.5 cm. Kerry Stokes collection, Perth.

31. Eugene von Guérard, *North-east view of the northern top of Mount Kosciusko*, 1863. Oil on canvas. 66.5 x 116.8 cm. Courtesy of National Gallery of Australia, Canberra.

32. Louis Buvelot, *Waterpool near Coleraine (Sunset)*, 1869. Oil on canvas. 107.4 x 153 cm. Purchased 1870. Courtesy of National Gallery of Victoria, Melbourne.

33. William Strutt, *Robert O'Hara Burke*, 1862. Oil on canvas on board. 98 x 64 cm. Private collection, Melbourne.

34. Eugene von Guérard, *Mr Clark's Station, Deep Creek, near Keilor (Glenara)*, 1867. Oil on canvas. 68.2 x 121.8 cm. Purchased with the assistance of the National Gallery Society, Victoria, and Mr and Mrs Solomon Lew, 1986. Courtesy of National Gallery of Victoria, Melbourne.

35. Charles Summers, *The Burke and Wills Monument*, Melbourne, 1865. Bronze statue. 390 cm; pedestal 460 cm. Courtesy of La Trobe Collection, State Library of Victoria, Melbourne. Photograph: Charles Nettleton, *c.* 1875. (H36540)

36. Theresa Walker, *Self portrait, c. 1840*. Adelaide. Wax. 9 cm diameter. Private collection, Walkerville. Photo courtesy of Art Gallery of South Australia.

37. Richard Daintree and Antoine Fauchery, *Group of Aborigines*, 1858. Albumen silver photograph. 13.4 x 19.4 cm. From the album *Australia* , plate 48. Courtesy of La Trobe Collection, State Library of Victoria, Melbourne. (H2468)

38. J. W. Lindt, *Solferino, N.S.W. (Mining Town)*, 1870–3. Albumen print. 20 x 28 cm. Courtesy of State Library of Victoria. (H36540)

39. William Barak, *Ceremony*, *c.* 1880s. Ochres, watercolour, pencil. 58.8 x 70.2 cm. Courtesy of Staatliches Museum für Völkerkunde, Dresden. Photo: E. Winkler. (68706)

40. William Barak, *Samuel de Pury's Vineyard*. 1898. Ochres, watercolour. 56 x 76 cm. Courtesy of Musée d'Ethnographie, Switzerland. ©MEN Photo: Alain Germond, Neuchâtel. (MENV 1238)

41. Tommy McRae, *Scenes of Aboriginal life with squatters*, 1865. Pen and ink. 21 x 35.5 cm. Courtesy of State Library of New South Wales.

42. Mickey of Ulladulla, *Boats, fish; native flora and fauna*, *c.* 1888. Pencil, watercolour. 38 x 55.2 cm. Ulladulla Collection, Audiovisual Archives. Courtesy of Australian Institute of Aboriginal and Torres Strait Islander Studies.

43. Tom Roberts, *Allegro con brio, Bourke Street West, Melbourne*, 1885–6. Oil on canvas lined on composition board. 51.2 x 76.3 cm. Courtesy of the National Library of Australia. (R3292)

44. Charles Conder, *Impressionists' camp*, 1889. Oil on paper on cardboard. 13.9 x 24 cm. Gift of Mr and Mrs Fred Williams and family. Courtesy of National Gallery of Australia, Canberra.

45. Charles Conder, *A holiday at Mentone*, 1888. Oil on canvas. 46.2 x 60.8 cm. Courtesy of Art Gallery of South Australia, Adelaide. Bond Corporation Holdings Ltd through the Courtesy of Art Gallery of South Australia Foundation and State Government funds, to mark the Gallery's Centenary 1981.

46. Arthur Streeton, *Golden Summer, Eaglemont*, 1889. Oil on canvas. 81.3 x 152.6 cm. Courtesy of National Gallery of Australia, Canberra.

47. Arthur Streeton, '*Fire's on*', 1891. Oil on canvas. 183.8 x 122.5 cm. Courtesy of Art Gallery of New South Wales, Sydney. Photo:

Ray Woodbury for AGNSW. (832)

48. Frederick McCubbin, *Lost*, 1886. Oil on canvas. 115.8 x 73.7 cm. Courtesy of National Gallery of Victoria, Melbourne. Felton Bequest Fund 1940.

49. Tom Roberts, *In a corner on the Macintyre*, 1895. Oil on canvas. 71.1 x 86.4 cm. Courtesy of National Gallery of Australia, Canberra.

50. David Davies, *Moonrise*, 1894. Oil on canvas. 119.8 x 150.4 cm. Courtesy of National Gallery of Victoria, purchased 1894.

51. E. Phillips Fox , *Art students*, 1895. Oil on canvas. 182.9 x 114.3 cm. Courtesy of Art Gallery of New South Wales, Sydney. Photo: Ray Woodbury for AGNSW. (7319)

52. Clara Southern, *Evensong, c.* 1910. Oil on canvas. 54 x 112.2 cm. Courtesy of National Gallery of Victoria, purchased 1962.

53. Nicholas Caire, *Fairy scene at the Landslip, Black's Spur, Victoria,* 1878. Albumen silver photograph. 27.4 x 22.5 cm. Joseph Brown Fund 1981. Courtesy of National Gallery of Australia, Canberra.

54. Cardwell district, bicornual basket, before 1899. Lawyer cane. 81.5 x 57.5 x 39 cm. Photo courtesy of the Museums Board of Victoria. (x 5980)

55. Melville Island, Tiwi basket collected by Baldwin Spencer, 1912. Photo courtesy of the Museums Board of Victoria. (x 18062)

56. Baldwin Spencer, *Kakadu man killing a water snake*, 1912. Photograph from glass-plate negative. Photo courtesy of the Museums Board of Victoria. (x P9571)

57. Gagadju, Arnhem Land, bark-painting collected by Baldwin Spencer at Oenpelli. Photo courtesy of the Museums Board of Victoria. (x 19895)

58. Gagadju, Arnhem Land, bark-painting collected by Baldwin Spencer at Oenpelli Museum of Victoria. Photo courtesy of the Museums Board of Victoria. (x 19886)

59. Mabuiag, Torres Strait Islands, Turtleshell dance-mask, various materials. Height 80 cm. Courtesy of Barbier-Mueller Museum, Geneva. Photo: P. A. Ferrazzini.

60. Merric Boyd, Vase, 1916. Ceramic earthenware. Height 18.8 cm. Courtesy of National Gallery of Australia, Canberra.

61. Norman Lindsay, *Pollice verso*, 1904. Pen and ink. 47.5 x 60.5 cm. © Jane Glad. Courtesy of National Gallery of Victoria, Felton Bequest Funds, 1907.

62. Blamire Young, Cover illustration for the magazine *The Lone Hand*, 1907. Watercolour, gouache. 52.4 x 34.6 cm. Courtesy of National Gallery of Australia, Canberra.

63. Jessie Traill, *The jewel necklace, Bland River*

and Lake Cowal, New South Wales, 1920. Etching, aquatint. 11.4 x 36.4 cm (Plate-mark) 21.0 x 46.1 cm (Sheet). Courtesy of National Gallery of Australia, Canberra.

64. Florence Rodway, *Portrait*, 1916. Pastel on paper. 94.3 x 43.5 cm. Courtesy of Art Gallery of New South Wales, Sydney. Permission of Ms S. G. Collins. Photo: Christopher Snee for AGNSW. (934)

65. Hugh Ramsay, *Two girls in white (The sisters)*, 1904. Oil on canvas on hardboard. 126.7 x 147.3 cm. Courtesy of Art Gallery of New South Wales, Sydney. Photo: Ray Woodbury for AGNSW. (849)

66. Max Meldrum, *The three trees*, (Sketch, Eltham), 1917. Oil on board. 35.5 x 25 cm. Private collection.

67. George Lambert, *Anzac, the landing, 1915*, 1920–2. Oil on canvas. 190.5 x 350.5 cm. Australian War Memorial, Canberra. ART02873.

68. Frank Lynch (sculptor) and Louis McCubbin (painter), *Pozières*, made in 1927. Diorama. 444 x 370 x 530 cm. Australian War Memorial, Canberra. (41019)

69. Roy de Maistre, *Waterfront, Sydney Harbour*, 1919. Oil on wood. Private collection. Photo: David Reid.

70. Margaret Preston, *Implement blue*, 1927. Oil on canvas on paperboard, 42.5 x 43 cm. Photo: Christopher Snee for AGNSW. (OA7.1960)

71. Margaret Preston, *West Australian banksia*, 1929. Woodblock print. 14.0 x 29.1 cm (comp.) 21.8 x 35.6 cm (sheet). Purchased from gallery admission charges, 1985. Courtesy of National Gallery of Australia, Canberra.

72. Grace Cossington Smith, *Trees, c.*1927. Oil on plywood. 91.5 x 74.3 cm. Collection of the Newcastle Region Art Gallery.

73. Grace Cossington Smith, *The Bridge Incurve*, 1930. Tempera and oil on composition board. 83.8 x 111.8 cm. Courtesy of National Gallery of Victoria, Melbourne. Gift of the National Gallery Society of Victoria 1967.

74. Hans Heysen, *In the Brachina Gorge*, 1928. Charcoal on paper. 47.3 x 62.6 cm. South Australian Government Grant 1934. Courtesy of Art Gallery of South Australia, Adelaide.

75. Nora Heysen, *Ruth*, 1933. Oil on canvas. 81.5 x 64.2 cm. Courtesy of Art Gallery of South Australia, Adelaide. South Australian Government Grant 1934.

76. Lloyd Rees, *The hillside*, 1932. Pencil. 20 x 26 cm. Courtesy of Art Gallery of New South Wales, Sydney. Photo: Suzie Ireland for AGNSW.

77. Harold Cazneaux , *The Spirit of Endurance*,

c. 1936. Gelatin silver photograph. 27.8 x 24.4 cm. 29.3 x 24.4 cm. Courtesy of National Gallery of Australia, Canberra.

78. Max Dupain, *Form at Bondi*, 1939. Gelatin silver photograph. 30.3 x 29.6 cm. Purchased from Visual Arts Board Funds, 1976. Courtesy of National Gallery of Victoria, Melbourne.

79. Albert Namatjira, *Landscape with ghost gum*. Watercolour. 35.4 x 25.5 cm. Private collection, Melbourne.

80. Otto Pareroultja, *James Range Country*, 1966. Watercolour. 54.5 x 74.8 cm. Ntaria Council, The Battarbee Collection, purchased 1998. Museum and Courtesy of Art Gallery of the Northern Territory Collection. (NAM-0229)

81. Margaret Preston, *Flying over the Shoalhaven River*, 1942. Oil on canvas. 50.5 x 50.5 cm. Courtesy of National Gallery of Australia, Canberra.

82. Margaret Preston, *Bush track, N.S.W.*, 1946. Colour monotype. 30.5 x 40.5 cm. Courtesy of National Gallery of Victoria, Melbourne, purchased 1948.

83. Yilkari Kitani, *Wagilag Story*, 1937. Natural pigments on eucalyptus bark. 126.5 x 68.5 cm. The Donald Thomson Collection on loan to Museum of Victoria from The University of Melbourne. (DT58)

84. Axel Poignant, *Yilkari*, 1952. Gelatin silver photograph. Courtesy of Roslyn Poignant.

85. Unknown artist, Groote Eylandt, *Mamariga, the south-east wind*, 1948. Natural pigments on bark. 76.5 x 39.5 cm (irreg.). Gift of the 1948 American–Australian Scientific Expedition to Arnhem Land 1956. Reproduced by permission, from the collection of the Queensland Art Gallery, Brisbane.

86. Unknown artist, Yirrkala, *The moon and yams,* 1948. Natural pigments on bark in wooden box frame. Yirrkala Dhanbul Assoc. National Museum of Australia, Canberra. Collected by Charles Mountford in 1948 as part of the American–Australian Scientific Ex pedition to Arnhem Land. 1985. (0067.0088)

87. James Gleeson, *The sower*, 1944. Oil on canvas. 76.2 x 50.8 cm. Courtesy of Art Gallery of New South Wales. Photo: Jenni Carter for AGNSW (OA13.1966)

88. Yosl Bergner, *Aborigines in Fitzroy, c.* 1941. Oil on board. 62 x 49.5 cm. South Australian Government Grant 1978. Courtesy of Art Gallery of South Australia, Adelaide.

89. Ludwig Hirschfeld Mack, *Desolation, internment camp, Orange, NSW,* 1941. Woodcut. 21.8 x 13.4 cm. Gift of Olive Hirschfeld, 1979. Courtesy of National Gallery of Australia.

90. Albert Tucker, *Victory girls*, 1943. Oil on cardboard. 64.6 x 58.7 cm. Courtesy of National Gallery of Australia, Canberra.

91. Arthur Boyd, *Self-portrait,* 1945–6. Oil on canvas. 89 x 78.5 cm. Private collection. Courtesy of National Portrait Gallery, Canberra. Photo: David Reid.

92. Joy Hester, *Girl*, 1957. Watercolour, brush and ink. 49.9 x 75.5 cm. Courtesy of National Gallery of Australia, Canberra.

93. Sidney Nolan, *Boy and the moon*, *c.*1939–40. Oil on canvas, mounted on composition board. 73.3 x 88.2 cm. Courtesy of National Gallery of Australia, Canberra.

94. Sidney Nolan, *Railway guard, Dimboola*, 1943. Enamel on canvas. 77.0 x 64.0 cm. Presented by Sir Sidney and Lady Nolan 1983. Courtesy of National Gallery of Victoria, Melbourne.

95. Sidney Nolan, *Ned Kelly*, 1946. Enamel on composition board. 90.4 x 121.2 cm. Courtesy of National Gallery of Australia, Canberra, gift of Sunday Reed, 1977.

96. Russell Drysdale, *The drover's wife*, 1945. Oil on canvas. 51.5 x 61.5 cm. Courtesy of National Gallery of Australia, Canberra. A gift to the people of Australia by Mr and Mrs Benno Schmidt of New York and Esperance, Western Australia through the American Friends of the Australian National Gallery, 1987.

97. William Dobell, *Joshua Smith*, 1943. Oil on canvas. 107 x 76 cm. Courtesy of Art Gallery of New South Wales, Sydney and Sir William Dobell Art Foundation.

98. Grace Cowley, *Abstract Painting*, 1950. Oil on composition board. 61.0 x 75.9 cm. Courtesy of Art Gallery of New South Wales, Sydney. Photo: Christopher Snee for AGNSW. (8720)

99. Godfrey Miller, *Seated figure*, date unknown. Pencil. Photo: Christopher Snee for AGNSW.

100. Robert Klippel, *No. 182 Metal construction*, 1965. Brazed steel, found objects (business machine parts). Height 70.2 cm. Private collection, Sydney. Photo: Michel Brouet.

101. Ian Fairweather, *Monsoon*, 1961–2. Synthetic polymer paint and gouache on cardboard. 98 x 188.5 cm. Courtesy of Art Gallery of Western Australia/DACS 1999. © Estate of Ian Fairweather 2000. All rights reserved. (1983/P12)

102. Fred Williams, *Sherbrooke*, 1966. Oil on canvas. 152 x 121.6 cm. Courtesy of National Gallery of Australia, Canberra.

103. Fred Williams, *Knoll in the You Yangs*, 1965. Oil on canvas. 150.1 x 206.2 cm. Courtesy

of Lyn Williams.

104. Janet Dawson, *Cave Hill*, 1976. Synthetic polymer paint on canvas. 183 x 244 cm. Private Collection. © Janet Dawson/DACS.

105. John Olsen, *Goyder Channel*, 1975. Watercolour and gouache. 190 x 100 cm. Courtesy of Art Gallery of New South Wales, Sydney. Photo: Ray Woodbury for AGNSW. (15.198)

106. David Moore, *The Impossible Tree (Angophora Tree, Lobster Bay, New South Wales)*, 1975. Courtesy of the artist.

107. John Brack, *The car*, 1955. Oil on canvas. 41 x 101.8 cm. Courtesy of National Gallery of Victoria, Melbourne, purchased 1956.

108. Jeffrey Smart, *Cahill Expressway*, 1962. Oil on plywood. 81.2 x 111.7 cm. Courtesy of National Gallery of Victoria, Melbourne, purchased 1963.

109. Brett Whiteley, *The balcony 2*, 1975. Oil on canvas. 203.5 x 364.5 cm. Courtesy of Art Gallery of New South Wales, Sydney. Photo: Christopher Snee for AGNSW. (116.1981)

110. Tony Tuckson, *Five white lines (vertical) on black ground*, 1970–3. Synthetic polymer paint on composition board. 213.5 x 122 cm. Bequest of Annette Margaret Dupree 1996. Courtesy of Art Gallery of New South Wales, Sydney/DACS. Photo: Christopher Snee for AGNSW. (1.1996)

111. Laurie Mungatopi, Bob One Apuatimi, Big Jack Yurnaga, Don Burakmadjua, Charlie Quiet, Unknown, *Tutini (Pukamani grave posts)*, acquired 1958. Natural pigments on iron wood. Courtesy of Art Gallery of New South Wales, Sydney, gift of Dr Stuart Scougall 1959. Photo: Jenni Carter for AGNSW. (PI-17.1959)

112. Mawalan Marika, *Djang'kawu, Creation Story*, 1959. Natural pigments on bark. 188 x 64.8 cm (irreg.). Courtesy of Art Gallery of New South Wales, gift of Dr Stuart Scougall 1959.

113. Unknown artist, Aurukun, *Fish on poles*, 1962. Painted wood. 140 x 216.5 cm. Used in Aurukun ceremonial dance no. 6 – bonefish. Collected by Frederick McCarthy in 1962. Courtesy of National Museum of Australia. (1985.0100.0023)

114. Nigel Lendon, *Structure for a specific site*, 1971. Steel-scaffolding. Courtesy of the artist.

115. Ken Whisson, *Disembarkation at Cythera (Idiot Wind)*, 1975. Oil on composition board. 82 x 112 cm. Courtesy of National Gallery of Australia, Canberra.

116. Arthur Boyd, *Bathers with Skate and Halley's Comet*, 1985. Oil on canvas. 267 x 414 cm. Collection Courtesy of Art Gallery of Western Australia, acquired with funds from the Sir Claude Hotchin Art Foundation, 1994. (994/373)

117. Clifford Possum Tjapaltjarri, *Bushfire II*, 1972. Synthetic polymer paint on board. 61 x 43 cm. Courtesy of National Gallery of Australia, Canberra.

118. Clifford Possum Tjapaltjarri and Tim Leura Tjapaltjarri, *Napperby Death Spirit Dreaming*, 1980. Synthetic polymer paint on canvas. 207.7 x 670.8 cm. Felton Bequest 1988, Courtesy of National Gallery of Victoria, Melbourne, and Aboriginal Artists Agency.

119. Turkey Tolson Tjupurrula, *Straightening spears at Ilyingaungau*, 1990. Synthetic polymer paint on canvas. 181.5 x 243.5 cm. Courtesy of Art Gallery of South Australia, Adelaide. Gift of the Friends of the Art Gallery of South Australia 1990. (906P17)

120. Emily Kngwarreye, *Wild Potatoes Dreaming*, 1991. Synthetic polymer paint on canvas. Reproduced by permission, from the collection of Queensland Art Gallery, Brisbane/DACS.

121. Rover Thomas, *Cyclone Tracy*, 1991. Natural pigments on canvas. 168 x 183 cm. Courtesy of National Gallery of Australia, Canberra.

122. John Marwurndjurl, *Ngalyod, the Rainbow Serpent*, 1988. Natural pigments on bark. 245 x 78 cm. Winner of the Rothmans Foundation Award for Paintings in Traditional Media, 5th NATIONAL SIAA, 1988. Courtesy of Museum and Art Gallery of the Northern Territory Collection. (ABART-1042)

123. Imants Tillers, *Untitled*, 1978. Photomechanical reproduction, synthetic polymer paint on canvas. Installation photograph of two canvasses, 185.5 x 263.9 cm. each. Courtesy of National Gallery of Australia, Canberra.

124. William Delafield Cook, *A waterfall (Strath Creek)*, 1980. Synthetic polymer paint on canvas. 198.2 x 156.2 cm. Art Gallery of New South Wales, Sydney. (65.1981)

125. Mike Parr, *O O Otohp (The Death of Ekim Rrap) In the Wings of the Oedipal Theatre, Part 2*, 1985. Installation shot, Perspecta, Art Gallery of New South Wales, Sydney, 24 October – 29 November, 1985. Variable, see letter Courtesy of Art Gallery of New South Wales, Sydney, 24 October – 29 November. By permission of the artist. Photo: David Cubby.

126. Fiona Hall, *Salix babylonica: urn*, 1991. Earthenware. 34 x 45 x 28cm. Courtesy of National Gallery of Australia, Canberra.

127. Bill Henson, *Untitled*, 1980–2. Gelatin silver photograph. Courtesy of National Gallery of Victoria. (PH069/1988)

128. John Wolseley, *The great tectonic arc: concerning the moving apart of Gondwana and the present position of Australia and Patagonia and how the great tree families Araucaria and Nothofagus evolved and were named and celebrated, followed by their radical depletion*, 1995. Arc of watercolour and pencil drawings on paper, plant specimens, photographs. Dimensions variable. © John Wolseley. Australian Centre for Contemporary Art, Melbourne. Photo: Robert Colvin.

129. Rosalie Gascoigne, *Set Up*, 1984. Synthetic polymer paint on wood, enamelware. 50 x 270 x 270 cm. Museum of Contemporary Art, Sydney, purchased 1995.

130. Paddy Dhatangu, David Malangi, George Milpurruru, Jimmy Wululu, and other Ramingining artists, Arnhem Land, *The Aboriginal Memorial*, 1987–8. Installation of 200 hollow-log bone coffins. Natural pigments on wood. Height to 327 cm. Purchased with the assistance of National Gallery admission charges and commissioned in 1987. Courtesy of National Gallery of Australia, Canberra/DACS.

131. Bea Maddock, *TERRA SPIRITUS ...with a darker shade of pale*, 1993–8. Drawing incised on paper and worked with hand-ground Launceston red ochre over blind letter-press, finished with hand-drawn pastel script. 51 sheets plus title page each 26.5 x 76 cm, in single horizontal line, overall length 38.76 m. Gordon Darling Fund 1998. Courtesy of National Gallery of Australia, Canberra.

The publisher and the author apologize for any errors or omissions in the above list. If contacted they will be pleased to rectify these at the earliest opportunity.

Index